World of Art

Suzanne Hudson is Associate Professor of Art History and Fine Arts at the University of Southern California. She is an esteemed art historian and critic who writes on modern and contemporary art, with an emphasis on painting, art pedagogy and American philosophy. She received her PhD from Princeton University.

Hudson's previous books include *Robert Ryman: Used Paint*, *Agnes Martin: Night Sea* and *Mary Weatherford*, and she is the co-editor of *Contemporary Art: 1989 to the Present*. She is a regular contributor to *Artforum*.

T0383486

1 Yue Minjun, *Inside and Outside the Stage*, 2009

World of Art

Contemporary Painting
Suzanne Hudson

First published in 2015 in the United Kingdom
as *Painting Now* by Thames & Hudson Ltd,
181A High Holborn, London WC1V 7QX

www.thamesandhudson.com

First published in 2015 in the United States
of America as *Painting Now* by Thames & Hudson Inc.,
500 Fifth Avenue, New York, New York 10110

www.thamesandhudsonusa.com

This edition published in 2021 as *Contemporary
Painting*

Contemporary Painting © 2021 Thames & Hudson Ltd,
London

Text by Suzanne Hudson

Art direction and series design: Kummer & Herrman
Layout: Adam Hay Studio

British Library Cataloguing-in-Publication Data
A catalogue record for this book is available from the
British Library

Library of Congress Control Number 2020933747

ISBN 978-0-500-29463-5

Printed and bound in Hong Kong, China through
Asia Pacific Offset Ltd

Contents

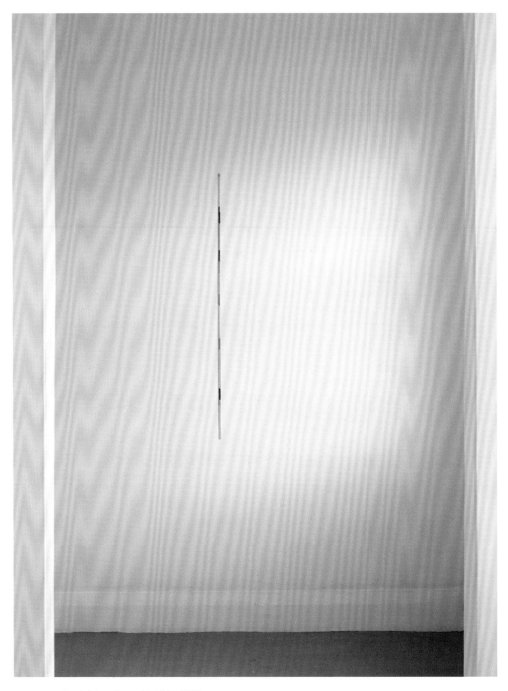

2 Patrick Lundberg, *No Title*, 2019

Introduction

This is a book about contemporary painting from the first two decades of the 21st century. The term 'contemporary' refers to art created in the present day and the recent past; it also specifies a historical period that comes after modernism's extension into postmodernism. Departing from the more ubiquitous sense that art is inevitably contemporary when it is made, this latter usage is characterized by pluralism and a global purview.

As contemporary painting remains consequential in our time, we might ask: how does it form, circulate and carry meaning? How does it relate to contemporary art more broadly, to its expanded geography and demographics? And to technology and media? Developing provisional responses to these and to related questions motivated me to write this book, which treats painting not as an isolated entity, but rather as a medium productively entangled in the world outside of its proverbial frame. Among so many other possibilities, a painting now may be outsourced to a village in Guangdong province, China, or it can be designed on-screen and printed on pre-primed linen using a commercial machine. A painting might hang on a wall, slight as a coloured shoestring or monumental as a space-filling mural, but it could also be used as a prop in a performance or serve as the backdrop for other actions, at times involving an audience that participates in realizing the work.

For many centuries, painting was an exemplary humanist object and the most prized form of Western art, but it needs to be addressed straight away that some readers might well question the fundamental premise of the book in assuming painting's continued relevance under changing circumstances. It has been contested in the digital age (and perhaps we should also ask what this tells us about our contemporary culture), though not for the first time. Indeed, the historical primacy of oil on canvas was reviewed with the arrival of photography in the 19th century: why labour over a painting when a camera

3 Raqib Shaw, *Paradise Lost*, 2001–13

could deliver an image with even greater verisimilitude? In the following century, it was opposed more directly by the readymade (the found object nominated as art by virtue of an artist asserting it as such, transforming it categorically, if not actually, as though with a magic wand).

Marcel Duchamp's use of the readymade in the 20th century coincided with a decisive abandonment of painting, or in his words, 'retinal' art. In fact, the 'smell of turpentine' that Duchamp detested did not prove so easy to leave behind. A great many artists persevered with painting, and, in the years after World War II, again the medium flourished. Debates about the primacy and even feasibility of painting picked up in the 1960s, with pop art's extensive use of commercial imagery. Artists engaged techniques used in photographic reproduction, as well as mechanical means of production, challenging traditional methods of painting and the once sacrosanct boundaries between media. Later in that decade, text-based practices (often photographic), performance and other ephemeral actions gained prominence.

Where modernism came to be embodied by abstract painting that shunned external references, subsequent approaches expanded the idea of what an artwork could be, encompassing not just images and words but also that which surrounds them: architecture, the institution itself, the passage of time and people's lives. This intersectionality came to be known as postmodernism. The new priorities seemed to disqualify painting, which was allegedly outdated and static by comparison, and was perceived as being divorced from conceptual currency and activist engagement.

Such considerations came to a head in the 1980s, with the triumphant return of painting. Partly in reaction to the liberation politics that characterized the preceding decades,

a recuperative universalism renewed focus on ideas with presumed common applicability. This was the perfect storm for the ascendancy of neo-expressionism, wildly gestural painting that materialized human touch on the surface and supposedly communicated deep emotions. For supporters, it evidenced a transhistorical humanism that connected the entirety of creativity in paint, from works in caves to those displayed in the white cube. This convinced many that the recent topical avoidance of painting had been an insignificant blip in a longer, corrective course.

At the same time, certain eminent artists, writers and curators described the collapse of modernist painting and advent of postmodern art using the language of endgame. This is a term borrowed from chess, referring to the last stages of a game. In art, endgame was used to describe the theory that as modernist painting collapsed and postmodernism – a heterogeneous set of practices united in their scepticism regarding collective truths, idealism and moral authority – took root, painting could not be furthered. Instead, it would potentially endlessly re-examine ideas that had come before. This was not a critique of the practicability of the whole of painting, just its production under modernist circumstances.

In this context, 'the death of painting' became glib shorthand for debates about the meaning of art in general and painting in particular in a free-market culture. Unable to achieve the weightiness that it once attained, painting lived on, but – in light of identity politics and war, economic crises and clashes between generations – it was seen as complicit in conservatism, retrograde in means and ends. Abstraction was panned for lacking content, and figuration for wallowing in canned sentimentality. Either way, it was seen as anachronistic, delivering value only as trifling decor, or so the argument went.

Of course, most critical stances on modernist painting were underwritten by historicism: a relativist, as opposed to universalist, approach to art history, which considers the significance of historical or geographical circumstance in the development of art. This was used to justify the timeliness of a reappraisal of medium. In this light, the endgame argument of the 1980s might be regarded as part of this same story, since it also involved re-evaluating the logic that had sustained the art practices being called into question. The idea of genres of art – or even art as such – coming to an 'end' point is not unprecedented. Pliny, a Roman polymath who attempted a consolidated account of art in his *Natural History* (1st century CE), recorded that Greek art had stopped for more than a hundred years because the era was characterized by Hellenistic 'Baroque' art that he did not much care for. A parallel to neo-expressionism resonates here.

So there existed an ideological antagonism when it came to painting: for or against. This was not contravened in the 1990s; if anything, the geopolitical events that occurred at the very end of the previous decade – from the fall of the Berlin Wall and the collapse of Communism in the Soviet Union and the rest of the Eastern Bloc, to the tumultuous civil protests in China – begged for more immediate engagement, which often took other artistic forms.

The 1980s had seen what came to be known as the 'culture wars', a series of social and aesthetic controversies that chiefly played out between conservatives and liberals in the US, which put representation and the expression of values at the heart of deeply partisan morality politics. The struggle to define American culture was driven by extreme suspicion and paranoia on the part of the political Right about the decline of traditional Christian religious values, as focalized by the increasing visibility of homosexuality and availability of abortion. In the wake of this, many artists demonstrated their positions by taking up abject bodily work, a form that was also adopted in response to the unprecedented trauma of the AIDS crisis, and which became typical of identity politics of the time. All of these factors contributed to a retreat from painting as the dominant medium. Aesthetic criticism, the return of the language of beauty and painting itself fought against this. But the ascent of certain kinds of theory, notably feminism, multi-culturalism and postcolonialism, further fostered pluralism, eliminating the superiority of any one medium.

The discrete, studio-made object began to smack of nostalgia, if not outright archaism, within an emergent global exhibition culture; this was rapidly assimilated post-1989 and

encouraged by such factors as festivals and biennials spread across continents, the peripatetic lifestyle of artists and the rise of commissioned, site-based multimedia work. This shows no sign of abating despite evidence of climate change – in response to which Tate's directors, as an industry bellwether, declared a climate emergency in 2019 – and confession of complicity in waste caused by all this travel. Resources are expended in the construction and demolition of new walls, and through the air or heat needed to regulate pop-up, circus-like fair tents. Then there is the energy consumed by engineering to guard against the incursion of flood waters into cold-storage facilities, or to defend structures housing significant art collections from the threat of rapidly advancing wildfires.

In any case, travelling between locales became customary, giving rise to participatory, 'relational' art. Artists took advantage of the absence of conventional institutional frames to facilitate social interaction within the raw exhibition space – as exemplified in 'Untitled (Free)' (1992) by Rirkrit Tiravanija (b. 1961, Buenos Aires, Argentina) at 303 Gallery, New York, in which the artist cooked curry and shared it with those present in the gallery. The digital revolution (which also brought about an efflorescence of Internet art), together with the explosion of social media in the 2000s, allowed for access to events and installations happening elsewhere. It also precipitated a further, radical reconfiguration of the art world, predicated upon fluid distribution of images of art.

But the problem with the narrative behind departure from the art object is that it supposes the separation – even incompatibility – of the material and the conceptual. Conceptual artists believed it was the message that mattered, not the medium, as if thought could be immaterial. While the concept might be an idea or a method, either way, such art retains a formal dimension that is generally unacknowledged. In the 1970s, the common denominator among media was the supposition that conveying information was the sole or primary objective of representation. This has recently been revived through the model of the network: the idea that nothing exists in isolation, so a painting cannot ever be autonomous. Instead, it is one feature in a network of interrelated strands, none of which function independently of the larger web. This model puts a premium on communication while downplaying form, except insofar as it might expose the system's workings.

As will be maintained throughout, I regard material experimentation as inherently conceptual, meaning that painting, too, is capable of manifesting its own signs. This is to say it is capable of producing meaning from within, not as

merely 'process' but as embodied thinking. This position is held neither to reassert the pre-eminence of painting nor to avow its uniqueness, but to claim that painting has become more, rather than less, viable after conceptual art, as an option for giving idea form and hence for differentiating it from other possibilities. As American writer Glenn O'Brien humorously put it in conversation with Albert Oehlen and Christopher Wool: 'Why are all the conceptual artists painting now? Because it's a good idea.'

At issue, too, is terminology. I address individuals as 'artist' rather than 'painter', a decision based on the enormous transformations wrought by post-studio practice, among other factors. In short, the term 'artist' is generic while that

4 LEFT Francis Alÿs, *The Green Line*, Jerusalem, 2004. Still from video documentation of an action. In collaboration with Julien Devaux
5 OPPOSITE Sheila Hicks, Installation view of *Escalade Beyond Chromatic Lands*, Arsenale, 57th Venice Biennale, 2017

of 'painter' is specific, and the former is now customary in academic and critical milieus, as well as favoured by many choosing to work in paint who might also embrace other media, from performance to animation. Defying predetermined notions of painting, Francis Alÿs (b. 1959, Antwerp, Belgium) has in one project provocatively walked Jerusalem's 1948 partition lines, leaving a trail of green paint behind him, and in another collected hundreds of copies of a portrait of the Christian Saint Fabiola. Alÿs questions the identity of the 'painter' in his collaborations with Mexican sign painters (*rotulistas*) to enlarge or otherwise interpret his paintings. Also building on the definition of painting, Sheila Hicks (b. 1934, Hastings, NE) is best known for her sensual, vibrantly coloured fibre sculptures, which often hang from the wall, or, as in *Escalade Beyond Chromatic Lands* (2016–17), cascade forth from them. She has adamantly asserted that these works derive from the perspective not of weaving but of painting.

Moreover, the description 'artist' signals a capaciousness, within which painting becomes a choice. Many instances I cite are not paintings, since painting is made not in a vacuum but in response to an expanded field that includes both painting and other kinds of art (not to mention social, political and

other circumstances entirely outside of art and its media).
I do not therefore isolate painting from these other kinds
of art, which I include to make examples of painting more
meaningful. By 'painting' I mean to stipulate work that is done
with the materials, styles, conventions and histories of painting
as the principal point of reference. This might be seen in the
jewel-encrusted dreamscapes of Raqib Shaw (b. 1974, Calcutta,
India), in which the symbolism of the old masters is applied
with new resonance, or in the immense paintings of Kristaps
Ģelzis (b. 1962, Riga, Latvia), which play with the variables of
size and perception. Painting exists in a state of flux, connected
to but exceeding supporting traditions, whether or not the
final artwork consists of a rectangular piece of linen covered
in pigment, framed and hung.

As already implied, this is not to deny the medium, but,
paradoxically, to defend it as an expansive practice. I also mean
to resist modernist notions of medium specificity, whereby
painting was understood purely in terms of its material limits
(to be fair, even Clement Greenberg and Michael Fried, two

6 Kristaps Ģelzis, Installation view of *Artificial Peace*, Latvian Pavilion,
54th Venice Biennale, 2011

significant formalist critics known for their circumscribed view of the medium, were also aware of the potential for a broader definition). Similarly, I reject postmodernist ideas that deny medium specificity, in favour of a pragmatic approach in which a painting is tested or evaluated relative to the histories and traditions of the medium. This means that I do not rely on received definitions but recommend that each work solicits us to rethink the applicability and meaning of that definition. I thus focus more on method than on pictorial imagery, though forms do, of course, recur. And finally, I avoid clustering artists together on the basis of style, as objects that look alike might have nothing to do with one another, just as images that look different might be powerfully related. Eschewing classification, then, the following chapters are organized by ongoing investigations into, and conversations about, practice.

Chapter 1: Appropriation addresses the adaptation of images from a pre-existing source as the basis for a new work. This might be embodied through incorporation of source materials into the art itself, sometimes in an act of critique, as in the

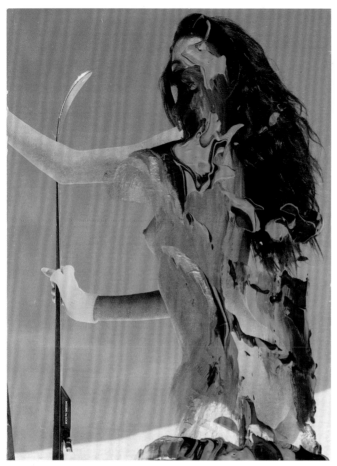

7 ABOVE Sofie Bird Møller, *Interferenz*, 2011
8 OPPOSITE Bénédicte Peyrat, *Dog*, 2007

7 work of Sofie Bird Møller (b. 1974, Copenhagen, Denmark), who muddies fashion advertisements and images from pornographic magazines with smears of paint in subversive acts of effacement. Though predating the digital revolution, appropriation has accelerated as a result of the Internet, with the act of borrowing often made into a subject, or treated as a curatorial act of selection, organization and framing. The impulse to discover and re-contextualize rather than to generate a picture reintroduces questions of intention. Why did they pick that? What did they do to it? To what end?

 This curiosity about motive also applies to works that are not recycled, and Chapter 2: Attitude asks how it might

be communicated through the physical stuff of painting. Can meaning be transmitted clearly from artist to painting to viewer? Does the handmade object, or the expressive stroke – once the material manifestation of authenticity and authorial presence – still impart depth? Or might contrivance of affect be a substitute for true interiority, and persona for person? Tactics of self-fashioning are conceived in relation to an art world that shares promotional strategies with the entertainment industry, using these to frame the artist and their work. Positioning in the market matters a great deal. Artists' oppositional stances might also be entrepreneurial, including the co-opting of 'bad painting'. This term can refer to the outmoded or what lies outside the norms of acceptable taste, as in *Dog* (2007), offered by Bénédicte Peyrat (b. 1967, Paris, France), its paw raised, beseeching, against a sketchy sky.

Also important here is the appropriation of historical painting techniques and practices for diverging purposes: to extend a tradition, comment on it, introduce it to a global

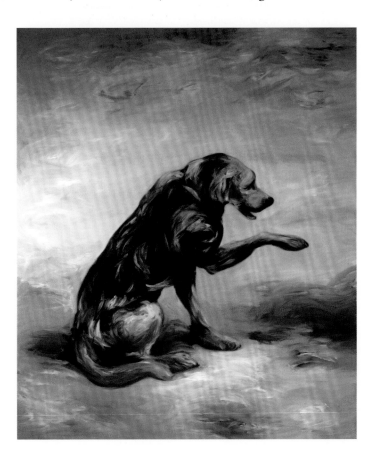

9 LEFT Adam de Boer,
*Narsisis Mantrijeron
no. 1*, 2017
10 OPPOSITE Jumaldi Alfi,
*Een Prachtig Landscape #4
(Postcard from My
Past)*, 2005

market, and so on. As these works get shown all over the world,
it becomes harder to fathom the local scenes from which they
arise, and how such scenes inflect works that might share
common aspects despite other incommensurable differences.
The complexity of cultural hybridity was eloquently exhibited
at the World Trade Centre, Jakarta, in 2018, in a pairing of
Adam de Boer (b. 1984, Riverside, CA) and Jumaldi Alfi (b. 1973,
Lintau, West Sumatra, Indonesia), a founding member of the
Jendela Art Group. The American artist's work, dealing with

9
10

his Dutch-Indonesian cultural legacy through Indonesian craft practices (leather carving, batik and tile) and colonial motifs, was juxtaposed with the Indonesian artist's engagement with aspects of Western painting, notably landscapes depicting mountains or coconut palms (subjects rejected by nationalist artists for their Dutch colonial roots).

Moving more explicitly to matters of procedure, Chapter 3: Production and Distribution focuses on how artists make paintings in studios and on screens, and then negotiate complex mechanisms of distribution: that is, how paintings travel (in galleries and fairs, across continents and the Internet), with or without their makers. Chatchai Puipia (b. 1964, Mahasarakarm, Thailand) draws attention to these lives of images across time and place, as exemplified in an updating of Vincent van Gogh's painting of a vase of sunflowers: in Puipia's version, the flowers have blackened and died.

11

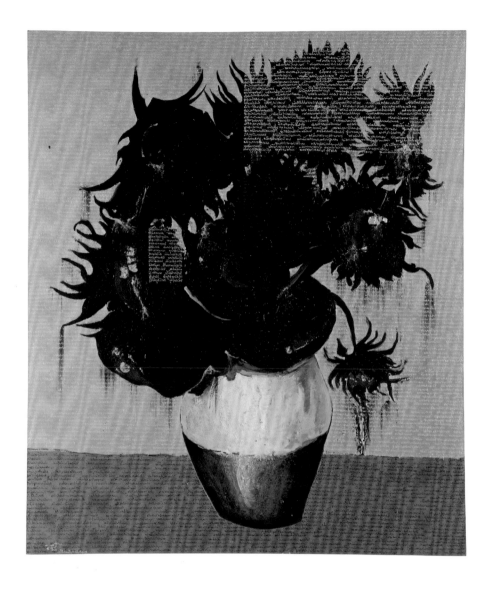

11 ABOVE Chatchai Puipia, *Vase with twelve sunflowers 120 years after Van Gogh*, 2009
12 OPPOSITE Lynette Yiadom-Boakye, *A Whistle in a Wish*, 2018

Many paintings are painted – at least in part – by someone other than the named author, sometimes far away. This is to say, contemporary painting now recalls, to a surprising degree, the workshop tradition of apprentices and skilled assistants; it also inhabits the industrial space of divided labour so common to conceptual art, as well as to the commercial design studio or architectural firm. By the 1960s, sculpture had achieved separation of concept and realization (when fabrication was contracted out, due to material factors or scale), but painting remained far removed from these changes. This is no longer the case. Nevertheless, many artists still assert the specificity of their own hand, and also their individual capacity for

imagining. See, for example, Lynette Yiadom-Boakye (b. 1977, London, UK), whose personal interpretation is key as she conjures fictional black women and men in thin, washy veils, which blur even though they are right there, materialized on a surface as if from an unreachable dream.

Chapter 4: The Body pushes back at notions that critiques of the body and experience cannot occur in painting. The body has remained central to painting in many genres, including portraiture and history painting. The chapter also considers

how the body is also, if differently, registered in non-objective works through vigorous paint handling that visibly records the physical movement necessary for its achievement. The subject of the body is, in many ways, the subject of agency, as seen in the work of Michaël Borremans (b. 1963, Geraardsbergen, Belgium). In his enigmatic scenes, bodies – often occluded or turned away, and maybe lifeless – are subjected to external and seemingly malevolent systems, through which they retain little sovereignty.

Figurative work has importantly engaged issues of privilege, asking who has had access to representation (and self-determination), and who still does not. Many artists redress exclusion of subjects from preceding art on account of gender, sex or race. In one such example, Drea Cofield

13 OPPOSITE Michaël Borremans, *Six Crosses*, 2006
14 ABOVE Drea Cofield, *Double Spank*, 2018

14

(b. 1986, Orange, CT) provides a platform for the non-binary body in her paintings of colourful nudes in a rainbow of hues. Many are gender-ambiguous, like in *Brimming* (2018), which shows the figure's breasts and penis hanging down from the bent-over body, a head with long tresses of hair peering out from under itself. In *Double Spank* (2018), a fluorescent pink body and a brown body are entwined, heads buried, and buttocks marked by matching tattoo-like handprints; the arms of each figure are yellow, as if producing a third entity out of the two.

Chapter 5: Beyond Painting investigates how the body is commonly introduced as a complement to a painting from outside its frame. This may happen in abstraction that registers the passage of the body that made the lingering marks, or quite differently, painting may be treated as a tool for social engagement. It also functions in performance or as the

hypothetical or actual backdrop for an event, as in the work
of Lucy McKenzie (b. 1977, Glasgow, UK), whose 'Slender Means'
installation might be taken to consist of architectural sketches,
theatre scenery or independent paintings. Artists negotiate
questions not only of what a painting is, but also temporal ones,
such as when a painting becomes a prop. This example alone
suggests the 'beyond' of the title, but the chapter also studies
instances in which paintings exist in exceptional presentational
formats. Karen Kilimnik (b. 1955, Philadelphia, PA), for example,
constructs multi-part installations in which painting serves
as one focal element in mise-en-scènes. These might consist
of fog machines, period furniture and chandeliers, or turf,
boxwood hedges and a functioning fountain: lush, immersive
fantasies that serve as environmental extensions of her
diminutive canvases.

If the discussion of appropriation begins with an analysis
of art about art, Chapter 6: About Painting loops back to this
legacy by way of paintings about painting. One such example
can be seen in work by Florian Meisenberg (b. 1980, Berlin,
Germany), who frames the picture plane with curtains in
a play on bygone expectations of illusionism. The chapter
examines not just artists who bend painting to look at itself,
but also those who foreground the institution as the frame
for their intervention: its physical architecture, but also its
power to make meaning of what it authorizes for display. This
is true of Patrick Lundberg (b. 1984, Stockholm, Sweden), who
exaggerates the vastness of the walls on which he appends
modest acrylic paintings on shoelaces (p. 6). Critique of the
institution is expanded further by some artists, who protest its
policies and political entanglements. And still others identify
painting as an institution in its own right, the better to expose
its internal logic and the claims for its sanctity. In this vein,
Analia Saban (b. 1980, Buenos Aires, Argentina) engages in
a study of substance, often acting on painting physically:
unravelling painted canvases or shrink-wrapping paintings
to distort the paint underneath.

Some work turned to the analytic deconstruction of
painting's materials and procedures so utterly that abstraction
again came to seem solipsistic. It was charged as lacking
content apart from a narrative of how it was made. This
produced a powerful backlash against abstraction – but this

15 OPPOSITE ABOVE Lucy McKenzie, Installation view of 'Slender Means',
Galerie Daniel Buchholz, Cologne, 2010
16 OPPOSITE BELOW Karen Kilimnik, Installation view of *Fountain of Youth*
(*Cleanliness is Next to Godliness*), Brant Foundation, Connecticut, 2012

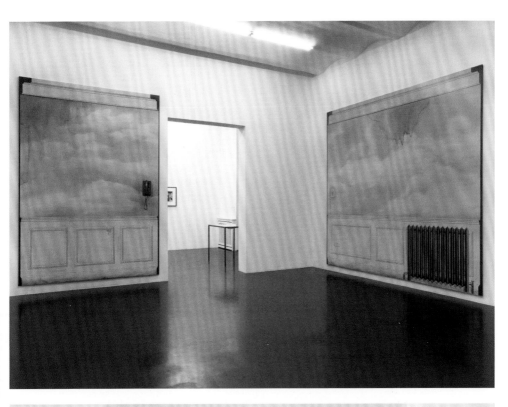

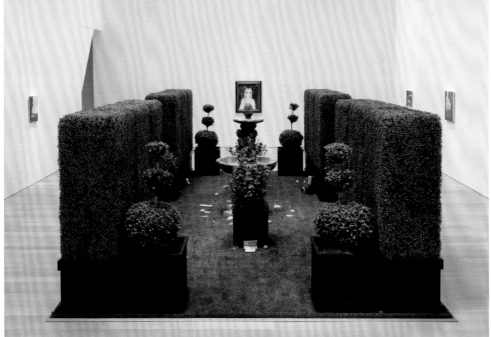

17 LEFT Florian Meisenberg, from the series *Continental Breakfast, Overmorrow at Noon*, 2011
18 BELOW Analia Saban, *Claim (From Chair)*, 2013
19 OPPOSITE Ana Teresa Fernández, *Borrando la Frontera* (Erasing the Border), 2011

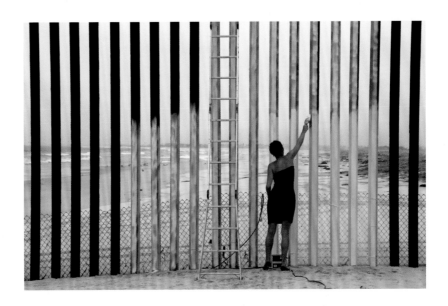

time, interestingly, it did not bring all of painting along with it. Figurative work running counter to this strain came to the fore instead, intersecting with issues of identity politics and social justice. Chapter 7: Living Painting, and so the book, concludes with painting holding a space for active engagement with current issues. In one such project, Ana Teresa Fernández (b. 1980, Tampico, Mexico) first made *Borrando la Frontera* (Erasing the Border) in 2011, when she and volunteers took a stretch of the wall dividing the United States (San Diego) and Mexico (Tijuana) and painted it the colour of the sky so that it would look as if it had disappeared. She has since painted other sections in Mexicali, Nogales, Agua Prieta and Ciudad Juárez, imagining a continuous landmass without borders.

19

Real as these chapter divisions are, they are artificial barriers that apportion material in ways that might imply a fixity that they should not. The rubrics are there for clarity, as provisional containers of arguments and ideas, giving thematic shape without reverting to older taxonomic divisions of genre, such as landscape or the nude (although these do pop up as artists engage with them afresh). Most artists included in one chapter fit just as readily into others, particularly given their range of work, which in many cases cannot be accommodated in this volume. All are involved in appropriation in one way or another. I cannot imagine that any artist does not think about how their paintings are made and how they will find an audience, in real life or online, or does not contemplate the nature of painting,

even if – or especially when – moving beyond its traditional
parameters. The frequency with which such inquiries
become part of the work's subject relates to my claim that the
conceptual overlaps with the material: beyond painting and
about painting are two sides of the same coin. 'Bad painting'
means many things, and countless artists ride the line between
abstraction and figuration, though this also implies a pedantic
distinction, a binary that I do not uphold. I have, however,
attempted to keep related artists together where feasible.

Attention is inevitably uneven in what aims to be a wide-
ranging survey. My blind spots and biases as a critic, long-based
in New York and now living in Los Angeles for almost a decade,
will doubtless be evident to those whose primary art world is
a different city or country; that said, this is not a disclaimer
and I make no disingenuous apologies for partisanship. The
artists included here are singular, though they are also, taken
together, generally representative of the work comprising
the art world in the specified period, and as such give a
sense of what one would have seen exhibited in independent
and commercial spaces in such art centres as New York and
Los Angeles, London, Berlin and Hong Kong. Precisely because
of their wide applicability, these chapters offer ways to restart
debates around painting that may avoid the impasses of the
1980s, and that, if successful, will help to make sense of – even
provide a language for – discussion of artists and paintings not
covered in these pages.

Just as globalization is wildly asymmetrical, so is painting, as
revealed by Konstantin Bessmertny (b. 1964, Blagoveshchensk,
USSR) in his images of cultural clashes (in one such example
from 2011, *E. meets W.*, he shows samurai entering a Danish
home). My best efforts at international 'coverage' are certainly
not comprehensive, nor would I pretend or want them to be.
Some precedents or discourses are more 'live' in some regions,
cities or art schools than others, and some traditions ('native'
or otherwise) resonate where others do not, despite fantasies
of a wholly integrated, accessible and representative art world.

What I do wish to make intelligible are the connective
threads, between the works themselves, but also between the
cultures in which they exist and the mechanisms that enable
their passage among them. This means I attend to paintings
and their surroundings, be they physical (the walls on which
they hang), institutional (the ways that they are seen, whether
in a museum or gallery, on a screen, in the palm of a hand or in
a press release) or discursive (the aesthetic, social and political
conventions to which they belong and respond). These priorities
are manifested in the choice of images, which comprise single

20 Konstantin Bessmertny, *E. meets W. Lost in Translation*, 2011

paintings and installation shots alike. These artworks are not intended to serve as illustrations of my theses, but as motors to generate them.

This introduction sketches some parameters of the medium 'painting' and its place. Let me finally return to the other word of the title, the emphatic, if elusive, 'contemporary'. As asserted at the outset, the titular 'contemporary' designates the time period considered here, which is, roughly, painting since the turn of the millennium. There are other moments this text might have taken as its starting point, such as 1989, with its political upheavals that reshaped the balances of power internationally, or 2008, with the collapse of the world's financial markets showing the neoliberal order to be a small, connected sphere after all. Following the latter, many awaited a corrective accounting for the bloated and overly permissive

21 Gabriel Orozco, *Stream in the Grid*, 2011

art-world system that fed off the preceding flush years. As it happened, business continued apace, and there was an odd time lag before the effects of a new arrangement were slowly and partially born, as art spaces began to close, funding diminish and sales slacken; then, phoenix-like, others arose even more powerfully in their place, thanks in part to online viewing and selling of art.

The turn of the century is fundamentally arbitrary, though it does mark the beginning of a truly global art world; it also allows for the discussion of two decades across which shifts can be charted. The chapters are not exactly chronological, though they do express a successive (if overlapping) set of

conditions that underpinned work and interests that motivated it. Some trends came and went. Some realities have proven more durable. As acknowledged by Gabriel Orozco (b. 1962, Veracruz, Mexico) in his 2011 monument to the events of September 11, 2001, *Stream in the Grid*, we still live in their aftermath. All work is anticipated by what has come before, in life and in other art, and as such, discussion of each painting could feasibly take us back decades, if not appreciably further. While these instances are alluded to where practical, and certainly matter a great deal, the point of this book is to make sense of the just-past and the enduring. It attempts a response, *in medias res*, to the recursive and generative contemporaneity of painting.

It also appreciates the temporality of writing, with the example of *Boomerang*, a 1974 work by Richard Serra (b. 1938, San Francisco, CA) and Nancy Holt (1938–2014), firmly in mind. This is a video in which Holt's speech is interrupted by her words played back to her with a delay through a headset: the now slipping into the past at the moment of its articulation. For Holt, this audible repetition triggered recognition, a mode of self-analysis. This precedent helps me to think about how to grasp the contemporary, in that it not only admits the present as fugitive, crossing into history just as it comes into being, but also begs for a reflexivity about this process, which hopefully marks these pages.

Chapter 1
Appropriation

References to works past are widespread in the history of art. Artists will often consciously evoke major precedents, and indeed, this is even how painters traditionally learned their craft: by copying or emulating the exemplars of masters, and reinterpreting specific features or motifs. Referencing prior works continued in the 20th century, but in addition to this, artists began to use similar techniques to turn art against itself in an act of self-conscious borrowing called appropriation. This involves an artist using a pre-existing item – most commonly, a found object, commercial image or someone else's art – to make something new. The strategy consolidated into what came to be known as 'appropriation art' in America in the late 1970s. To date, it remains an influential critical method that intentionally challenges received ideas of authorship and originality. This is especially so as the act of appropriation alters the meaning of the sourced material and exposes the relation of contemporary practice to painting as a historically esteemed art form.

Appropriation in the contemporary period relates to conditions outside art as much as to genealogies within it, and in these, transformations in technology and media are key. Highlighting technological developments in a pointed engagement with obsolete equipment, Cory Arcangel (b. 1978, Buffalo, NY) hacks video games to serve new aesthetic possibilities. In *Super Mario Clouds* (2002), Arcangel modified a 1985 Nintendo Entertainment System (NES) video-game cartridge to erase everything but the clouds, leaving behind a depopulated and strangely sublime blue-skied landscape of pixels. Appropriation might involve a translation in kind, as in Arcangel's game modifications, or, say, from a photograph to a photograph; alternatively, it could involve a conversion from one medium

22

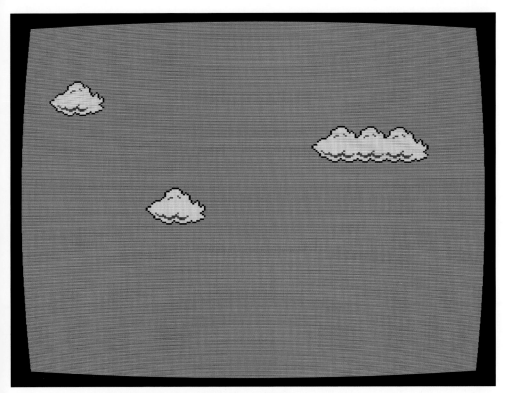

22 Cory Arcangel, *Super Mario Clouds*, 2002

into another, like a painting into a photograph, as in the work of Vik Muniz (b. 1961, São Paulo, Brazil). Muniz remakes famous paintings out of miscellaneous materials such as diamonds, dust and junk, before photographing them: he fashioned Leonardo da Vinci's *Mona Lisa* (*c.* 1503–6) in peanut butter and jelly, and Vincent van Gogh's *Wheat Field with Cypresses* (1889) with scraps torn from the pages of glossy magazines and books, transporting and transforming images between media.

23

In the act of appropriation, material is passed through various interpretive constructions, showing that meaning may be determined by context as much as content. This can be seen in the work of Miguel Calderón (b. 1971, Mexico City, Mexico): beginning with content screened on Mexican tabloid television, he staged events and photographed them, before employing a local horse-portrait painter to depict them. These artisan-produced paintings wound up as part of the set design in Wes Anderson's film *The Royal Tenenbaums* (2001), completing a circuit that returned them, reconfigured, to moving images.

Interpretations of meaning would naturally differ between viewers who first encountered the original content when it was initially screened on television, prior to its subsequent stages of transformation, and those who came across that content by watching Anderson's film.

To give a very different example of the movement of material through multiple frameworks, fashion designers threeASFOUR's Fall 2019 runway show involved a re-engagement with patterns from their debut collection twenty years earlier, together with fabric sourced from rejected paintings by artist Stanley Casselman (b. 1963, Phoenix, AZ). These geometric abstractions consist of expertly blurred colours pulled across vast canvases with squeegees; they were first made as deliberate knockoffs of paintings by Gerhard Richter (b. 1932, Dresden, Germany). Casselman's project began in 2012 at the prompting of art critic Jerry Saltz, who ran a Facebook contest asking

23 BELOW Vik Muniz, *Wheat Field with Cypresses, after Van Gogh (Pictures of Magazines 2)*, 2011
24 OPPOSITE threeASFOUR featuring Stanley Casselman, runway show during New York Fashion Week, February 2019

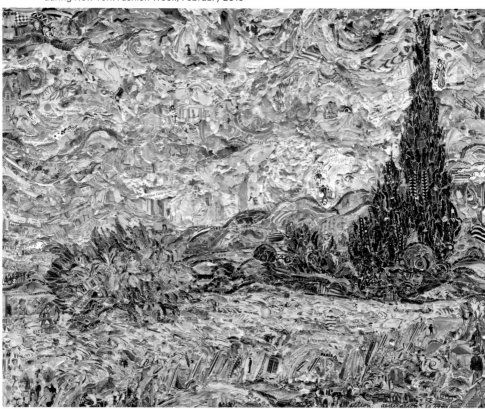

for the perfect fake for $155 plus the cost of materials. Later that year, Saltz opined in *New York Magazine* that professional forgers would not work for such a trivial fee, deadpanning that:

in the art world, noncriminal fakes aren't news. We don't even call them "fakes." We prefer the term "appropriation," whereby a new artwork incorporates or reproduces another. Copyists lie on a continuum: At one end, you have extremely original artists (Richard Prince, Elaine Sturtevant) who use the old to make something new. [Sturtevant learned the techniques involved in remaking other artists' paintings, sculptures and films from scratch.] *At the other, you have people deceiving buyers. In between, you have artists who merely make covers, trying to get attention...*

How, then, do new artworks emerge? Through what means, and to what ends? These key questions serve as the basis for considering the artists presented in the chapter to come.

Beyond Pictures: A Recent History of Appropriation

As appropriation developed in the United States in the late 1970s, it directly challenged safeguards against copyright infringement in American law. The nature of appropriation involved opposition to private property, which was, more broadly, a critique of the prevailing economic order and the social order, including the patriarchy. For many artists at the time, buoyed by student protests, civil rights and feminism, the canon of major works by Western male artists was to be challenged rather than extended. These artists took issue with the inequities of gender, sex and race underlying art production, exhibition and collection – and appropriation aimed to expose this power imbalance. The goal was to dismantle the institutionalized system of values that supported the identification of masterpieces and perpetuated media stereotypes.

At the same time, a dominant force in painting was neo-expressionism, as discussed on p. 9. These intensely emotive, maximalist works were often infused – in form and content – with a masculine and at times misogynistic energy. This was at odds with the increasingly socially conscious views of many artists, and neo-expressionism – as propounded by David Salle (b. 1952, Norman, OK) and Georg Baselitz (b. 1938, Kamenz, Germany) – was indicted by its opponents for celebrating sexist clichés and worse. (As late as 2013, Baselitz held forth in an interview for *Spiegel Online*: 'Women don't paint very well. It's a fact.')

Some artists indulged in large-scale panels given over to adolescent fantasies of naked women cavorting and permitting unimpeded visual access. Others perfected renditions of old myths to link their production to a venerable past, the inheritance of which they claimed. Julian Schnabel (b. 1951, New York, NY), for one, festooned the canvas with broken crockery to achieve the appearance of spontaneity and to signify emotional catharsis. In this way he takes on the handmade, invoking women's domestic labour and craft, but paradoxically reserving it for male use. Such work sold – often for great sums – and in so doing it raised these artists to the status of celebrities (a cult of personality that had its casualties, as with the tragic death of Jean-Michel Basquiat). For other artists and critics, these market conditions represented the dispiriting interchangeability of painting and commodity.

This apparent contamination of the canvas meant that during the 1980s more appropriation occurred in other media: most notably photography, as in the projects of the American artists Sherrie Levine (b. 1947, Hazleton, PA) and Richard Prince

(b. 1949, Panama Canal Zone, US). Both Levine and Prince re-photographed images taken by others and presented the 'new' images as their own. Levine, appropriating the work of men, famously reproduced bookplates of Walker Evans's government-sponsored Farm Security Administration images of Depression-era tenant workers and their dwellings. In a 1981 press release accompanying their first showing, she wrote:

I am interested in issues of identity and property—i.e. What is the same? What do we own? I suspect auratic notions about art: "authenticity," "the genius," "the masterpiece," "the hand." When every image is leased and mortgaged, a photograph of a photograph is no more remarkable than a photograph of a nude.

For his part, Prince captured Marlboro cigarette advertisements of American cowboys, stripping them of brand logos and copy. This movement has been dubbed the Pictures Generation after a small but hugely influential 1977 show in New York curated by Douglas Crimp, simply titled 'Pictures'. Prince and Levine were exhibited alongside other artists including Jack Goldstein and Robert Longo. Many Pictures Generation artworks made their sources clear, for the point was to dismantle and recontextualize the 'original' material, not to create an image from scratch. Although these artists aimed to release the hold of consumer culture on the collective imagination, their attacks could be misunderstood as repeating the problems inherent in the material they were critiquing. In distinction from collage, which makes visually evident that material has been brought together from multiple sources, a re-photographed photograph looks just the same. How could one tell the difference between the 'original' and the 'copy'? And how could one assess intent when images were unmoored and perpetually on the move (a phenomenon that would later be facilitated by the Internet)?

The ahistorical mining of readymade imagery became so widespread that in 1982, American cultural theorist Fredric Jameson identified 'pastiche' as a central theme of postmodernism in 'Postmodernism and Consumer Society', a talk at the Whitney Museum of American Art, New York. He defined the term as the disorganized and non-hierarchical circulation of quotations without regard to their initial presentation and meaning. Nevertheless, appropriation signified criticality, irrespective of what it actually depicted or to whom it was directed. It also asserted the activity of aesthetic transfer as meaningful in and of itself.

In the present day, however, this definition of appropriation is no longer adequate (Jerry Saltz's cheeky lambast against

25 Kelley Walker, *Black Star Press (rotated 90 degrees)*, 2006

noncriminal fakes and mere covers gives one voice to this position). To be sure, any belief that the act of appropriation as such would trump the meaning of its content has long since passed. In retrospect, this assumption of revolutionary politics on the part of the artist sometimes served as an excuse – even an alibi – for problematic subject matter and gross instances of cultural appropriation, a form of privileged authorship that opportunistically adopts aspects of minority cultures to maintain one's own power.

Take Kelley Walker (b. 1969, Columbus, GA). Beginning in the early 2000s, he made works dealing with the relation of an artwork to its mediation: the way in which the idea is presented, but also how the idea is always already framed prior to that point, acknowledging and addressing the networks through which it travels before an artwork ever gets made. His *Disaster* series (2002) references Andy Warhol's early 1960s series *Death and Disaster*, rife with imagery of car crashes and electric chairs, and exists on CDs inserted into computers and as digital images running through electric currents or retrieved from storage clouds. Walker selects images of the titular disasters as his source material – grim shots of passenger-airline crashes

and earthquake debris – and solicits participation from the viewer by offering modifiable high-resolution image files to be manipulated, reproduced and disseminated by the user, in what becomes a succession of palettes and styles. While none of the customizations diminish the inherent horror of the images, the ethics of the series were long overlooked. Instead, discussion lingered on Walker's process, a focus that his work encouraged: in another piece, he made a large, freestanding sculptural relief of the universal recycling logo, an emblem of his own structure of reprocessing.

It was not until 2016, when paintings made a decade earlier were shown at the Contemporary Art Museum, Saint Louis, Missouri, that Walker became the target of rebuke. The show opened almost exactly two years after the police shooting of unarmed teenager Michael Brown in nearby Ferguson: an event that spurred demonstrations and catalyzed the Black Lives Matter movement in the United States. (This movement seeks to dismantle institutionalized racism and violence against black people; it was established in 2013 after the acquittal of George Zimmerman for the fatal shooting of African American teen Trayvon Martin.)

Walker's retrospective featured a giant poster-like image of the singer Kelis smeared with whitening toothpaste, and sensationalizing paintings of African American teenager Walter Gadsden being attacked by a police dog. The latter paintings appropriated Bill Hudson's photograph of the civil-rights protests in Birmingham, Alabama, in the spring of 1963. Walker's versions were inspired by Warhol's equivocating paintings of police-dog attacks at Birmingham, which were in turn appropriated from photographs by a different photographer, Charles Moore. Walker additionally layered pools of white, light and dark chocolate over the gruesome and dehumanizing scene. The exhibition was boycotted; the works in question had come to be recognized as a vulgar instance of a white man co-opting the suffering of others for the purpose of exhibition and sale.

Moreover, despite the outsize significance of the practice and theory that grew around the group of artists working out of New York, the politics of appropriation in the 1980s that were sketched on pp. 36–37 do not, of course, apply to many other parts of the world. The same caveat of geographically specific implications goes for the laws of copyright: for a show at Warsaw's Center for Contemporary Art in 2006, Paulina Olowska (b. 1976, Gdansk, Poland) screened *The Neverending Story* (1984) continuously, twenty-four hours a day, for free. This was permissible under Polish law and so was not subject to copyright violation, but it would not have been possible elsewhere. Therefore, while appropriation does continue apace in the American scene, it can also be used as a starting point from which to consider more global histories of art.

International appropriation is epitomized in the work of Wang Guangyi (b. 1957, Harbin, China). He scorns communism and consumerism by reworking icons of the Cultural Revolution in the guise of American pop art. This is the default reference for Wang and many other artists, despite the chronological precedence of pop-art movements in other countries, such as the Independent Group in Britain, or the Nouveaux Réalistes in France. This says much about the hegemony of American art in the post-World War II period.

Wang's *Great Criticism* series responds directly to the influx of Western luxury goods into China in the 1990s, and the advertising campaigns that accompanied this. He places the triumvirate of idealized revolutionary types – soldiers, peasants and workers – in the frame with products from iconic foodstuffs (Coca-Cola, M&Ms) or rarefied brands (Porsche, Chanel). This imagery is often set against saturated backgrounds the colour of Mao's *Quotations from*

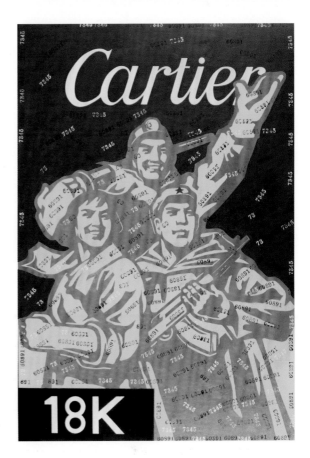

26 Wang Guangyi, *Great Criticism – Cartier*, 2002

Chairman Mao Tse-tung (1964), commonly known in the West as the 'Little Red Book'. In *Great Criticism – Cartier* (2002) Wang gold-plates the figures and, in so doing, shows the imagistic regimes of Chinese propaganda and Western-style capitalism to be compatible, almost indistinguishable, despite their antagonism.

The use of appropriation to draw attention to ideological hypocrisies is a tactic engaged by artists around the world. From 1988 to 1992, José Toirac (b. 1966, Guantánamo, Cuba) was a member of Grupo ABTV, a radical artistic collaboration with Tanya Angulo, Juan Pablo Ballester and Ileana Villazón. His more recent productions include mixed-media work relating to Walker Evans's photographs of poverty-stricken Havana in 1933, a video based on a speech Fidel Castro delivered in 2003, and a series of appropriated photographs of Cuban history over which he stamped logos of Western brands. In

the latter, the Apple logo floats above Che Guevara in Alberto Díaz Gutiérrez's classic shot of the revolutionary, in mockery of the company's endorsement of thinking differently, while the emblem of Yves Saint Laurent's Opium perfume warps a press image of Pope John Paul II shaking hands with Castro, none too subtly conjuring Karl Marx's dictum that 'religion is the opiate of the people'. Toirac collaborated with critic and curator Meira Marrero (b. 1969, Havana, Cuba) – the two have worked together since 1994 – to create a series of portraits of Cuban leaders that was censored for its political implications when scheduled to debut at the National Museum of Fine Arts in Havana in 2007. The series, *1869–2006* (2006), presents a pantheon of men who have held the office of governor or president of Cuba since the time of the first insurgency against the Spanish, chronologically arranged up to the present; the country's uncertain fate is signalled by a lone nail awaiting the next image.

Indeed, appropriation has become ubiquitous across the globe for reasons besides 'Pictures', not least of which is the spread of the Internet. Those with access to this technology are afforded near-instantaneous access to information of all kinds: pictures, clips or other materials from almost every conceivable time and place. Alexander Vinogradov (b. 1963, Moscow, USSR) and Vladimir Dubossarsky (b. 1964, Moscow, USSR) have explored our relation to unbounded media in the composite work *Total Painting* (2001), a madcap conjunction of subjects drawn from socialist realism and consumer culture. In 2003, they installed thirty-eight panels of *Total Painting* at Deitch Projects, New York, under the title *Our Best World*. The panels formed a single 'endless painting' that wrapped

27

28

27 BELOW José Toirac and Meira Marrero, *1869–2006*, 2006
28 OPPOSITE TOP Alexander Vinogradov and Vladimir Dubossarsky, Installation view of *Our Best World*, Deitch Projects, New York, 2003
29a–d OPPOSITE BELOW Christian Marclay, Stills from *The Clock*, 2010

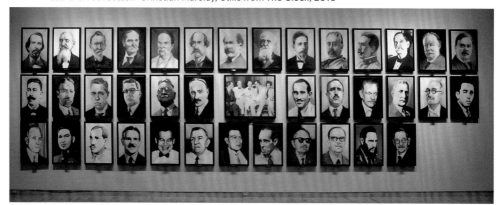

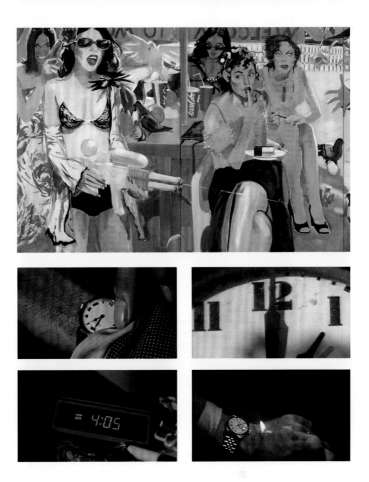

around the gallery in its entirety, creating a dizzying total
immersion. A comparably absorptive effect is achieved in
The Clock (2010) by Christian Marclay (b. 1955, San Rafael, CA),
a twenty-four-hour-long video composed of Hollywood film and
television fragments, with timepieces visible in each frame that
mark the actual passage of time, shot by shot. It is predicated
upon an inexhaustible archive of found, endlessly plastic
sources that can be reassembled according to one's individual
needs and preferences.

 In this world so saturated by the Internet, it is not just
a resource but also a culture. With unabashed fixation on
the latter, Sam McKinniss (b. 1985, Northfield, MN) conjures
high-keyed, melodramatically glamorous renditions of screen
grabs of Princess Leia, Whitney Houston, Madonna and other
icons of secular worship. In the course, he muses on the way

29a–d

30

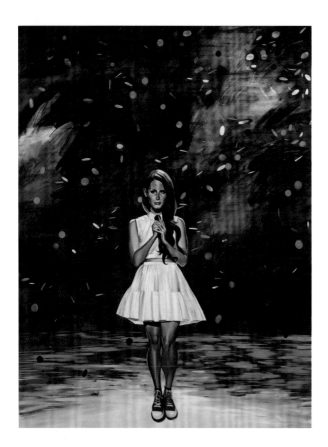

our consumption of celebrity culture has migrated from print tabloids to online outlets. His paintings feature quasi-cinematic stories, cast with characters resulting from a Google search. In exhibitions, McKinniss clusters these vaporous captures amidst paintings of art-historical emblems of transience, such as his imitations of Henri Fantin-Latour's lush dahlias and fairy roses, as well as cute animals, imagery native to the Internet culture that is, beneath all these pictures, his great subject.

Even with this prevalent Internet culture, the history of art remains the primary point of reference for some artists, whether through first-hand observation of artworks or their mediation through photography, books and online resources. Tomoo Gokita (b. 1969, Tokyo, Japan) creates surrealistic portraits of archetypes from art history, such as the Madonna and child, as well as geishas and Hollywood ingénues, all recounted in a gradient from black to white. A comparable absorption of art-historical references can be seen in the work

31

30 OPPOSITE Sam McKinniss, *American Idol (Lana)*, 2018
31 TOP Tomoo Gokita, *Mother and Child*, 2013
32 ABOVE Makiko Kudo, *Missing*, 2010

Appropriation

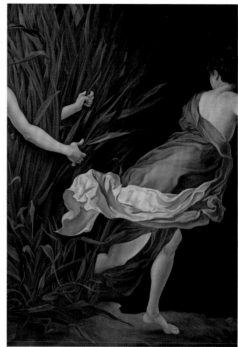

33 Jesse Mockrin, *Syrinx*, 2018

of Makiko Kudo (b. 1978, Aomori, Japan). She shows young girls amid traditional Japanese imagery of plant and animal life, in dreamlike springtime scenes that closely recall the lushly dappled impressionist landscapes of Claude Monet and the hyper-pigmented, sinewy fauvism of Henri Matisse, among others, thoughtfully jammed together in novel hybrids.

Jesse Mockrin (b. 1981, Silver Spring, MD) paints sumptuous worlds in twilight, spotlighting bits of anatomy for intensity and near-theatrical emphasis. She appropriates Rococo paeans to love and longing: delicate bent fingers or arms extending to another figure, in the frame or pointing elsewhere. Mockrin's sampling of compositions by Jean-Honoré Fragonard, as well as Peter Paul Rubens and Hans Baldung Grien, preserves the cropped details of cited artworks as fragments. These can be recombined into androgynous subjects, complicating the meaning of these ritualized gestures. Her *Syrinx* (2018), composed using elements of Rubens and Noël-Nicholas Coypel, is an allegory of artistic creation based on a Greek myth. The namesake wood nymph had to flee from the unwelcome desire of Pan, an Arcadian deity of fertility and carnal desire. In the

course of avoiding rape, she metamorphosed into river reeds, which Pan – in an act of sublimation born of his unfulfilled passion – turned into a musical instrument.

Mythical characters like these course through the history of art, and for Tammy Nguyen (b. 1984, San Francisco, CA), their reimaging becomes an implement of confrontation. In *Đức Mẹ Chuối* (Holy Mother of Bananas) (2018), she offers a conspicuously yellow Venus, the goddess of love and beauty, turned Cyclops from a primordial race. The work constitutes a riposte to a tradition deeply threatened by non-white models. (Witness the continued disbelief in response to the evidence that Classical statuary was not, in the days of antiquity, the bleached marble that became a centuries-long ideal. In fact, it was covered in richly painted and deeply pigmented skin tones, representing the range of ethnicities across the vast Greek and Roman empires.) In this near life-size painting, Nguyen reconfigures the central figure in Sandro Botticelli's *Birth of Venus* (c. 1485). Swirling hair and iconic pose remain, yet the seashell is now

34 Tammy Nguyen, *Đức Mẹ Chuối* (Holy Mother of Bananas), 2018

34

a bed of fanning bananas, and the figure's crotch – modestly covered by Botticelli – becomes a fertile patch from which sprouts a thick purple stem, budding into a flower.

This is one of many ways in which mediation can re-value source images, be they paintings, photographs or otherwise. The same wealth of possibilities applies to documents and historical artefacts, which assume a different tangibility in a world oversaturated with virtual imagery. William Daniels (b. 1976, Brighton, UK) and Caragh Thuring (b. 1972, Brussels, Belgium) have both turned to earlier moments in a rampant conversion of cultural relics, making claims for their mutability. Daniels reconstructs well-known paintings as maquettes composed of scavenged quotidian stuff, which he then puts to use as models for his own painted works. This is well demonstrated in *The Shipwreck* (2005), after Romantic painter J. M. W. Turner's 1805 painting of the same name. Subdued in tone and flattened into cardboard planes, Daniels's works recall the faceting of cubism as much as their source imagery. Thuring's five paintings on unprimed linen,

35 BELOW William Daniels, *The Shipwreck*, 2005
36 OPPOSITE Caragh Thuring, *4*, 2009

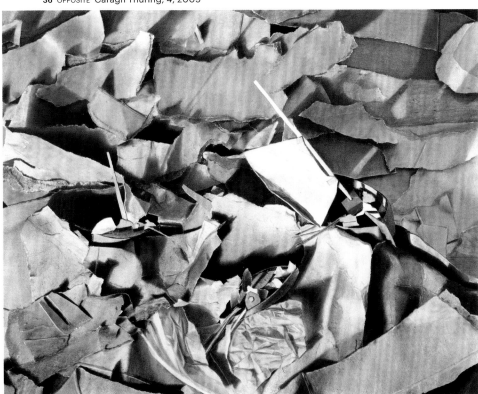

36 *1, 2, 3a, 3b, 4* (all 2009), flirt with legibility as pastoral scenes.
On account of their blank spaces – passages that are left empty
in one painting of the series but not in another – it is only
in aggregate, like images brought together through a search
engine, that the images resolve into a whole referencing their
source: Edouard Manet's *Déjeuner sur l'herbe* (1863), which is
based on Marcantonio Raimondi's engraving *The Judgment of
Paris* (*c.* 1515), which was made after a drawing by Raphael.
The cycle of appropriation goes on and on.

Choice in and as Subject Matter

Chapter 2 addresses the issue of intention and how it is
signalled within the artwork. When it comes to appropriation,
artists' decisions in terms of source material are consequential
(as the Kelley Walker case on p. 38 grants in the extreme).
For Wilhelm Sasnal (b. 1972, Tarnów, Poland), who for a time
worked in advertising in Kraków, subject matter is momentous
and often political. Alongside mass-media imagery relating to
the history of post-Communist life in his birth region, as well
as snapshots of friends and family, he uses cartoons from Art
Spiegelman's iconic comic strip about the Holocaust, *Maus*
(1991) – in which Jews are depicted as mice, the German Nazis
as cats and the Poles as pigs – to reflect on Poland's role in

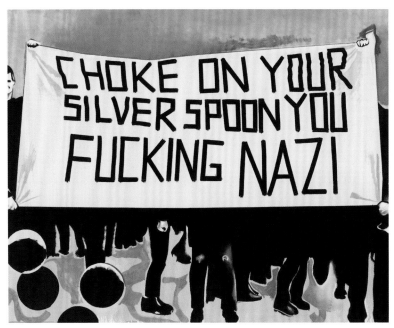

37 Wilhelm Sasnal, *Untitled (Choke)*, 2017

and experience of World War II. Other subjects have included former United Nations Secretary-Generals, including Kurt Waldheim, who was complicit in Nazi war crimes. In an even more explicit painting, *Untitled (Choke)* (2017), a photograph from a rally in Oakland, California, taken the day after Donald Trump's election, is manipulated into a saccharine pink field. In it, protesters hold an anti-fascist banner reading: 'Choke on your silver spoon you fucking Nazi'.

Following the collapse of the Eastern Bloc, Yevgeniy Fiks (b. 1972, Moscow, USSR) began to examine forgotten and repressed histories of the Left – while post-Soviet culture set about eradicating the legacy of those years. Fiks views this recovery as an activist project, in which 'interventionist tactics normally applied to physical social space can and should be effectively applied to history'. For the oil-painting series *Songs of Russia* (2005–7), he appropriated stills from World War II-era Hollywood films about the Soviet Union, which President Franklin D. Roosevelt sponsored to galvanize favourable public opinion towards Stalin at the brief moment when Soviet and American interests coincided. During the onset of the Cold War, these same films became the focus of the House Un-American Activities Committee hearings regarding Communist

37

38

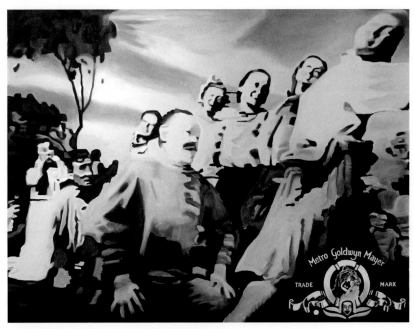

38 Yevgeniy Fiks, *Songs of Russia no. 10*, 2005–7

infiltration of Hollywood. Adrian Ghenie (b. 1977, Baia Mare,
Romania), who grew up under Communist dictator Nicolae
Ceauşescu, was also drawn to appropriation as political
critique. In *Untitled (Ceauşescu)* (2010), Ghenie takes as his
source a widely publicized image from the day of Ceauşescu's
nationally televised execution. He actively blurs the image,
which seems to physically disintegrate, in what might be a nod
to an old photograph or, more grimly, a freighted recollection
of the exhumation of Ceauşescu's body. Ghenie also disfigures
other 20th-century totalitarian leaders: in *The Moth* (2010), an
insect leaves a purple smear on Joseph Stalin's face. Other
images cover Adolf Hitler with paint strokes, thick and gooey
like custard, evoking the mischief gag of pie-throwing, and
mimicking its ritualistic humiliation by other means.

 Others choose more subtle avenues through which to
approach politics and history. Consider Julie Mehretu (b. 1970,
Addis Ababa, Ethiopia): through meticulous underdrawings
of maps, city plans, civic buildings, palaces and ruins, she
examines how architecture is overtaken by history, and the
ways the built environment bears the traces of successive
actions. Her accumulations of ink and acrylic marks function
as metaphors; embedded in strata of translucent acrylic, they

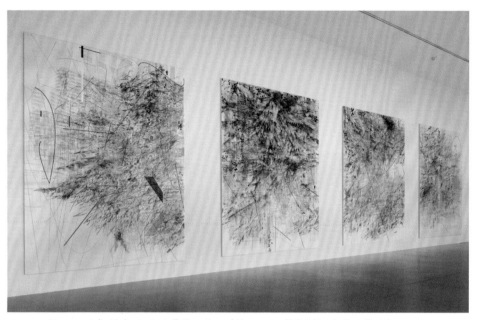

39 ABOVE Julie Mehretu, Installation view of *Mogamma (A Painting in Four Parts)*, Documenta (13), Kassel, 2012
40 OPPOSITE Maryam Najd, *Self-Portrait VIII*, 2006–7

both build upon and efface what has come before. Mehretu expresses the dynamism of contemporary cities, which seem to explode into shards across the surfaces of her monumental canvases, leaving certain markers of place intact amidst bands of colour and passages of geometric abstraction. Such works as these were created before 9/11 and in the aftermath seem prescient. In *Mogamma (A Painting in Four Parts)* (2012), a series exhibited at Documenta (13), Kassel, in the year of its production, Mehretu took on subsequent insurgencies, notably events surrounding the spontaneous uprising in Cairo's Tahrir Square the previous year. She incorporates architectural drawings of the government building at the site that gives the series its title, collapsing Egypt's postcolonial history and its 2011 revolution.

Where Mehretu buries the image, Maryam Najd (b. 1965, Tehran, Iran) veils it as a surrogate for the body. These layered, concealed images have included photographic screenshots of television programmes and a series of fake self-portraits, in which Najd aligns her identity with images of Margaret Thatcher, Farah Pahlavi and Osama bin Laden, in a canny take on stereotyping and mass-projection – e.g. Iranian equals terrorist – in a post-9/11 world. These last works indicate the

39

40

priority of appropriated media images for Najd. Her series *Masquerade* (2009) centres on images of Iranian protestors demanding the removal of Mahmoud Ahmadinejad from office; under significant threat, they are shown wearing protective masks and scarves to conceal their identity, transforming theatrical accessories into tactical disguises. Najd also abstracts from abstractions, as in her *Non Existence Flag Project* (2010–12), in which she took over one hundred national flags and erased each of their lines and contours. Next, she calculated the percentage of each colour used in a flag's design and mixed them, in the same proportions, to achieve a single hue. Najd then used this colour to paint a monochrome panel for each symbolically deracinated flag.

In this way, artists can stress content as well as form. Indeed, the two are often rendered inextricable. Many artists have embraced appropriation as a kind of curation that makes plain the act of having chosen source material. This can be traced to Marcel Duchamp, who legitimized the acts of finding and

selecting rather than making (through his nomination of a
urinal as art by placing it on a pedestal and submitting it to
a space dedicated to art, in *Fountain* [1917], and more generally,
his identification of the readymade as art). This lineage is
continued in Ruth Root's (b. 1967, Chicago, IL) press release for
a 2008 show at the Andrew Kreps Gallery in New York, in which
she placed thirty-five heterogeneous sources into the form of a
mathematical equation. Ellsworth Kelly, Josef Albers and Blinky
Palermo were given the same value as such items as bathmats
and ski socks. All of these components were connected by plus
signs, the sum total of which 'equalled' the exhibition. Far
from reducing her wafer-thin paintings to a game of sources, it
generously revealed a tendency to accumulate and synthesize:
part of practice that typically remains out of view.

Unlike Duchamp's readymades, Root's paintings are
carefully crafted artefacts, but the crux is her acknowledgment
of what has come before them. In this forthright act of
authorship, she takes responsibility for those selections

41 LEFT Ruth Root, *Untitled*, 2017
42 OPPOSITE Mamma Andersson,
Installation view of 'Memory
Banks', Contemporary Arts
Center, Cincinnati, 2018

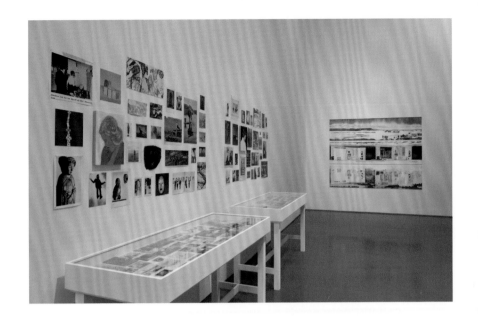

41 and what they help to generate. In a more recent series shown at 356 Mission in Los Angeles in 2017, Root made such appropriations even clearer within the paintings themselves. Each work has two discrete but interlocking physical sections: one of patterned fabric of the artist's own design, pulled taut over softly swelling wadding, and the other painted Plexiglas, which hangs from the first like a giant earring from a lobe. The fabric is a sort of digital sampler, comprising portraits of Ruth Bader Ginsberg, textile fragments from Sonia Delaunay and Wiener Werkstätte, the sharp geometry of a security envelope design, a pizza slice and icons of Root's own art, in what becomes a miniature retrospective.

Mamma Andersson (b. 1962, Luleå, Sweden) has also been transparent about the resources that she consults. Revealing her inspirations in folk art and cinema, among others, she appropriates photographs and other mnemonically rich ephemera within her paintings. When exhibiting these

42 dreamlike Nordic scenes at a show at the Contemporary Arts Center, Cincinnati, on the occasion of the FotoFocus Biennial 2018, Andersson hung the paintings together with their sources. She installed the reference photographs and book pages on the wall and in vitrines in tight clusters, as so-called formal 'memory banks'. (These take their title from her painting *Memory Bank*, 2011, in which two ghostlike figures row a boat.) The presentation of Andersson's works alongside such an

array of materials – including stacks of books, ready for re-use, a photograph tacked to the wall and a television set – shows a kind of before and after in terms of the transformations of imagery and ideas.

Some artists not only reference their own work and sources but also expand this referentiality to the institutions of art. In a 2007 show at Maureen Paley, London, Andrew Grassie (b. 1966, Edinburgh, UK) placed paintings depicting the gallery's exhibitions from the previous year during their installation. Each work hung in the same spot in the gallery as Grassie had stood in when he took the photograph on which it was based. He has also made literal the act of curation involved in selecting sources, as in 'New Hang', 2005, when he curated works from the Tate gallery's collection, by George Stubbs, Henry Moore and others, in an imaginary display. His photorealistic paintings of this hypothetical rehang were exhibited in the same gallery space that they depicted.

Rather than engaging with an extant corpus, Matts Leiderstam (b. 1956, Gothenburg, Sweden) assumes the possibility of curatorially reframing the whole of art history through its newly examined details. Leiderstam exhaustively researches an image type or artist, such as Nicolas Poussin, and builds an archive around it. The resulting exhibition might include optical instruments (colour filters, magnifying glasses,

43

43 Andrew Grassie, *Installation: Martin Creed, Rennie Collection, Vancouver,* 2012

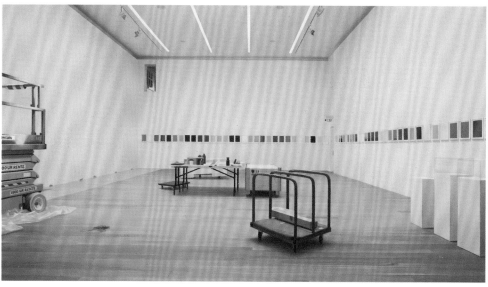

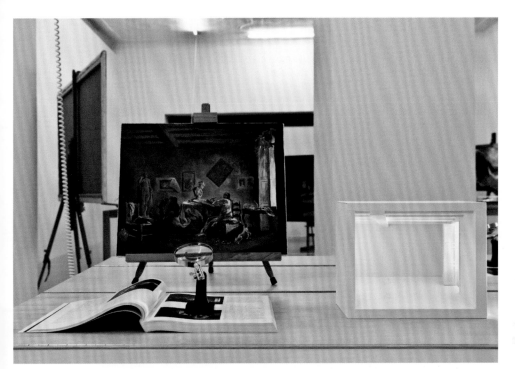

44 Matts Leiderstam, Installation view of *Grand Tour* (1997–2007), Grazer Kunstverein, Graz, 2010

field scopes, slide projections and computer animations) and his own hand-painted reproductions of paintings, for use with other items of study (catalogues, books, light boxes, slides and photographs). Possibly the most complete realisation of this approach is found in *Grand Tour* (1997–2007), first shown in connection with the 1997 Venice Biennale and variously configured in other locations, including Magasin 3 (Stockholm, Sweden) in 2005. Inspired by the origins of cultural tourism, Leiderstam discovered that designated stops along the circuit for wealthy young men of the 18th century, who were presumably gaining knowledge of connoisseurship in order to build art collections, match those in modern gay travel guides. Leiderstam thus highlights the incipient eroticism in abundant images of grottoes, deserted landscapes and public parks, as well as in specimens of the classical nude.

Taking physical appropriation still further, some even insist on literal reclamation, like Uwe Henneken (b. 1974, Paderborn, Germany). He chooses 'used' canvases – already painted by someone else and discarded by earlier owners, perhaps when

44

45 Uwe Henneken, *Vanguard #66*, 2006

they fell out of favour – as settings for his protagonists named Vanguard and Nihil: goofy-looking cartoon heads peeking over the horizon as if it is a wall. These characters are derived from World War II-era 'Chad' graffiti, which American and British servicemen sketched wherever they were stationed, leaving residues of occupation in their wake. Just as public walls became sites to be defiled, already-worked paintings serve a corresponding role for Henneken, functioning as the prepared surface on which he superimposes his figures. In so doing, he exaggerates the delirious tastelessness of art from various eras and locales, showing the constant shifting of preferences in art to be linked to cultural trends. Instead of arguing for a history in which events reach a clearly defined endpoint, Henneken proposes a model of interconnectivity, in which nothing really goes away.

Henneken is not alone in retrieving already-painted canvases as the basis for his production. In selecting someone else's art as readymade, artists highlight their activities as scavengers – curators of a different kind – picking over the

remains of past production. They also point to the potential utility of actual recycling, with its ethos of 'reduce and reuse', to offset the deleterious effects of commodity production.

46 Dirk Bell (b. 1969, Munich, Germany) also claims 'readymade' paintings – often by anonymous artists and procured at flea markets in Berlin – as the ground in his work. On these, he builds a scrim of white paint or washy, swirling overlays to suggest a dream state; elsewhere, he transplants elements between the paintings, excavating a section from one to incorporate it into another arrangement. While some paintings are revised, others remain in their found condition, matched with companion paintings or supplemented with sculptural components.

47 For his series *Modern Paintings* (1997–present), Pavel Büchler (b. 1952, Prague, Czechoslovakia) cleans discarded canvases before applying acrylic primer to the surface; thereafter, he peels off the paint, launders the canvases in a washing machine, reattaches the removed paint, and

48 re-stretches the work. Recalling Büchler, Lucas Ajemian (b. 1975, Waynesboro, VA) has treated, soaked and bathed already-painted canvases donated by friends and students, before cutting them into multiple segments, adding raw fabric to them or distending the material to accommodate a new stretcher. While the artists responsible for Büchler's source paintings remain anonymous, in Ajemian's work this is hardly the case; the readymades – what he designates as 'hosts' – have been offered up by such artists as Julien Bismuth, Anna Craycroft, Tim Harrington, Katja Holtz, Nate Lowman, Dean Monogenis, Dana Schutz (p. 291) and Cheyney Thompson (p. 241), all of whom are named. The resultant

46 Dirk Bell, *Zitat*, 2007

works are exercises in social practice, built as they are out of a community of peer engagement. Yet, just as much, they are exercises in formal judgment, and in this the decisions of the original artists are obscured by those of Ajemian in terms of what might become a new composition, fashioned from the old.

The social aspect of appropriation is stressed by Radu Comsa (b. 1975, Sibiu, Romania), who insists that he belongs to a community of viewers in which appropriation acts as a mechanism for survival. He is pictured by his friend Ciprian Mureșan (b. 1977, Dej, Romania) in the cartoon animation *Untitled (Eating Trash)* (2007), characterized as a bear scavenging rubbish as a testament to his eclectic range. In 2009, Comsa and colleagues began to work in the Paintbrush Factory in Cluj, Romania, a collective space for contemporary artists. For a 2010 show at Sabot Gallery (located in the Paintbrush Factory), titled 'Being Radu Comsa', he referenced his peers directly, installing wooden constructions as supports for inset circular paintings. These works reproduce details and whole images made by his colleagues: Ghenie (p. 51), Victor Man, Marius Bercea and Serban Savu (p. 174). As Comsa painted them by his own hand, he never achieved an exact replica of those works he incorporated. Comsa capitalized on the recent success of the peers whose work he appropriated – they had received successful promotion since their debut at the 2007 Prague Biennial, and are now known to a larger art-going public – and, given the exhibition setting, he made the collective space where the artists laboured a part of the structure of his work.

47 BELOW LEFT Pavel Büchler, *Modern Paintings No. A45 (cartoon figures in a barn, "Sumie 98," Manchester, August 2007)*, 1997–2007
48 BELOW RIGHT Lucas Ajemian, *Laundered Painting (26x26) I*, 2014

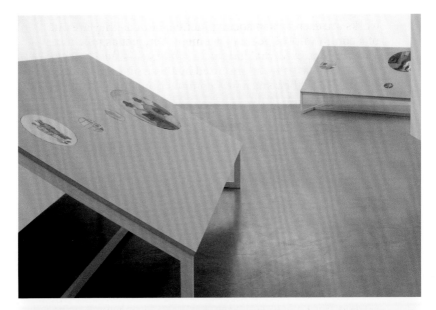

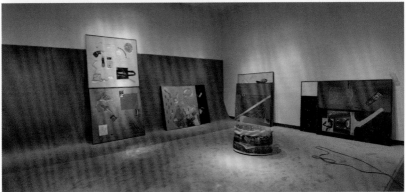

49 TOP Radu Comsa, Installation view of 'Being Radu Comsa', Sabot Gallery, The Paintbrush Factory, Cluj, 2010
50 ABOVE Alex Da Corte, Installation view of 'Fun Sponge', ICA at MECA, Portland, Maine, 2013

50 Alex Da Corte (b. 1981, Camden, New Jersey) performed sociability in a related manner for an early project, 'Fun Sponge', at the Institute of Contemporary Art at Maine College of Art in 2013. Using his social network, he made paintings that condense – or in his words, 'absorb' – his friends' work, by placing their paintings behind adhesive sign vinyl before pressing them against Plexiglas, where they remain in perpetuity.

Appropriation after Appropriation

As appropriation, like postmodernism, comes to be understood as an art practice associated with a particular period in the past (the 1980s) and cultural context (the US), its history is also being redrawn. As discussed in the introduction, some characterized photography and painting as antithetical. But this was far from a decisive binary (and the interaction between them was not limited to the former serving as a source for the latter); nor was painting a stranger to appropriation. Testament to this is the oeuvre of David Wojnarowicz (1954–1992), who worked in appropriation-based collaged painting and photography as well as music, film, sculpture, writing and activism, refusing a single medium – above all painting or photography – or style. He powerfully weaponized painting in the midst of the AIDS crisis and culture wars of the late 1980s and early 1990s to give form to cultural metaphors of marginality and violation.

While painting-based appropriation was often disparaged in the 1980s, re-examination of the period has reframed its value; it is now deemed not only viable but also desirable, and even the source of humorous recapitulation. A 2008 show, 'Who's Afraid of Jasper Johns?', conceived by the gallerist Gavin Brown and Urs Fischer (b. 1973, Zürich, Switzerland), invented a wryly self-conscious exhibition model. Installed at Tony Shafrazi's

51 Urs Fischer, Installation view of 'Who's Afraid of Jasper Johns?', Tony Shafrazi Gallery, New York, 2008. Wallpaper: Urs Fischer, *Abstract Slavery*, 2008. Works featured on wallpaper, from left to right: Gilbert & George, *MENTAL NO. 4*, 1976; Cindy Sherman, *Untitled #175*, 1987

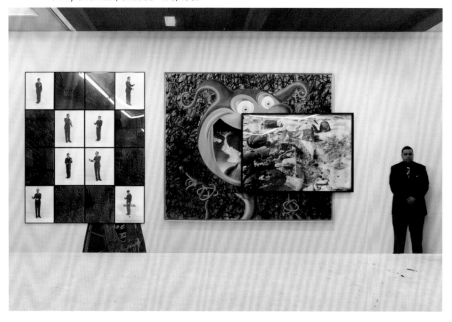

52 Peter Halley, Installation view of *New York, New York*, Lever House Art Collection, New York, 2018

New York gallery, it featured a photographic mural of Shafrazi's recent exhibition 'Four Friends' (Donald Baechler, Jean-Michel Basquiat, Keith Haring and Kenny Scharf). This captured the installation in its entirety: guards, gallery infrastructure, walls and artworks. Over this full-scale, trompe l'oeil wallpaper hung 'real' works by twenty-two artists, ranging from Francis Bacon and John Chamberlain to Jeff Koons (p. 74) and Christopher Wool (p. 113), each of which had passed through Shafrazi's hands for sale on the secondary market. A Rudolf Stingel (p. 138) carpet covered the floor, while two works by Rob Pruitt (p. 69) bracketed the whole show: *Eternal Bic* (1999), an endlessly burning Bic-lighter-turned-sculpture seen upon entry, and a Viagra-infused waterfall that coursed alongside the front stairs.

Peter Halley (b. 1953, New York, NY) has undertaken a different kind of reconsideration of the role of painting in appropriation. The driving force behind his work is postmodern philosophy; resulting works propose that appropriation

53 Sherrie Levine, Installation view of *Gray and Blue Monochromes after Stieglitz: 1–36* (detail), 2010

operates on the level of theory and that theory, too, can be appropriated. A staunch opponent of the figurative tradition, Halley paints cells and prisons (squares and rectangles, respectively), and conduits (lines) in a palette of Day-Glo paints. These are punctuated with passages of Roll-A-Tex, an industrial paint, the textured appearance of which recalls stucco. Halley's diagrammatic paintings expose the use of geometry in the public sphere as an agent of control, with the individual trapped in social systems, somewhat literally illustrating the French post-structuralist theory that underpins their logic. In his 2018 commission for the Lever House, New York, he realised an architectural environment extending from the circuit-like compositions of his earlier paintings into actual space. A choreographed succession of rooms culminated in a gallery with walls covered by an intricate latticework of diagrammatic prisons, illuminated only by black light.

Meanwhile, the re-evaluation of painting has made clearer the significance of Sherrie Levine's concerted attention to the medium. Begun a few years after her better-known photo-based work, her 1980s compositions (often chequered or striped) recall modernist abstraction, not through specific antecedents such as Piet Mondrian or Barnett Newman, but as a generic decorative scheme. Levine's *Knot* paintings, made from 1985–2002, in which she colours in the knots on plywood sheets, are wry meditations on the painting as readymade. In 2006, she

52

created *Equivalents: After Stieglitz 1–18*, a grouping of eighteen photographic prints that decompose the greyscale of Alfred Stieglitz's *Equivalents* (1925–34), his series of increasingly abstract photographs of the sky, into squares of solid hues. Whereas the *Equivalents* acted as pathetic fallacy to express Stieglitz's inner state, Levine's was a more intellectual approach. And yet, Levine subsequently completed two
53 series of eighteen monochrome paintings based on the same photographs, this time responding to the skies rather than reproducing them.

As with Levine, for many younger artists, including Blake Rayne (b. 1969, Lewes, DE) and Wade Guyton (b. 1972, Hammond, IN), the legacy of conceptualism has prompted painting-based appropriation, often not of a specific image, object or painting precedent, but of an idea of period style. Both directly engage with the sense of self-criticality that developed within 20th-century painting. This was a type of licenced introspection regarding the nature of painting, whether in a historical, material or institutional sense. As Rayne asserts in an undated artist's statement titled 'Totally Over-Determined Program for a Project With No Plan':

I see the task of my own practice to be that of putting the beliefs attributed to the sign "Painting" to the test by subjecting it to the material conditions of the medium of painting. These material conditions...are for me: modes of distribution and external framing (context); internal procedures of formation (process); and relationships to other types of images, including those constitutive of a "subject" (performativity).... I have developed an evolving set of procedures by transforming the particular conditions of the medium from definitions to operations. These... include...processes of translation, decontextualization, folding, superimposition, and the following of "scripts" grafted from other sites of cultural production.

54 This strand of thinking runs through *Untitled 2 through 8 (Dust of Suns)* (2008), a group of large-scale paintings created by Rayne in accordance with predetermined steps, which involved exploitation of the properties of folding. After selecting and cutting fabric, he marked off the pictorial space and folded the support; he then painted and re-stretched it, before cutting and re-sewing it into three horizontal registers. The series nods to the work of Supports-Surfaces, a politically astute group of French artists working in the late 1960s, who used unconventional materials and procedures, including folding, to take apart the tools of painting. Another way Rayne

54 ABOVE Blake Rayne, *Untitled Painting No. 3*, 2008
55 OPPOSITE Wade Guyton, *Untitled*, 2010

re-examines the 'beliefs attributed to the sign "Painting"', as
he puts it, is through his experimentation with the spray gun,
through which he eschews lyrical gesturalism and distances
himself from painted marks.

Like Rayne – and, to some extent, the artists discussed
in Chapter 3 – Wade Guyton uses production (process) and
distribution (context) to test painting as a medium, similarly
referencing or appropriating the interrogatory stance of 20th-
century painting. In 2002, he began using an office-quality
printer to make assisted drawings: computer-generated images
(Xs and Us in Blair ITC Medium font predominate), which at
times overlay source material culled from art, architecture

and design magazines, as well as auction catalogues and monographs. Two years later, Guyton started painting along these lines, and in 2007 he began producing so-called 'ostensibly black monochromes' with a computer and an Epson large-format photograph printer that spits ink onto pre-primed linen intended for oil.

Despite the uniform process, the results vary according to the amount of ink, overprinting slippages, imperfect syncs or the printer running askew. Print settings, such as draft, economy, black-and-white or colour, provide controls. In a 2010 project for the Museum Ludwig, Cologne, Guyton produced entire rolls of linen, which he installed floor to ceiling in a hiccupping pattern of rectangles. Another group by Guyton, displayed in 2018 at Petzel Gallery, New York, featured knowing images of paintings drying on the floor, scraps of linen, the remains of lunch and other studio scenes.

Artists such as Rayne and Guyton deliberately subvert their technical skills, a manoeuvre referred to as de-skilling. Yet taking away one kind of skill – traditional draughtsmanship, say, or varnishing – necessitates re-training in others. Plus, these artists clearly instigate the process, and evaluate, conclude and legitimize it through the authoring of self-imposed rules.

R. H. Quaytman (b. 1961, Boston, MA) goes through the same procedure for each series, beginning with researching an aspect of the location where the work will first be exhibited and viewed. Quaytman uses standardized sizes of wood panels, which she brushes with a traditional primer before adding layers of other paints and surface items (including Spinel Black, the oil paint engineered to make the Stealth Bomber undetectable, and crushed glass); she also silkscreens photographs or abstract patterns. She then organizes her paintings into thematic series conceived as 'chapters', which she numbers chronologically: *The Sun, Chapter 1* (2001), *Łódź Poem, Chapter 2* (2004), *Optima, Chapter 3* (2004), and so on, to *+ ×, Chapter 34* (2018). The latter was made to be shown in conjunction with Hilma af Klint's gnomic spiritual abstractions in the 2018 show 'Hilma af Klint: Paintings for the Future' at the Guggenheim Museum, New York. Each group of Quaytman's works is interdependent, containing references

56 R. H. Quaytman, Installation view of *+ ×, Chapter 34*, Solomon R. Guggenheim Museum, New York, 2018–19

57 Rob Pruitt, Installation view of 'Pattern and Degradation', Gavin Brown's enterprise and Maccarone, New York, 2010

to its constituent members – often by means of hall-of-mirror-like repetitions within the images – and to their site. Her paintings' bevelled edges also stress the picture plane and, crucially, emphasize the oblique position from which they will be viewed after the exhibition, once returned to storage racks.

While Quaytman has established a governing framework within which she operates, her appropriation is still poignantly motivated by personal inclinations. This is perhaps exemplified in *Distracting Distance, Chapter 16* (2010), a group of works created for the 2010 Whitney Biennial, which were partially based on Edward Hopper's painting *A Woman in the Sun* (1961). This painting was made the year of Quaytman's birth, and it solemnly depicts Hopper's ageing wife (and long-time model) standing alone, naked and introspective in a shaft of sunlight. Quaytman recreated a similar scene in the gallery space of the Whitney Museum of American Art, and silkscreened this on wood panels for several works in *Distracting Distance*. The series was then hung in that same gallery space. The chapter demonstrates an element of personal engagement, and a possible emotive connection to the original.

Contrarily, Rob Pruitt (b. 1964, Washington, D.C.) could be said to demonstrate hostility towards the objects of his appropriation, as well as highlighting unseemly claims of taste and sociability. He is known for his glitter-encrusted

paintings of zoo pandas, and for perversely instigating a range of spectacular actions. These span from offering a buffet of cocaine on a floor mirror to producing an annual art-award ceremony at the Guggenheim Museum in New York and a monument to Warhol in the city's Union Square. Pruitt's 2010 show at Gavin Brown and Maccarone galleries was called 'Pattern and Degradation', referencing the wonderfully eclectic Pattern and Decoration movement from the 1970s. The show included fabric patterns procured from the fashion designer and socialite Lilly Pulitzer (designed by Suzie Zuzek), along with photos appropriated from the Internet – which led to a flash-mob demonstration protesting their lack of attribution – and colour-saturated canvases inscribed with scribbled lines that capture fragments of human faces and expressions. These items were placed in the proximity of 'People Feeders': stacks of tires functioning as giant dishes for sweets and cookies. Taken together, the works took the hangover of pop art as a filter of popular culture and extended it into the digital age, envisaged at its most radically eclectic. In Pruitt's hands, images, clips and all manner of media are grist for the appropriative mill.

To return to the legal issues discussed at the beginning of this chapter, a pivotal concern has become whether it matters if the appropriated artwork is seen as visibly altered. This raises the spectre of fair use, which became topical anew in 2011: a federal court judge in Manhattan ruled that Richard Prince broke the law when he appropriated the French photographer Patrick Cariou's previously published images of Rastafarians in Jamaica for a body of collages and paintings. In 2013 this verdict was appealed and, with the exception of five of the thirty works, overturned in Prince's favour because his paintings 'have a different character' from Cariou's photographs. This somehow carried weight despite Prince's admission that he '[didn't] really have a message' and that he was not 'trying to create anything with a new meaning or a new message'. Whatever the merits of this judgment, the case shattered the fiction that all material exists for the taking. This remains a continuing problem in another case regarding the same artist's appropriation of other people's Instagram posts in a series of screengrabs that he inkjet printed on canvas, described by one of the subjects, Zoë Ligon, as a violation of boundaries and a 'reckless, embarrassing, and uninformed critique of social media...in 2019 it's tone deaf'. Beyond Prince, or North America for that matter, these affairs have become commonplace – so much so that in 2019, the Court of Arbitration for Art (CAfA) opened in The Hague as the world's first court devoted to settling these and other kinds of disputes involving art.

Many have argued for the utopian social potential promised by the digital universe, or the development of collaborative, open-source systems with less disciplined and regulated communication; on this basis they have even founded notions of an interconnected, globalized art world. With the perpetual shuttling of images, objects, designs, styles, materials and techniques, however, these same systems have contributed to retrenchment into single authorship and differentiation of individuated product. In the world of the selfie, the conveyance of identity is congealed in and perpetrated through the branded image, in which personal sovereignty is presented as the upshot of self-actualizing choices. But as in the selfie, which often masks more than it exposes, neither the artist nor the artwork necessarily divulges personal content – the truth of the self – even if it appears to be doing exactly that. In the following chapter we return to questions of intention and the degree to which it is revealed formally, whether the painting takes its basis in appropriation or not.

Chapter 2
Attitude

This chapter considers various strategies of self-presentation that artists use to frame themselves, and their work, by means of stylistic and procedural devices. The former refers to a work's physical presentation, whereas the latter relates to the way in which a work is made; both elements of this act of framing extend well beyond the apparent completion of the painting as an object, and are continued through the positioning of both the artist and their work in the public realm. Stylistic devices range from exaggerated brushstrokes meant to stand for expressivity (or to parody it) to the anti-aesthetic stance of 'bad painting'; procedural devices include the historically conditioned uses of Western and non-Western painting methods and practices, for instance to question the privileged place of Western, and especially North American, painting within the history of modernism.

One such novel procedural device was achieved by Vitaly Komar (b. 1943, Moscow, USSR) and Alexander Melamid (b. 1945, Moscow, USSR) in *People's Choice* (1994–97). Working before the Social Web, the artists commissioned polls in eleven countries, including Russia, China, France, the United States and Kenya, to determine the most and least wanted paintings for each national constituency – which they then created. Effectively demonstrating how artists can serve a cultural function (rather than sharing private feelings), the project is provocative in its exploration of certain forms of populism and for using a crowdsource culture ahead of its time. It continues to gain in relevance as artists find increasingly sophisticated ways to exploit the Internet; it also admits the world to be both interconnected and decidedly local. (How artists negotiate this bifurcation is discussed in this chapter, as well as in Chapter 3.)

In the years since the unveiling of *People's Choice*, artists' attitudes and the cultivation of an artist's persona have become quintessential factors in contemporary art. Historically coincident with Komar and Melamid's project was the appearance of the Young British Artists (YBAs), whose position in the 1990s – concisely characterized by one art critic as being 'oppositional and entrepreneurial' – was consolidated by their education, exhibition and patronage by the London-based collector and advertising executive Charles Saatchi. In a testament to the effectiveness of ego and marketing, they achieved remarkable traction under the sign of the enfant terrible, as exemplified by Damien Hirst's *The Physical Impossibility of Death in the Mind of Someone Living* (1991), a preserved tiger shark swimming in a minimalist cube of formaldehyde, or Tracey Emin's *My Bed* (1998), a rumpled bed, its stained sheets conspicuously littered with condoms and detritus. Some became household names, a level of renown typically reserved for media figures with a cultivated persona and a knack for self-promotion, a description that also applies to star artists such as Jeff Koons.

Perhaps it goes without saying, but the shaping of an artist into a public personality, even a pop idol, through an artwork – or as the artwork – is the hallmark of mediagenic culture. In one focal acknowledgment of this state of affairs, Marina Abramović (b. 1946, Belgrade, Yugoslavia) sat silently in a chair in the atrium of the Museum of Modern Art, New York, for three months in 2010, performing *The Artist is Present*. Abramović appeared like a statue from a distance, though many of the museum visitors who took the invitation to approach her were overtaken with emotion. So moved were they by this eye-to-eye encounter that scores of testimonial-like portraits now populate a website, 'Marina Abramović Made Me Cry'. Cynics do not see this as broadcasting sincerity or prompting empathy: for them, these images of tear-streamed faces parody the modern fancy for achieving self-validation through art and prove an instance of celebrity legitimizing itself through the faux-generosity of communion.

No matter how it is interpreted, *The Artist is Present* confirms a widespread yearning for the kinds of affective connection apparently lost in daily lives that now so disproportionally happen on-screen – even in museums, where people often walk head-down, staring into handheld devices rather than at the art or one another. Abramović claimed an aesthetic but also physical space in which this wished-for experience of real-life connection might occur. This nevertheless also imperils one to the possibility of interpersonal antagonism.

58 Jeff Koons, *Gazing Ball (Rubens Tiger Hunt)*, 2015

After a book signing at the Palazzo Strozzi in Florence in 2018, a man carrying a painting attacked Abramović by slamming the canvas over her head.

Harnessing this morbid public curiosity with artists, who are alternately fetishized and reviled, Nathaniel Kahn's documentary *The Price of Everything* (2018) casts Larry Poons (b. 1937, Tokyo, Japan) as the underdog in his story about a multi-billion-dollar international market. Clad in paint-splattered clothes, Poons perpetuates the heroic myth of the painter as lonely genius (a highly codified trope of its own). Portrayed toiling for his craft, separate from venal commerce and the commodification of creativity, he discusses having refused a signature style to the detriment of his reputation and sales. Thus is Poons paired effectually with Jeff Koons (b. 1955, York, PA), a former Wall Street commodities trader. Koons is shown supervising a giant painting workshop where a team of technicians produces handmade, stroke-by-stroke replicas

of well-known masterpieces, finished off with the addition of a spherical gazing ball. Although the shiny blue baubles extend the illusion of the painting beyond the frame, their mirrored surfaces are also projective vehicles in the spirit of a Rorschach test. 'This experience is about you,' says Koons, displacing authorial intention onto the experience of reception as a kind of permissive, ultimately consensual narcissism, 'your desires, your interests, your participation, your relationship with this image.'

Who, or What, Does a Painting Reveal?

Koons famously skirts issues of intention. He rejects visions of mythic inspiration associated with creativity; his concern is with art as an asset class (a term used with regard to investments, indicating a group of financial concerns with similar characteristics). The genesis of his work lies in consumer-oriented market analysis. What will audiences find pleasurable? What will they deem prestigious, collectable? Koons claims no critical intent. Hedging his bets, he does offer backstories to works and provides keys to their symbolism. To the first point, as a nine-year old boy he is said to have painted and signed copies of works of old masters, which he sold in his father's furniture store. To the second, he has announced that his popular balloon pieces (extending from the blown-up rabbit of his *Inflatables* series from the late 1970s to his more recent oversized balloon dogs in mirror-finished stainless steel) are about breath, and moreover, they are bracing emblems of life and optimism.

Chloe Wise (b. 1990, Montreal, Canada) mocks the pretensions of capital upon which Koons trades. Her *Bread Bag* series (2014–present) lampoons the language of wealth (think of the connotations of the 'breadwinner' and 'dough') with handbags acknowledging the perishability of trends in art and fashion alike. Wise's version of status 'it-bags' from the likes of Chanel or Fendi are sculpted with plastic urethane and painted with oil to look like pancakes or waffles; they are further embellished with chains and dangling charms, plus the requisite luxury-brand logos. Her paintings of herself and friends – shot with her phone to control the light – feature the sitters in exaggerated poses. They offer up products (commonly fresh and processed foodstuffs) on tables or pressed against exposed body parts. As in 17th-century Dutch still lifes, the transactional nature of these arrangements portrays the sexualized bounty of accumulated wealth, none-too-subtly showcased in one of Wise's repeated iconographies: the vaginal slit of ripe fruit pried open.

59 Chloe Wise, *Lactose Tolerance*, 2017

Invested in crafting a social media presence around this, Wise posts studio selfies, self-constructed and wholly mediated images of the artist posing before a matching painted self-portrait. Even artists who operate at some remove from publicity systems remain implicated in them, if not always to this degree. And artists are not alone. This might be Koons's point, as he encourages the arresting of each viewer's visage, however transiently or involuntarily, on his high-gloss surfaces. There, a viewer might seek to memorialize the encounter, taking photographs of the work and their reflection as a souvenir, living in perpetuity in the cloud. Spectator-driven reception is very much in line with cultural tendencies in which consuming and producing are intertwined: for many, experience counts only when documented on social media. Notwithstanding Koons's anecdote of his precocious painterly exploits, this occurrence may work to drive a wedge between authorial biography and communicated meaning; the one need not causally determine the other. At the very least, it is clear that meaning is remade through each individual's appropriation of a work for their own purpose, as Chapter 1 explores.

In terms of an artist's self-presentation, when it is cleaved from lived experience, anonymity can be recuperated for gain. Banksy (b. unknown) is one of the best-known artists in the world, although his identity remains shrouded in mystery. The artist paints in public sites but manages to stay out of view. Above and beyond his facelessness, his most dumbfounding exploit came in 2018 when he sold a version of his 2006 mural *Girl with Balloon* at Sotheby's auction house for a record price – and then immediately activated its destruction with a hidden shredder built into the frame. The process stopped partway in what was apparently a technological malfunction. This begs questions as to the motive behind this act of self-vandalism: it could have been a gesture of reprimand directed at an overheated industry and its theatrical sales spectacles, or it could simply have been an example of the very same thing.

60 Banksy, *Love Is In The Bin*, 2018

There remains, too, the lingering query as to whether Sotheby's was involved in the stunt. Regardless, phoenix-like, the work is now retitled *Love Is In The Bin* (2018), and memes of its canvas being sliced into long ribbons were quickly used in ads for fast-food outlets and spread across many other platforms.

While this was an extreme case, many artists undermine their positions within an entertainment-industry-like system that expects the artist to play a certain role, often crudely gendered, or cast along lines of race or class. This stereotyping is fabulously satirized in the work of Jayson Musson (b. 1977, New York, NY), more commonly known as Hennessy Youngman. Donning hip-hop apparel and speaking in clichés, Musson – as Youngman (a kind of portmanteau from comedian Henny Youngman and Hennessy cognac) – hosts

61 Yoshitomo Nara, *Miss Spring*, 2012

62 Wangechi Mutu, *Forbidden Fruit Picker*, 2015

an Internet series, *Art Thoughtz* (2010–present). In these episodes, he introduces concepts relating to art practice. One such: 'How To Be a Successful Black Artist'. To this prompt, Youngman supplies the answer to 'be angry'; in a kind of gallows humour, he also recommends working oneself into this state by viewing videos of pit bulls fighting, the Rodney King beating or photos of the brutally murdered Emmett Till in his coffin.

For others, the professed desire to separate self from representation does not always secure public treatment on these grounds. Yoshitomo Nara's (b. 1959, Hirosaki, Japan) work is frequently discussed vis-à-vis his life story – as a product of his latchkey past – despite his use of *kowa kawaii* ('creepy cute'), a popular flat graphic style that has, in part, developed as a counterpoint to traditional, refined aesthetics in Japanese culture. Rather than serving as a confessional tool, Nara uses this style to evoke childhood innocence and a rather more diffuse and broadly relatable condition of loneliness that is not tethered uniquely to his history. A divergence between the meaning expressed by the artist and that applied by the viewer is also evident in the work of Wangechi Mutu (b. 1972, Nairobi, Kenya), whose fantastic hybrids – warped amalgams of plants and animals, pornography, medical diagrams and black women – stand in for the human condition. Although

61

62

63 Nedko Solakov, Installation view of *The Yellow Blob Story* (from *The Absent-Minded Man* project) at 'Emotions', Kunstmuseum Bonn, 2008

the artist insists on separation between herself and the images she creates, critics have wondered aloud whether they bespeak rather more exactly her own experience of the African diaspora. Proponents of this message may feel that it animates cultural needs, but to this, one might counter whether, or how, the diminishing of humanist representation into racial type achieves this.

It is therefore understandable that artists do not always intend for their works to be read as conduits of their own experience. Nedko Solakov (b. 1957, Cherven Briag, Bulgaria) takes issue with the fiction of transparency: the belief that his pure presence is communicated directly through his work. At Documenta 12 (2007), in Kassel, Germany, he exhibited *Fears*, produced in the same year, a work consisting of a suite of drawings that presented individual anxieties as depersonalized, even collective. In this way, he refused to convey specific interiority (a connection between the psyche and a drawn or painted surface). More emphatically than Nara or Mutu, Solakov discouraged any interpretation of artistic identity as being exclusive to personal history or psychological state. This message is furthered in *The Yellow Blob Story* (2008), a wall painting completed by a gallery assistant who was given control over its form – and this person, who remained

63

unnamed, was just as adept at performing the task as Solakov would have been, upending the privilege of uniqueness.

Continuing this disavowal of art as a purveyor of direct meaning, artists have taken to exaggerating fictive dimensions of their work and undermining superficial realism. This follows in the tradition of Adam McEwen (b. 1965, London, UK), a former obituary writer for *The Daily Telegraph* who has exhibited oversized reproductions of fake newspaper obituaries of famous people (Bill Clinton and Nicole Kidman, as well as Koons) who are in fact still alive at the time of the work's production. This is used as a means to question our knowledge and its sources, as well as what and how a painting communicates. Is it showing us the 'truth' of the author or the viewer, or neither?

Truth is a prevalent theme in the work of Peter Saul (b. 1934, San Francisco, CA), known for his surrealist paintings skewering polite society and the systemic inequities and gross violence on which it is built. In 2017, he hung six new paintings at Mary Boone Gallery, New York, under the banner of 'Fake News'. The reference here is to the propagandistic pseudo-information campaigns that roiled the United States in the 2016 election; in its aftermath, the impact of these has extended to self-segregating constituencies and post-truth politics. In some of the paintings, Donald Trump is shown

64

64 Peter Saul, *Quack-Quack Trump*, 2017

shooting firearms, and in others, he melds into a sun-baked lizard. If Saul turns a critical lens on fiction, focusing on it so as to subject the unethical practice of spreading lies to fierce interrogation, Toyin Ojih Odutola (b. 1985, Ife, Nigeria) approaches fiction as an authorial strategy to produce an overarching fable. Two Nigerian families, connected by marriage, figure prominently in her pictorial chronicle. In telling invented family sagas across generations, she claims for her own purposes 19th-century portraits and historical representations of Blackness, expansively narrating a past that never was.

65

65 Toyin Ojih Odutola, *Wall of Ambassadors*, 2017

66 Francesco Clemente, *Self Portrait with and without the Mask*, 2005

Critical Expression

66 Identity constituted a central theme for Francesco Clemente (b. 1952, Naples, Italy), a painter who matured through first-generation conceptual art but who is best known for his leading role in the Transavanguardia, or Italian neo-expressionist movement, of the 1980s. His self-portraits lay personal mythology and shifting identities onto bodies that are malleable, often suggesting a state of becoming gendered or even human. Neo-expressionism has been attacked for exploiting authorial emotion, yet even a work that is heavy with nominally personal content, or painted in the gestural style long associated with it, does not necessarily convey sentiment or authenticity.

Through mechanical means and the incorporation of readymade materials and processes, contemporary artists might dissociate themselves from production process (think back to Chapter 1, and to Wade Guyton's use of the printer [p. 66]). In so doing they can reject preconceived composition, as well as the role of the hand and technical skills that were once considered fundamental to the medium. This indicates the different possibilities for painting and its function within burgeoning economies and viewing sites. At the same time, many enact comparable critiques using signs for expressivity in painting – for example, thick, quick brushwork, as though the unconscious were emerging automatically in the course of making – without believing or hoping to convince their viewers that those strokes are necessarily a calligraphic stand-in for their presence.

67 LEFT Albert Oehlen,
FM 38, 2011
68 OPPOSITE Charline
von Heyl, *Corrido*,
2018

This distancing is evident in the work of Albert Oehlen
(b. 1954, Krefeld, Germany), who uses gestural painting for
his sustained inquiry into painterly conventions. Oehlen
tried to make calculatingly bad paintings early on in his
career, abandoning the project once these works became
indistinguishable from the neo-expressionism he was trying
to oppose. Begun in 2008, his *Fingermalerei* (Finger Painting)
jams together hackneyed figuration and garish abstraction.
He applies paint to the canvas with his bare hands. This means
touch – that would-be guarantee of aura through direct bodily
and, by extension, psychic imprint – becomes the primary
agent in building the painting's surface. Yet no less visible are
the collaged advertising posters, text fragments and printed,
heavily pixelated digital images that Oehlen often affixes to the
white-primed canvases. On these, he adds oil in drips, globs
and murky stains, in a drab palette that recalls the muddied
colour of early American abstract expressionism. Careful to
separate himself from his predecessors' professed sincerity,

67

Oehlen executes marks from the playbook of mid-century painting that look spontaneous but are carefully planned. Jokey inclusions of slivers of bikini-clad girls, playing cards or sausages, as well as letters or whole words, play against the painted sections, preventing any sense of continuous tone.

A similar equivocation about the painterly act and what it communicates underlies Charline von Heyl's (b. 1960, Mainz, Germany) fusion of gestural painting and conceptual art. Her big, energetic works avoid a signature style in favour of intense colour and pattern: splashes, stripes, diamonds, barbed wire and orbs. Visually assertive, they are difficult to analyze, particularly since she often reverses figure and ground, adding in backgrounds at the end with a fine brush. Though they are built from sources traversing literature and pop culture, philosophy and personal memory, the final works are, above all, self-referential. These pictorial illusions are based upon paradoxical spaces but nonetheless maintain the surface as

a physical thing. In von Heyl's words, each becomes 'a new image that stands for itself as fact'.

Von Heyl frequently makes paintings with protrusions, spikes and tentacles, and incorporates an image of Medusa, the monster from Greek mythology with writhing venomous snakes in place of hair. This engagement with Medusa, whose eyes could turn onlookers into stone, accords with von Heyl's refusal to reveal the work's meaning. This owes much to her rejection of the cult of celebrity promoted in 1980s Cologne by artists represented by the gallerist Max Hetzler and, above all, by the jocular machismo of Martin Kippenberger (1953–1997). Even as she kept hold of painting, she critiqued it from within. As she later recalled: 'Neo-Expressionism was seen as a signifier of stupidity, and the antidote was irony, mostly in the form of really stupid jokes. I liked the work, I liked the guys, but it wasn't something that I could, or wanted to, do. But I loved the idea that you could be aggressive and cool via painting!'

While he may not have swayed von Heyl's approach, Kippenberger had a profound generational influence, and not just in Germany. He is best known for lampooning the art establishment and its products through his alter-egos: exaggerated caricatures of the artist, and fictional characters (including the Spiderman, the Egg Man and the Frog). His wide-ranging practice encompasses wonky sculptures of lampposts and a petrol station purchased during a trip to Brazil in 1986. *Lieber Maler, male mir...* (Dear Painter, paint for me...) (1981–83), his series of twelve paintings based on photographs, chronicles the amblings of its subject, from a bar crawl through the streets of Düsseldorf to a couch abandoned on a New York street corner. Kippenberger executed this series in collaboration with a commercial artist ('Mr. Werner', a Berlin-based film-poster painter), thus opposing the romance of the painterly gesture that is characteristic of neo-expressionism and, in the course, creating new parts for his protagonists (with Kippenberger himself reprising the role of a movie star throughout the series). Revelling in excess that contributed to his death from alcohol-related liver cancer at the age of forty-four, Kippenberger believed that one's life should be the basis for one's art, a credo that embraced self-invention as artistic lifestyle.

69 Günther Förg (1952–2013) is still recognized for the sensuous, rough-hewn paintings of monochromatic bands on lead that he produced when the predominantly male Hetzler cohort's bad-boy antics were at their most pronounced (Hetzler also bears the distinction of introducing Jeff Koons to the German public). Förg's later abstract canvases are unencumbered by his relation to this group but remain in tune with Kippenberger's

69 Günther Förg, *Untitled*, 2008

preoccupation with selfhood in the 1980s. With their prominent signature displayed in the top corner of each panel, these newer works investigate identity, and, more significantly, in their riotous colour swatches and facture, they embrace the elemental act of painting. Förg's atomistic marks evoke the activity of artmaking under the banner of the named maker as an arrangement of colours and shapes. But, like Cy Twombly's asemic scrawl (a wordless open semantic form of writing), in which calligraphic skeins that could be doodles or vines approximate but do not inhabit language, Förg's marks refuse to cohere into a legible composition or analogous statement.

Attitude

Also inspired by Kippenberger, Cosima von Bonin (b. 1962, Mombasa, Kenya) began her career by proclaiming herself 'the artist' among her circle of friends. This act – a declaration that she has spent the last decades fulfilling – manifests her interest in the social field that surrounds the artist and her objects. In the 1990s, von Bonin collaborated with critics, musicians and other artists, inviting them to contribute photos, paintings or performances to her solo shows, and in a 2010 exhibition at the Kunsthaus Bregenz, she hosted, among other things, a concert by Moritz von Oswald and his Trio, and screened a series of films on the Austrian writer and poet Thomas Bernhard. Just as Sigmar Polke (equally well known in this circle) had famously refused to attend his own openings, insisting that his paintings existed independently of him, von Bonin's withdrawal into her peer group and away from the public sphere constitutes a deliberate act of removal.

Collaboration can be understood as implicitly challenging single authorship, but von Bonin has also made artworks under her own name that include used textiles. She sources printed fabrics, felt, dishcloths and wool blankets to manufacture her so-called *Lappen* (rags) – collaged, painting-like panels emblazoned with appropriated images – as well as to tailor costumes for performances and to fabricate oversized plush toys. Yet she shies away from using these enigmatic objects to directly articulate meaning, instead allowing it to be conveyed through such framing mechanisms as text, social norms and codes of display. A 2011 show at Friedrich Petzel, New York, featured a sculpture of Pinocchio, a recurring character in her work, positioned facing the canvas almost as if it is he who is the artist. She uses this as an emblem of exaggeration and deceit, themes that she then enacted by subtitling a dark-fabric wall work with a fictional Web address.

Kippenberger's assistant, Michael Krebber (b. 1954, Cologne, Germany), has commandeered components of other painters' signature styles: Polke's readymade surfaces, Georg Baselitz's inverted figures and even the manufactured textiles favoured by von Bonin, to name a few. (In Krebber's case, patterned bed sheets and blankets are attached to stretchers without the addition of paint, though at times they also provide the background for such motifs as a prancing horse, evocative of German Romanticism.) A show in London at Maureen Paley in 2007, 'London Condom', recalled Kippenberger in its use of canvases produced by a professional sign writer. The uniformly sized black-and-white panels were imprinted with text from a recent lecture, 'Puberty in Painting', and form part of a larger series first shown at Daniel Buchholz, Cologne, under the

70

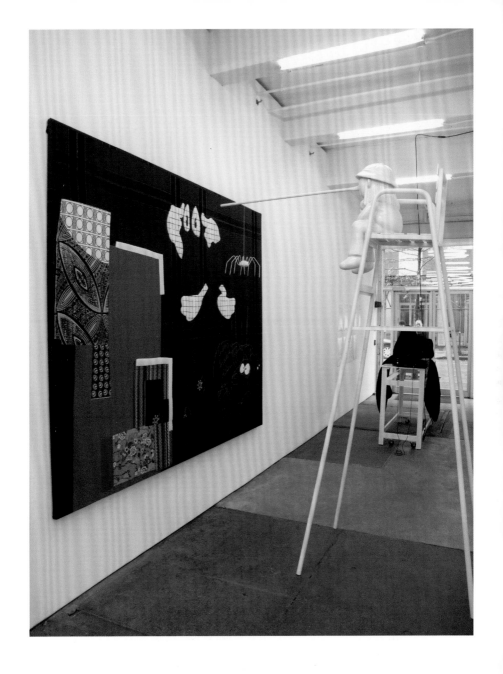

70 Cosima von Bonin, Installation view of 'The Juxtaposition of Nothings',
Petzel, New York, 2011

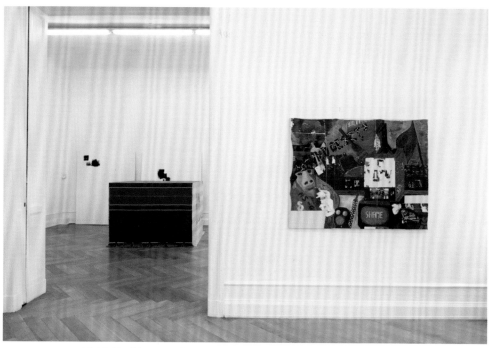

71 ABOVE Michael Krebber, Installation view of *Das politische Bild (1968/2010)* (The Political Picture), Galerie Buchholz, Berlin, 2010
72 OPPOSITE John M. Armleder, Installation view at Almine Rech, Paris, 2018

title '*Respekt Frischlinge*' (Respect Fledglings), and at Chantal Crousel, Paris, as '*Je suis la chaise*' (I am the chair). Krebber titled the works in the official language of the country in which they were shown.

Krebber turned to painting in the early 1990s, although these works are only part of his heterogeneous output, which is often less about the nature of personality than its institutional framing. Yet Krebber frequently withholds as much as he produces. At the Secession, Vienna, in 2005, he disregarded exhibition conventions and left a sizeable space vacant, thereby calling attention to the architectural envelope that organizes the display of artworks. (His titling of the aforementioned body of work in multiple languages to reflect its transit through the international art system also might be considered to achieve this.) In a text accompanying a 2010 show at Daniel Buchholz, Berlin, Krebber further challenged custom:

"*Miami City Ballet*" [the Berlin show] *shall be the first stop in, or the downbeat of, a series of "new" exhibitions following a lengthy*

period of inactivity.... I should like to perform in this exhibition that it doesn't matter what I do, whether it is good or bad, or that it conforms however to whatever criteria—the fact that I call myself an artist is enough here.

Krebber courts failure by limiting production and shunning a consistent approach. In producing anything at all, however, he opens himself to the possibility of it being deemed good or bad – whether or not he cares one way or the other (his reference to 'performance' vacillates). In 'Miami City Ballet' he included a history painting, *Das politische Bild* (The Political Picture) (1968/2010), which he made as a teenager and salvaged the year of the show, meaning that it was created before Krebber became an 'artist'.

John M. Armleder (b. 1948, Geneva, Switzerland), whose vertiginously eclectic practice has employed everything from flower-encircled scaffolding, abstract painting, wallpaper, fluorescent lights, mirrors, silver Christmas trees, limbs, stuffed animals, piles of coal and disco balls, has also exhibited grade-school doodles, including a mountain landscape that he made at fourteen. Armleder was once involved in Fluxus, an international movement inaugurated in the early 1960s, primarily in Germany and the United States, that questioned the separation between art and life by dramatizing the

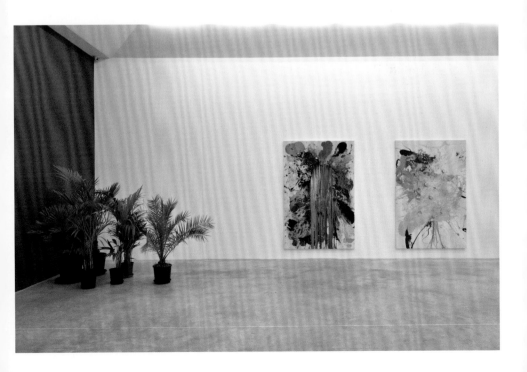

banalities of the everyday and elevating them to the level of theatre. (This often took the form of performances or events, which were categorically ephemeral, to challenge the monumentality of the art object – especially painting.) He was also a founding member of the Groupe Ecart, a collective based in Geneva, Switzerland.

Where Armleder has long accommodated all media without concession to coherence of style, or distinctions of good and bad, Anselm Reyle (b. 1970, Tübingen, Germany) has spoken of his own rebellion against good taste. He frames this as an Oedipal act against his parents, particularly his mother, an amateur artist who painted abstract works in the mid-century tachiste style, described by some as the European equivalent to the American abstract expressionist movement. Known for his subversion of modernist formalism, Reyle produces lavishly oversized, shiny, bright paintings composed of abstract stripes and silver foil, as well as mixed-media sculptures, neon installations and paintings alluding to other bad art. A recent example of the latter depicted a forlorn Yorkshire terrier, in a reference to Jeff Koons's giant flowering topiary *Puppy* (1992).

73

73 Anselm Reyle, *Little Yorkshire*, 2011

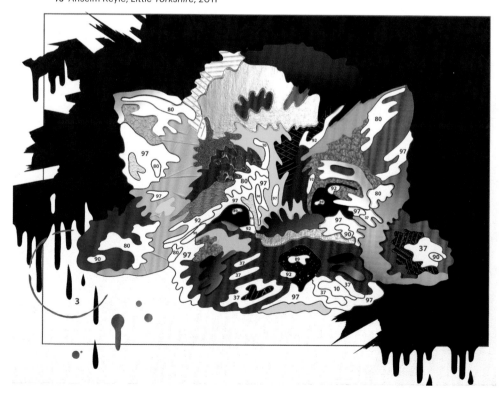

74 André Butzer, *Blauer Schlumpf* (Blue Smurf), 2009

74

A rebellious spirit is also present in the work of Dan
Colen (b. 1979, Leonia, NJ), who in 2016 began, in a flippantly
adolescent gesture, to stick saliva-slick chewing gum to oversize
canvases, on which these lumpen wads swarm in viscerally
colourful visual fields. In another rejection of conventions of
taste, André Butzer (b. 1973, Stuttgart, Germany) draws upon
Edvard Munch and Walt Disney to create garish landscapes
populated with grotesque characters: manifestations of his
'science fiction expressionism'. Then there is The Museum
of Bad Art, founded in 1994, which collects and showcases
amateur art both online and in its Boston galleries: the
criteria for inclusion is that these works have 'a special
quality that sets them apart in one way or another from
the merely incompetent'.

The moniker originally derives from a 1978 show at the
New Museum, New York, '"Bad" Painting' – curated by Marcia
Tucker, founder of the museum – and was more recently
revived in the 2008 exhibition 'Bad Painting, Good Art', held

at the Museum of Modern Art in Vienna. The Vienna show brought together over twenty artists, including Francis Picabia, René Magritte and Asger Jorn, who had rejected the assumption of good taste decades earlier. Tucker argued that despite the show's name, the exhibited works were, in fact, good painting: they simply thwarted conventional taste by mixing high and low references and savouring a preference for irreverent content. The work stopped short of conveying orthodoxies, whether the standards of academic painting in the West – with values that stem from academic training in Europe and consequently the United States, such as the relationship between colour and contour, and the creation of space – or the more immediate classicizing tendencies of minimalism; it was faux-naive, but neither subservient nor deliberately bad (like Oehlen's efforts at aping neo-expressionism, or Krebber and Armleder's more catholic assaults). Ultimately, taking up a disparaged style could provide the freedom to dismantle traditional value systems.

Objects under consideration for qualification as 'bad painting' are not consistent in type, as the terms that are used – kitsch, vernacular, amateur – and their application change over time and even within a single situation, as seen in the Vienna show above. Mutability of taste – bad bad paintings as opposed to good bad paintings – became the subject of *Thrift Store Paintings* by Jim Shaw (b. 1952, Midland, MI), a curatorial project-cum-artwork begun in 1990, which championed the outmoded. Shaw scoured flea markets and junk shops for paintings suitable for his ersatz pantheon of art. Already rejected – hence their being lost to second-hand shops and yard sales – these paintings reveal the ephemeral predilections of American middle-class taste, as well as painting as folk art. While Shaw, a consummate insider, has also faked his own thrift-store paintings, most of his specimens were initially made without awareness of the legitimizing institutions and standards that his collection explicitly set out to question.

The American artist Mike Kelley (1954–2012) also displayed an irreverence that did not disqualify sincerity. Eschewing easy condescension, Kelley preserved the meaning of the wretched, outdated or discarded, using figurines and mass-cultural materials that referenced his blue-collar Detroit childhood. Shaw and Kelley were friends (both were members of the 1970s band Destroy All Monsters, together with another University of Michigan art student, Lynn Rovner, and filmmaker Cary Loren); Shaw made down-market excursions for cast-off stuffed animals and handmade throw blankets to populate Kelley's

75 TOP Jim Shaw, *Oist Children Portrait (Girl & Dog)*, 2011
76 ABOVE Mike Kelley, *Horizontal Tracking Shot of a Cross Section of Trauma Rooms*, 2009

found-object assemblages. Although much of his work took the form of performances, installations and films, Kelley returned many times to monochrome painting. His *Timeless Paintings* (1995) reveal an interest in mid-century imagery, which he extended a decade later in a denunciation of the banal brutalities of family life and the social landscape. A 2009 show at Gagosian Gallery, New York, called 'Horizontal Tracking Shots', comprised substantial, multi-part polychromatic panels that evoke television colour bars while also looking and functioning like a stage set (thus breaking down the boundaries between supposedly high and low art). These works seemingly avoided cultural references, but behind the facade of one freestanding panel, three monitors alternated monochrome screens showing videos depicting ungainly and often merciless childhood footage found on YouTube. Like a return of the repressed, the work remains tied to pop culture.

In his challenge to normative values, Kelley deconstructs notions that established compositional structures are inherently 'better' or more correct, and that systems of representation are infallible or apolitical. Something similar might be said of Carroll Dunham (b. 1949, New Haven, CT), whose work – from early cartoon-like paintings on wood veneer

76

77

77 BELOW Carroll Dunham, *(Hers) Night and Day #1*, 2009
78 OPPOSITE Tala Madani, *Projections*, 2015

to later raunchy compositions of figures with phallic noses
and gaping orifices – contrasts the cloying colours of pop
with the baseness of its subjects. Differently engaged in
contesting the politics of representation and the authority
that underpins it, Tala Madani (b. 1981, Tehran, Iran) paints
luscious canvases and makes stop-action animations (in which
a camera records still, painted images sequentially, wiped
and created, frame by frame) depicting hirsute, barely clad
men who objectify themselves and each other and engage in
rituals of torture and idolatry. Oleaginous paint slips in and
out of coherence as material and the bodily fluids it depicts,
be that urine, faeces or semen. Paintings shown at David
Kordansky Gallery, Los Angeles, collected under the heading
'Shit Moms' (2019), conjure female bodies smeared in, or
made of, paint evocative of excrement. They are manipulated
by small children in tableaus that recall the Greek myth of
Pygmalion, who sculpted and fell in love with a statue of
a woman, which then dramatically came to life – a tale that
is here scatologically recast.

78

The Intentionality of Style

There are plenty of artists working in local traditions who have not been assimilated into a 'global' art system: the kinds of artists Miguel Calderón employed to paint his pictures, as discussed in Chapter 1 (p. 33), or whom Jim Shaw discovered after they were gone (p. 94). For *Fruit and Other Things*, a project for the 2018 Carnegie International in Pittsburgh, Pennsylvania, Lenka Clayton (b. 1977, Belper, UK) and Jon Rubin (b. 1963, Philadelphia, PA) recalled artists lost to history in a different way. Taking archival records of paintings submitted for the open calls that characterized the International between 1896 and 1931, they compiled a list of some 10,632 rejections, their records detailing artists' names as well as works' titles and dates. The artists hired sign painters to sit at facing easels in the gallery, where they painted every title in alphabetical order, before drying each painting on the adjacent walls. There they formed a horizon of language that conjured vistas for which no visual correlate survives.

79 LEFT Lenka Clayton and Jon Rubin, *Fruit and Other Things*, 2018
80 OPPOSITE Odili Donald Odita, Installation view of *Equalizer*, The Studio Museum in Harlem, New York, 2007–8

If bad painting is good painting so long as the viewer knows that the artist knows the difference, what happens in cases in which the artist's attitude, or critical stance, cannot be presumed? This might happen for many reasons, chief among which is cultural difference. However vital cities including New York, Berlin, London or Beijing might be, there has been a deep structural change regarding the nature of borders, travel and the global economy. This renders the model of a centre, or even multiple centres, all the more contingent, and the artwork produced in any one of them harder to gauge on its own terms – and then there is the matter of how the same work communicates differently to different audiences.

Although the fractured planes and off-kilter geometries of murals by Odili Donald Odita (b. 1966, Enugu, Nigeria) seem non-objective, they often reference the textiles, clothing and landscape of his native Nigeria. *Equalizer* (2007), a site-specific project that inaugurated the Project Space at the Studio Museum in Harlem, New York, takes the interactions of colours and shapes as the basis for what Odita calls a conceptual journey, based on the transatlantic slave trade and more recent waves of emigration from Africa to the Americas.

Imran Qureshi (b. 1972, Hyderabad, Pakistan) takes substantial public spaces – the courtyard of Beit Al Serkal for the 2011 Sharjah Biennial, a former dry dock on Cockatoo Island in Sydney Harbour for the 2012 Sydney Biennial and the roof of the Metropolitan Museum, New York, for a 2013

80

81

81 ABOVE Imran Qureshi, Installation view of *They Shimmer Still*, 18th Biennale of Sydney, 2012
82 OPPOSITE Shahzia Sikander, Still from *Disruption as Rapture*, 2016

installation – as ground for the application of paint in often
blooming coverts. Qureshi studied at the National College of
Arts in Lahore, Pakistan, a school founded in the 19th century
by Lockwood Kipling, father of *The Jungle Book* author Rudyard
Kipling, to train local artists. There Qureshi was steeped in
miniature painting, which he has used as a means to comment
on contemporary politics in the region. Both the artist's
miniature and large-scale painting projects respond to the
fragility of life in Pakistan, which remains subject to conflict
between different religious and ethnic groups, particularly
militant Sunnis and Shiites. Qureshi's use of paint the colour
of dried blood, applied in an ornamental, flowering pattern,
splashed or allowed to seep in viscous pools, might be seen
as a response to the cruelty of everyday life, one that differs
in meaning relative to the site of its display across different
continents and incommensurable milieus.

 The highly technical Indian and Persian miniature painting
at the National College of Arts in Lahore also formed the
82 foundation of the studies of Shahzia Sikander (b. 1969, Lahore,

Attitude

Pakistan), and her subsequent work, which juxtaposes Hindu and Muslim iconography, and has included performances exploring issues of cultural typology and dislocation. (One such piece entailed Sikander wearing a veil in public, something that she did not do prior to living in the US.) In her paintings, murals, digital animations and installations – like that exhibited in the 2013 Sharjah Biennial in the United Arab Emirates, based on the silhouettes formed by the stylized hairstyle of worshippers of the Hindu god Krishna – Sikander emphasizes the effects of wider ideological systems, whether the imperial legacy bequeathed to a region or the inherited history of an art form.

Artists can use elements of style and media to refer to their individual contexts, giving the viewer clues as to how the works should be interpreted. The Indian artist Bharti Kher

83

(b. 1969, London, UK) makes glorious abstractions out of, and covers sculptural forms with, a multitude of discrete bindis (the decorative forehead dots worn by women in South Asian culture), as signs for the bodies to which they refer. Playing a game of double signification, they also knowingly reframe a tradition of autonomous geometric abstraction: whereas this style once referred only to itself, Kher's use of these materials introduces another kind of content, pointing elsewhere, beyond the frame. In a different marriage of media and content, Meena Hasan (b. 1987, New York, NY) uses acrylic on handmade Khadi paper sourced on trips to Dhaka, Bangladesh, where her family is from, to paint the vibrant petals of marigolds – flowers that are closely associated with weddings in Bangladesh – and subjects including a series of women depicted from close range, at the nape of their necks. The use of Khadi paper relates to the

84

textile traditions of that country: the paper is made of recycled cotton rag, with a soft, absorbent texture and thick weight.

Although so many of the artists discussed earlier in the chapter deliberately hamper their facility, skill – based on learning particular ways of thinking and making – is still taught and prized at schools around the world, from Lahore
85 to Boston. Benjamín Domínguez (b. 1942, Ciudad Jiménez, Mexico), for one, has spent a long and noteworthy career using Renaissance painting techniques to depict the contemporary human body. Moreover, the continuity of style can help an artist to cater to an international market; highly motivated uses of past techniques can allow an artist to retain a deep connection to a local history and to the history of modern and contemporary art. Through an inventive approach to the calligraphy in which he was classically trained, and by experimenting with contemporary graphic design, Mohammad
86 Ehsai (b. 1939, Qazvin, Iran) manipulates Islamic texts and script into visual motifs that resonate with Shi'i symbolism and Western abstraction: notations can turn into a dense and almost illegible thicket of form.

85 OPPOSITE Benjamín Domínguez, *El Sueño II*, 2013
86 ABOVE Mohammad Ehsai, *Loving Whisper, 1973–2008*, 2008

Attitude

87 ABOVE Tsherin Sherpa, *Peace Out,* 2013
88 OPPOSITE Dedron, *Down below the Snow Mountain,* 2009

The US-based artist Tsherin Sherpa (b. 1968, Kathmandu, Nepal) studied traditional Buddhist *thangka* painting (tools for meditations and components of religious festivals, *thangka* paintings customarily depict Buddhist motifs such as the Wheel of Life, mandalas and images of the Buddha and other deities) under the guidance of his father, Master Urgen Dorje, a renowned artist from Ngyalam, Tibet. Although he went on to paint monastery murals in Nepal, Sherpa's work now depicts less-obvious subjects given this pedigree: spirits transplanted

to new-age Buddhist centres in California. In contrast, Dedron (b. 1976, Lhasa, Tibet) remains in Lhasa, where she was born and trained, and preserves the structure and sometimes the iconography of traditional Tibetan art while rejecting its aesthetics, which she revises according to modernist principles.

89 Lisa Yuskavage, *PieFace*, 2008

Lest this wielding of skill as a vehicle for preserving and critiquing traditional cultural values be seen as only happening relative to non-Western histories of form and practice, Lisa Yuskavage (b. 1962, Philadelphia, PA), John Currin (b. 1962, Boulder, CO) and Will Cotton (b. 1965, Melrose, MA) are also invested in upholding painting as a site of expertise, albeit for entirely different reasons. Though capable of painting photorealistically, they tend to distort reality, mixing technical facility with risqué subject matter. But their facility in creating compositions, modelling forms or building up glazes confuses when used to depict figures with bulbous protrusions, nudes fondling one another or sugary landscapes, and raises the question – also broached by Shaw and Kelley, Dunham and Madani – of whether transgressions of taste are, in some parts of the world, more disturbing than sexual deviation.

89 Yuskavage's coupling of technical mastery with anatomical boldness results in pneumatic female nudes, who, despite their over-developed breasts and swollen abdomens, resemble pubescent, doe-eyed children. Carefree in their self-absorption – so total that they grope themselves unselfconsciously or spread their legs with abandon – her characters inhabit homey interiors or quixotic theatrical landscapes. But for all Yuskavage's attention to detail, the scenes do not resolve within the frame; they point elsewhere, to the long history of representation of the female figure in art – so often fixed as saint or sinner, goddess or witch – and to the viewing subject, whom she provokes into imposing or refusing moral judgment. Implicit in her portrayals is the issue of whether making women available to the gaze promotes lasciviousness, and whether spectators become complicit in this, even if they are not misogynistic.

90 Yuskavage's classmate at Yale University, John Currin, shares her sympathy for misshapen physiognomy, though his strangely proportioned figures are more obviously deformed by a skewed formalism – the attempt to draw badly but paint perfectly – rather than just a cruel act of nature. This obtains despite his use of his own face and body as well as live models to flesh out scenarios taken from pin-ups, mid-century films, stock-photo catalogues and Internet porn sites. His early works – anodyne yearbook-style faces that double as veiled self-portraits, sick girls languishing in bed, women with water-balloon breasts barely contained by tight sweaters, posing with or without older male companions – raised objections that have been partly quelled by Currin's mastery of paint and flaunting of art-historical sources: old master and mannerist works were particularly essential to him, as were those by Gustave Courbet and Norman Rockwell, among countless others.

90 ABOVE John Currin, *Hot Pants*, 2010
91 OPPOSITE Will Cotton, *Cotton Candy Cloud*, 2004

Currin's first show in 1992 elicited a now-infamous review in the *Village Voice*, urging readers to boycott it on account of its sexism. His exhibition at Gagosian Gallery, New York, in 2006, only furthered the cause when he titled several paintings of group intercourse after Northern European cities – Rotterdam, Copenhagen, Malmö – designating the nationality of the nudes. He has since pulled back from these prurient fantasies. In the vein of some of his paintings from the late 1990s and early 2000s, which depict such subjects as women preparing a Thanksgiving turkey and men making pasta, he has revisited the theme of bourgeois satire.

In 2009, Will Cotton produced a number of paintings based on Thomas Cole's epic cycle of five allegorical landscapes, *The Course of Empire* (1833–36), a morality tale that visually instructs that all empires, no matter how powerful, will necessarily fall. And yet his work has otherwise disregarded such portentous overtones, tending rather to trumpet a kind of amorality unburdened by affairs of state. In 1996 he built an arrangement of foodstuffs in his studio, from which he constructed excessive painted worlds of molten chocolate, mountains of cake, peppermint hedges and lollipop trees. This cornucopia of gastronomic desire was conflated with other fleshly pleasures through his introduction of lanky female models, sometimes posing supine, like languid salon nudes, on cotton-candy clouds. Because the items decay so quickly, Cotton bases his works on digital videos of maquettes. He has since expanded this culinary conceit, producing saccharine portraits of women wearing meringue and other candy headdresses. Cotton names the pop singer Katy Perry as a muse; he illustrated her 2010 album *Teenage Dream*, and also served as artistic director for the music video of the lead single from the album, *California Gurls*.

A 'let them eat cake' mentality pervades this work and aids its circulation as a luxury good of unapologetic frivolity. Having said this, in comparison to some works of schlocky opulence – take Jeff Koons's seventeen sculptures scattered around the lavish rooms and gardens of the Château de Versailles in 2008, including a red aluminium lobster hanging alongside a crystal chandelier in the Mars Salon – Cotton's 'bad' paintings are decidedly circumspect. Questions of intent, however, registered differently later that same year, after the collapse of the financial system in 2008 and the market corrections within the art world that left many artists in a very different financial position than they had been in just months before. The 2009 recession precipitated a comprehensive accounting of which art matters beyond its cost and why. The market – itself an abstraction personalized, the same being true of corporations – became a prime target, albeit a moving one, in relation to which one might know the price of everything and the value of nothing.

Still, both before and after 2008, the idea that an artist should be committed to the work above all else – even if it ultimately (and maybe always inevitably) was marketed and traded as a commodity – remained key to the public conception of the artist as individual creator (a consideration with which this chapter began in underscoring the romance of the serious, market-averse maker in *The Price of Everything* [p. 74], as a hedge against market manipulation). It also remained central to the respect artists might have for their peers, particularly again in the 2010s as the art market boomed back. After a 2007 sale at Sotheby's, New York, of *White Canoe* (1990–91) by Peter Doig (b. 1959, Edinburgh, UK) – a painter of dreamlike landscapes that appear suspended in time, and figurative images that often dissolve into abstract motifs – for $11,300,000, curator Paul Schimmel exclaimed that Doig went from being 'a hero to other painters to a poster child of the excesses of the market'. This was then the auction record for a living European artist, but it has since been topped many times over, and plenty of careers have come and gone in collectors' speculative games of buying and dumping the art of emerging talent after inflating and then crashing their sales records.

Consequently, questions of psychological depth registered in a painting, and the intentionality or genuineness behind them, still matter – maybe even more in the face of uncertainties in the world outside the aesthetic. To cite just one notable example, the writing around the British artist Merlin James (b. 1960, Cardiff, UK), known for his historical-genre paintings that frequently picture domestic architecture and flotsam from the

92

92 Merlin James, *Two Poplar Trees*, 2009–11

past, turns on the matter of attitude. Is the work a return to a shop-worn humanism or an ironic critique of this very tradition? The distinction between humanism and critique matters because irony positions many artists as 'critical', in opposition to the market and its excesses.

This means that irony becomes an act of earnestness and protest. Until it doesn't. As with the case of Doig, the market for Christopher Wool's (b. 1955, Chicago, IL) sign-like paintings – black-and-white compositions featuring blocky, stenciled words shorn of punctuation (SELLTHE/HOUSE S/ELLTHEC/AR SELL/THEKIDS) and sometimes vowels (TRBL) – and non-representational paintings exploded in 2014, helped by a Guggenheim Museum, New York, retrospective and a ruthlessly promoted Christie's Post-War and Contemporary curated evening sale titled 'If I Live I'll See You Tuesday'. Framed in its press materials as 'encapsulate[ing] the gritty, underbelly-esque side of contemporary art', the sale was marketed with a video featuring a professional skateboarder riding through the backrooms of the auction house, past staff and the forthcoming lots, accompanied by the soundtrack of 'Sail' by Awolnation. To critics he presented a target, or at minimum, a cautionary tale: symbols of the rebel fuel the capitalist machine, after all.

93 Bjarne Melgaard, Installation view of 'IDEAL POLE', Ramiken Crucible, New York, 2012

To be sure, one might as well take a more aggressive, oppositional stance out of a keen entrepreneurial motive, to return to the marketing lessons of the YBAs (p. 73). To the point of taboo-breaking publicity stunts, witness the brutal, expressive paintings and installation works of Bjarne Melgaard (b. 1967, Sydney, Australia). Take, for example, his 2012 show 'IDEAL POLE' at Ramiken Crucible, New York, which contained live tiger cubs and art made by psychiatric patients at Bellevue Hospital – to say nothing of his racist polyvinyl sculpture of a contorted black woman under a chair, stiletto-adorned feet raised upward, photographed for public consumption for a *Buro 24/7* photo shoot with prominent Russian collector Dasha Zhukova gamely perched atop it.

The imagery was in part appropriated from the sculptor Allen Jones, a British pop artist whose engagement with explicit sexual imagery and fetish furniture used fiberglass bodies as domestic props, but Melgaard darkened the mannequins for reasons that remain unclear. Zhukova, however, offered in a public reckoning that the chair's 'use in [the] photo shoot is regrettable as it took the artwork totally out of its intended context, particularly given that *Buro 24/7*'s release of the

article coincided with the important celebration of the life and legacy of Rev. Dr. Martin Luther King, Jr.' To say the very least, this raises questions about prevailing conditions of mobility and access, meaning and the evolving authoring of content. Melgaard and his gallerist, Gavin Brown, later attempted to wrest control of the story, offering a statement that included the troubling sentiment 'that Melgaard has nothing left to portray but society in its utter decay'. Attitude may be the primary motive behind a work, then, for better or worse – and it may be used to excuse decisions regarding production, display and publicity. It is to these factors that we turn in the following chapter, which examines how paintings are made, as well as the paths they trace from that point on: how they move from studios into galleries and magazines, onto servers and phones, through chains of gossip and discourse, and between white walls, sales floors and cold-storage racks.

Chapter 3
Production and Distribution

In 1983, David Hammons (b. 1943, Springfield, IL) mounted his *Bliz-aard Ball Sale*, notoriously setting up shop as a vendor in downtown Manhattan, using the street – not the gallery – to sell fast-melting snowballs priced according to size. In a gesture mocking the covetousness of the collector and undermining the longevity of the object, the making of the work was coincident with its unmaking, but also with its exhibition and sale. In the years since, artists have continued to take on the institutions of art as a subject of their work, especially those institutions that present art (e.g. museums and galleries, far-flung and rapidly proliferating biennials and fairs), in a practice called institutional critique (also addressed in Chapter 6). As these institutions shift in nature and geography, so too do the ranges of responses to them.

This chapter looks at how art has been produced, exhibited and sold in the contemporary period, and further, how these conditions become structural aspects of the art that is created within them. Not all artists picture such connections in their paintings, though through education and networking, technology and professionalization, many more internalize institutional orders. Production anticipates distribution, and so too does distribution pre-emptively qualify production. This means that an artist might decide from the outset to compose a painting vertically rather than horizontally to fit the given dimensions of a smartphone or tablet, and to imagine that same painting as being, once completed, encountered by most viewers as a high-resolution photograph backlit on a screen, rather than seen as a physical object in a room. An artist might decide not to make a painting in a studio, but instead to fabricate it on-site in an effort to minimize crating fees and insurance costs across international borders, or to make of

94 Olivier Mosset, Installation view of *Untitled* (2010), Leo Koenig Gallery, New York, 2011

that labour an attention-grabbing, performance-based event. Or the artist might delegate this labour to other assistants in a separation of concept and execution common to the creation of architecture. Or the artist might decide not to make work at all, for a time and a purpose – or, inversely, to flood the market, to make entirely too much.

To say this differently, some artists welcome the behemoth that is the art-industrial complex, exploiting its potential for large-scale fabrication and vast channels of dissemination; others resist its demands, citing as the basis of their critique a system that sees paintings as inert luxury goods. (This now-familiar line of argument might be regarded as still another moment in a succession of the debates around painting as commodity – so lively since the 1980s – that are broached in the Introduction and Chapter 1.) Olivier Mosset (b. 1944, Bern, Switzerland) is committed to questioning the compromised nature of painting, and does so neither by deliberately exacerbating conditions, exactly, nor by ceasing production, but by continuing to paint.

Through his affiliation with B.M.P.T., a group of conceptually driven painters formed in Paris in the 1960s, Mosset and his peers – Daniel Buren, Michel Parmentier and Niele Toroni (their initials are reflected in the collective initialism) – sought to undermine authorship by signing one another's works

and repeating compositions. Since then, Mosset has turned to monochromes on shaped canvases, which implicitly comment on circuits of production and exchange. A show at Leo Koenig Gallery, New York, in 2011, brought together forty identically sized black paintings arranged in a grid. Coated with a rubberized polymer commonly used for truck-bed linings, the canvases absorbed and reflected ambient light, depending on the position of the viewer. Mosset related these works to the black hole of the art market, which sucks in everything around it.

The Studio as Commercial Workspace

If Mosset embodies one critical position relative to the art market, Damien Hirst (b. 1965, Bristol, UK) contrarily embraces another: he manipulates its free-flowing capital, seeing in this act the potential to use the market as a medium in itself. He has remained at the pinnacle of Brit-art notoriety since the debut of *The Physical Impossibility of Death in the Mind of Someone Living* (1991), mentioned at the outset of Chapter 2 (p. 73). The work was widely parodied at the time by the Stuckists, an international group founded to promote figurative art (they called fraud on the shark, noting that East London electrician Eddie Saunders exhibited a preserved shark on a wall in his J. D. Electrical Supplies shop in London in 1989), and it still provokes hostility. For one, the keen social observer I Nyoman Masriadi (b. 1973, Gianyar, Bali), best known for painting black-skinned figures with savage acuity, portrayed Hirst's shark emerging readymade from a digital file, as an object of scorn. Nevertheless, reclaiming antagonism to his work has become a pattern for Hirst, and a means for promotion. It has also led to greater market saturation inside and outside of the art world. Hirst went on to install a new rendition with a pair of two floating sharks, *Winner/Loser* (2018), at the Palms Casino Resort in Las Vegas, Nevada, in the 'Empathy Suite'. His design for the suite boasts, among other luxurious features, a cantilevered tub that overlooks the Strip. On opening in 2019, it was available to invitees with over $1,000,000 in credit at the resort, or to the general public for a cool $100,000 a night.

Typifying Hirst's engagement with the art market, in 2007 he financed and created an extravagantly priced, platinum-cast, diamond-encrusted skull with human teeth, *For the Love of God*, which became an instant icon of the artist's moxie – and which he may or may not have bought back himself in a widely publicized sale to an anonymous investment group that yielded $100,000,000. In September 2008, in an event entitled 'Beautiful Inside My Head Forever' held at Sotheby's,

95 TOP I Nyoman Masriadi, *Masriadi Presents – Attack from Website*, 2009
96 ABOVE Damien Hirst, *Winner/Loser*, 2018

97 TOP LEFT Damien
Hirst, *Oleandrin*, 2010
98 LEFT Emily Kame
Kngwarreye, *Ntange
Dreaming*, 1989

London, Hirst auctioned off 223 works finished within the previous two years, for an astonishing $200,000,000. The artist's staging of the sale was a watershed, made even more remarkable by unforeseen circumstances – by chance, the event coincided with the collapse of world financial markets mentioned in Chapter 2 – and was also notable for its management: collection highlights were sent to such outposts as the Hamptons and New Delhi, and videos were posted on YouTube, in a bid to bypass dealers and bring the work directly to the sales floor.

Despite the disapprobation that many expressed at the time, these strategies have become commonplace, with Hirst's disruption laying the ground for emergent online auctions, only some of which were tied to established auction houses or commercial galleries. In fact, businesses at varying levels are migrating online, using everything from eBay to Instagram as sales platforms, in an attempt to attract younger buyers and familiarize the activity of purchasing art at all price points to ever-expanding demographics.

Hirst has long outsourced the assembly of his work and has been frank about his commercial procedures, even publicly commending employees responsible for his *Spot Paintings*, bright circles on white backgrounds; he also redesigned his website in 2012 to include live footage of his team making new art during business hours. In 2009, at the Pinchuk Art Foundation in Kiev, and then the Wallace Collection, London, Hirst exhibited still lifes and landscapes that he claimed to have painted himself. So total has been his reliance on others to make his work that critics decried this proposition as a publicity gambit, or, more generously, considered the return to his own hand as a bid for atonement. The same dynamic played out almost a decade later in 2018, when he launched a new series of pointillist daubs, called the *Veil Paintings*, at Gagosian Gallery, Beverly Hills. The gallery material and the artist's own social media postings claimed that this represented another return to painting by his own hand – what he described in the press release as the 'human element' – but questions on this count emerged from the moment the show opened. Also troubling was the fact that the paintings, with their messier, more 'expressive' spots, look remarkably akin to the pulsating fields of overlapping colour painted by Emily Kame Kngwarreye (1910–1996) and other female Aboriginal artists working near Alice Springs, Australia: precedents, even flat-out appropriated sources, that Hirst did not name and claimed not to know of when the story broke.

97

98

Though extreme, Hirst is broadly representative in his use of assistants to execute his paintings. Few contemporary artists manufacture their own work from start to finish, and those who can afford to do so employ other artists who need day jobs to stretch, prepare or even – following their directions – execute canvases, and to manage their studios.

99 In one such example, Bernard Frize's (b. 1954, Saint-Mandé, France) bright geometric paintings are produced with assistants, among whom he divides the necessary tasks: they manoeuvre painting implements together across the work's surface in an integrated choreography. The paintings are based on systems that Frize establishes in advance, and achieved with concocted tools and techniques, like bundling brushes of different sizes together and using them to interweave colours as the tips glide across a thick, smooth layer of resin. Frize's position serves as a reminder that deconstructing authorship does not preclude physical acts of labour.

100 Even given the customary practice of distributing labour, however, Takashi Murakami (b. 1962, Tokyo, Japan), who has created an entire corporation with a global phalanx of assistants, is noteworthy. The assistants make the work and more broadly help him to maintain his brand identity: a hyper-stylized mix of modern pop, contemporary anime and manga (respectively, an animation style and a genre of comic books, both originating in Japan), which also reflects his command of traditional Japanese art (Murakami has a PhD in Nihonga painting – modern 'Japanese-style paintings' based on traditional techniques and conventions, and differentiated from Western oil painting – from Tokyo National University of Fine Arts and Music). As Murakami relayed the early stages of the corporation:

At the time [after founding Hiropon Factory in 1996]*, the "factory" was nothing more than a small workshop-like group of people assisting me with my sculptures and paintings.... As I took on new projects, the scale of my production grew, and by 2001, when I had a solo show at the Museum of Contemporary Art, Tokyo, the Hiropon Factory had grown into a professional art production and management organization. That same year I registered the company officially as "Kaikai Kiki Co., Ltd." To this day it has developed into an internationally recognized, large-scale art production and artist management corporation, employing over 100 people in its offices, studios, and gallery spaces in Tokyo, Saitama, and Long Island City, New York, as well as an animation studio in Hokkaido and an upcoming gallery space in Taipei, Taiwan.*

99 TOP Bernard Frize, *Ledz*, 2018
100 ABOVE Takashi Murakami, *727–727, 2006*

Production and Distribution

101 Aya Takano, *All Was Light*, 2012

101 Through Kaikai Kiki, Murakami also manages the careers of younger artists, like Aya Takano (b. 1976, Saitama, Japan), who re-imagines 1970s shōjo manga, a genre of Japanese comics marketed to girls, as empowering fantasies of release from social burdens of the contemporary city. Additionally, Murakami curates exhibitions promoting Japanese art and organizes an art fair in Tokyo named GEISAI. One lavish instalment of the fair, in 2008, occurred the day before the aforementioned Hirst sale took place and the bubble burst; subsequent iterations have been constrained by more modest budgets.

Murakami's 2007–8 retrospective '©MURAKAMI' at the Los Angeles Museum of Contemporary Art and the Brooklyn Museum, New York, featured a functional Louis Vuitton boutique within the exhibition space. This sold handbags and merchandise emblazoned with logos that the artist redesigned

for the luxury-goods company: jellyfish eyes, red cherry clusters and cherry blossoms alternated with the requisite 'LV' insignia in limited-edition patterns commissioned by the fashion designer Marc Jacobs. These appeared on accessories and wall panels, stretched like paintings. Lower-end items, such as cheerful flower-head plush toys, pillows and eraser heads, were available in the gift shop, while figurines and diminutive Kaikai Kiki goods in display cases were included in the curatorial content. This blurring of art and commerce led some critics to damn the concept for apparently mocking high culture. Others, more favourably, compared Murakami's varied goods to the painted screens, ceramics and lacquer boxes that Japanese artists historically held in high esteem and often created alongside other facets of their creative practice. In this way, he could be said to use the performance of his national identity as a positive means of differentiation.

Murakami is hardly alone in targeting a wide range of consumers by providing products at different price points, or in embracing fashion. His merchandise could be seen as an exuberant reframing of the Bauhaus philosophy of mass-producing design. Moreover, his collaboration with Louis

Vuitton is not unique: the company's Spring 2008 runway show featured supermodels dressed as nurses from Richard Prince

102 Louis Vuitton and Richard Prince, runway show 'Nurses', Paris Fashion Week, October 2007

paintings, sporting handbags emblazoned with the paint streaks and cartoon vignettes that feature in the American artist's joke works; in 2012 it unveiled its Yayoi Kusama collection of polka-dot-covered garments and bags; and Cindy Sherman, the Chapman brothers (Jake and Dinos) and others have also collaborated. Yet, like Hirst, Murakami's engagement with commercial enterprise is pervasive and self-referential; he constantly issues editions and maquettes, and sells small panels and preparatory drawings to lure new buyers.

Recognizing the role of his work within these broader economies, Kehinde Wiley (b. 1977, Los Angeles, CA) lent a painting to Art Production Fund's 2011 collaboration with New York City taxicabs, for use as advertising on their vehicles. In the vein of Murakami, Wiley has kept studios around the world – the US, China and Senegal – and has executed three-quarter-length portraits of young men, his signature works, for corporate clients. He began his career by portraying tracksuit-wearing African American men he encountered on the street, depicting them in poses adopted from European paintings. As an illustration of the workings of the global network, Wiley has shifted from using his primary surroundings as his source of subject matter and site of production to using sitters from different continents and making paintings in various locations. This is exemplified in the ongoing series *The World Stage*, begun in 2007, which incorporates youth from Nigeria, Senegal, Brazil, China, India, Sri Lanka and Israel. His wide travels ultimately led to his 2019 announcement that he was launching a multidisciplinary artist-in-residency programme, Black Rock Senegal in Dakar, claiming a desire for a more personal means of connecting to West Africa.

Wiley addresses skin colour and local details of costume and background (take his China paintings, which reference propaganda posters from the Cultural Revolution, or his Israeli subjects – Ethiopian and native-born Jews and Arab Israelis – whom he encircles with intricate patterns inspired by folk paper-cuts and ceremonial art). The result of his systematic approach across subject matter is one of stylistic sameness penetrated by the intensity of the sitter's personality. This was forcefully evident when Wiley unveiled a presidential portrait of Barack Obama at The National Portrait Gallery, Washington, D.C., in 2018, alongside Amy Sherald (b. 1973, Columbus, GA), who debuted a monumental depiction of Michelle Obama. Wiley depicts Obama in a wooden chair, facing forwards with crossed arms resting upon his knees, in a pose that echoes other presidential portraits, including George Peter Alexander Healy's 1869 rendition of

103

103 Kehinde Wiley, *Barack Obama*, 2018

Production and Distribution

Abraham Lincoln and Elaine de Kooning's 1963 homage to John F. Kennedy. But true to Wiley's style, the background is a thick tangle of lush foliage and blooming flowers, symbolic of where Obama has lived (chrysanthemums for Chicago, jasmine for Hawaii and Indonesia, African lilies for Kenya). The representation is attuned to a life lived amidst many geographies and cultures.

This sense of globalism is echoed in the attitude of Subodh Gupta (b. 1964, Khagaul, India). He has remarked in a statement of cosmopolitanism: 'Art language is the same all over the world. Which allows me to be anywhere.' His lavish work and its passage through so many international exhibition sites support this truism, which is underpinned by an intense privilege, despite the fact that his imagery pointedly explores economic transformations taking place in India. (To be sure – like Murakami and artists discussed in Chapter 2 [pp. 99–107], who use national style and traditional materials or techniques to position themselves in a global market – Gupta's is a specifically Indian iconography, ready for export.) Using vernacular materials – steel tiffin lunchboxes, bicycles, milk pails and cow dung – to erect such massive sculptures as *Line of Control* (2008), a mushroom cloud assembled out of kitchenware, Gupta embraces markers of place and custom while simultaneously disseminating them in the wider sphere. His early paintings explored ideas of emigration and return, presenting imagery of luggage, jerry-rigged parcels and travellers mid-transport; more recent paintings show a culture in thrall to consumerism, as in his fetishistic photorealist paintings of kitchen utensils, which depict them as both mundane and aspirational.

104

If, like Wiley, Gupta responds to and portrays globalization, he also manipulates it by using select symbols of national identity as international currency, in an individual strategy that represents larger patterns. The transit and consumption of artwork internationally both symptomizes and perpetuates globalization. This is exemplified in the nexus of interests that affected Dafencun, also known as Dafen Oil Painting Village: an entire factory town in China (just outside the Shenzhen Special Economic Zone in Guangdong) churning out handmade oil painting for international trade. Within the space of a few blocks, galleries, overflowing with wares, sell paintings of many genres and subjects. These are yielded on an industrial scale by regional artists, some of whom are trained in academies. Although local expertise in copying Western styles has contributed to tourism to the area, many more of these oil-on-canvas paintings are outsourced from elsewhere;

104 Subodh Gupta, *Saat Samunder Paar VII*, 2003

they are made on request, commonly from JPEG images, for private destinations or bulk orders to hotels, cruise ships and offices. This type of demand dropped off after 2008, and domestic buyers have since outnumbered those from overseas, contributing to a shift to manufacturing paintings from Chinese sources and cultural touchstones (e.g. portraits of Mao Zedong). In May 2017, the Shenzhen government cited almost 150 sites as fire hazards, leading to the destruction of many workspaces and rendering the village's long-term viability uncertain.

From the Easel to the Wall: the Artist and the Global Economy
In the meantime, Dafencun, its organization and its labour practices have become the subjects of other projects. For example, for the Second Guangzhou Triennial in 2005, Liu Ding (b. 1976, Changzhou, China) raised the question of exploitation in the Pearl River Delta, the event's regional focus. Liu hired thirteen painters from Dafencun to copy a factory sample

105 Liu Ding, *Samples from the Transition – Products, Part 2,* 2005–6

of a landscape with a rose sky, waterfall and pair of cranes, during a four-hour performance. With easels and folding chairs arranged in rows on a tiered platform before a live audience, the artists painted for a standard factory wage, attempting to make as many copies as possible in the allotted time. Liu later showed the paintings (which remained in various states of finish), set in uniform gold frames, in a mock 19th-century European interior at L. A. Galerie, Frankfurt, in 2006. In repeating the same banal image, the artists promulgated stereotypes of workers toiling in post-Mao China, while hinting at the opportunity for social advancement that was offered to them by their display of aesthetic refinement. Liu underscores the lingering exoticism that still colours perceptions of China in the West, and vice versa, and highlights the mutability of value of these images, especially when transposed to a German gallery replete with upholstered furniture to assist contemplation.

105

In Liu's *Store*, started in 2008, he takes a different approach to questioning the role of the artist in the new global economy. An ongoing project that explores systems of valuation under advanced capitalism, *Store* is both an online outlet for selling work – sorted according to 'product lines' – and a platform for organizing events. One such product line, *Take Home and Make Real the Priceless in Your Heart*, consists of a series of landscape paintings custom-made in a factory, but signed by the artist to ensure their symbolic, if not actual, value. By contrast, in *The Utopian Future of Art, Our Reality* – a group of vitrines, each of which holds thematically linked objects, products and works of art – the differences in value between the objects are levelled out, with items priced equally as a division of the total value of each cabinet and its contents.

106

'China Painters' (2007–8), by Christian Jankowski (b. 1968, Göttingen, Germany), was first exhibited in the Guangdong province (where the painting village is located, as well as the state-run Dafen Art Museum) before travelling to New York, Vienna, Stuttgart and lastly Guangzhou for the eponymous triennial. Jankowski asked Dafencun painters to create paintings of the as-yet unfinished interiors of the nearby Dafen Art Museum, a modernist shell then under construction

106 Christian Jankowski, *China Painters (Still Life)*, 2008

(the architects of which were unaware of what kind of art the building would later house). The Dafencun painters were asked to add to each of their portrayals the artworks they would most like to see displayed in the museum. The selections made in their paintings, with 'fantasy' artworks gracing the partially constructed walls of the museum interior, extended from 17th-century Dutch still lifes of flower arrangements to history paintings, including Eugène Delacroix's *Liberty Leading the People* (1830), in addition to family portraits and nudes. Although Jankowski includes the artists' signatures on the backs of the canvases – important, given the painters' designation as artisans – his authoring of the project is paramount. As with Liu, this depends on appropriation of the Chinese painters' work on the project, despite the authorial role they inhabit within it.

These instances also point to the ways in which large-scale exhibitions encourage event-like, multimedia and collaborative projects, which are commissioned for the occasion. These shows solicit site-specific interventions that account for not only the architecture, but also the cultural, geopolitical and commercial contexts surrounding specific objects and installations. Ragnar Kjartansson (b. 1976, Reykjavik, Iceland) is noteworthy for his understanding of the biennial as a flexible format that allows for a range of possibilities under its broad umbrella. Like Liu, he proposed a scenario in which paintings would be made before an audience, but, unlike Liu,

107 OPPOSITE Ragnar Kjartansson, *The End – Venice*, 2009
108 ABOVE Josh Smith, Installation view of 'Emo Jungle', David Zwirner, New York, 2019

the project he envisioned took place for the duration of the show, effectively marking the passage of time through the actualization of paintings.

107 For *The End*, performed during the 53rd Venice Biennale in 2009, Kjartansson spent six months making easel paintings inside the 14th-century Palazzo Michiel dal Brusa on the Grand Canal. The resultant works show artist Páll Haukur Björnsson in a Speedo swimsuit, drinking beer and smoking cigarettes. Kjartansson paired the tableau vivant (living picture) of his act of creation with a video projection of two men playing music in a dramatic snowy landscape. This was in part inspired by a Caspar David Friedrich painting, which depicts two men gazing in rapture at the moon: a paean to friendship and the notion of how representation, including in art, can surpass the rational and reach the sublime. Unlike the Romantic vision proposed by Friedrich, however, *The End* resulted in a space littered by studio debris, including the paintings, which Kjartansson conceived of not as autonomous panels but as props.

108 When the measure is time, and the goal is to accumulate lots of pictures, quantity rather than quality rules. Josh Smith (b. 1976, Okinawa, Japan) exploits the possibility of exhaustion through excess, churning out prodigious numbers of artworks based on his name, which is used as an abstract, formal trope, and, more recently, figurative motifs including fish, insects,

skeletons and leaves. Smith has admitted to completing the work for a show in a week. His output exposes the unhampered possibilities and excesses of contemporary production, pantomiming the superfluity of the billions of digital images circulating each day.

Smith's output imitates its setting, including, on a more local scale, the commercial gallery and its seasonal sales cycles. For his first solo exhibition in New York, 'Abstraction', at Luhring Augustine in 2007, he hung paintings in standardized sizes, upon which pricing was based: sizeable gestural compositions featuring the repetition of letters, and smaller palette paintings, which constitute palette boards painted with colour fields that were left behind when Smith used them to generate other paintings. During the exhibition, he also switched paintings and reconfigured the installation with new works, some painted midway through the show. This challenged the viewer to remember differences between comparable canvases and ask why they should matter.

Smith is also known for his collages of printed images of previous works, sometimes downloaded from his own website, which interrogate art as an iterative process, hypothetically without end. In turn, Eliza Douglas (b. 1984, New York, NY) made a series of large-scale paintings called *Josh Smith*, depicting a 2016 opening of his work at The Brant Foundation Art Study Center in Greenwich, Connecticut, in which his giant paintings are shown dwarfing the collectors who mill about them. (Smith took up residence there for nearly a month, converting it into a studio where he made the work on view.) For her part, Douglas relies on Dafencun painters to fabricate some of her paintings.

In the early 2010s, Parker Ito (b. 1986, Long Beach, CA), like Josh Smith, created art quickly to simulate better the mass production and consumption of images on the Internet. As he put it: 'I heard that Picasso made around 250,000 works in his lifetime. I could make that many JPEGs in five years.... And when I say five years, I mean five minutes.' Assistants (and even, on occasion, his gallerists' children) help him to make and install digitally edited canvases and sculptures, and he pumps out work in considerable volume, in distinctive and often-evolving installation scenarios. These entail the migration of

109

110

109 OPPOSITE Eliza Douglas, *Josh Smith*, 2019
110 BELOW Parker Ito, Installation view of 'A Lil' Taste of Cheeto in the Night', Château Shatto, Los Angeles, 2015

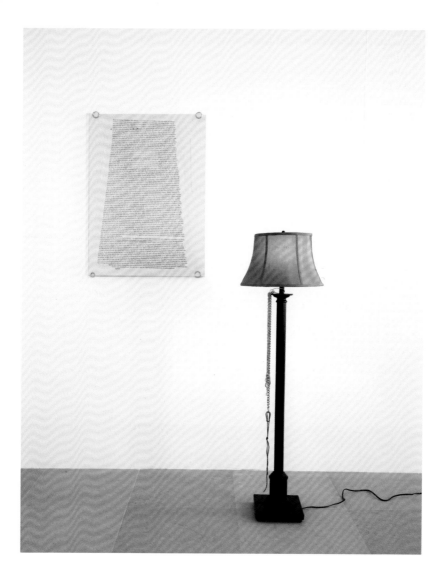

111 Josef Strau, *What Should One Do*, 2011

elements to multiple sites, across which they are transformed and layered. Adding yet another facet to the work, Ito sometimes uses pseudonyms and media personas, including Deke McLelland Two, Creamy Dreamy and Parker Cheeto.

While these artists have embraced producing en masse, others have taken the opposite approach, ceasing production as a form of critique. In the Cologne scene of the 1980s and 1990s (examined in Chapter 2, p. 86), interruptions in production were embraced as institutional critique and a refusal to undergo commercial validation. Subverting the idea that production of cultural goods is automatically uncritical, Josef Strau (b. 1957, Vienna, Austria), an artist, curator, gallerist and writer now based in Berlin, has questioned what he calls the 'non-productive' attitude. His catalogue essay for the 2006 exhibition at the Institute of Contemporary Art, University of Pennsylvania, 'Make Your Own Life: Artists In and Out of Cologne', challenges the Cologne group's approach. For Strau, turning to sociality and away from object-oriented practice was a manifestation of a 'narcissistic cultivation of insignificance and meaninglessness', an approach that was ultimately recuperated as style in the sense of both attitude and the formal properties of the resultant work.

Since closing Galerie Meerrettich, a small space he ran out of a former box office in a Berlin theatre from 2002 to 2006, Strau has focused on his writing, found-object sculptures and paintings. Many of the latter consist of a monochrome ground washed with a dirty white paint that serves as the base for texts penned by himself and others. His work moves from projects like the ones he examines in his writing – conversations, performances, ephemeral comings together – to those that take the form of room-bound objects. The refusal of the object that marked his earlier career does not persist in his current practice. In a 2010 interview published in *Mousse* 23, Straus expounds:

I have explained works in economic terms, like I make texts, but I organize a trade system for it, which maintains the practice and writing financially, like transforming flea-market lamps into a system of meaning and narratives and producing financial value through this.

In this way, while his work now is more bound to the object, Strau still enacts a kind of critique of the commodity, achieved by transforming what is essentially detritus – such as secondhand lamps – into something that can move within the market.

Correspondingly reliant upon the art system, Aaron Young (b. 1972, San Francisco, CA) digests production differently, by transforming it into spectacle. For the inaugural contemporary-art exhibit at the Park Avenue Armory in New York in 2007, Young staged *Greeting Card* with the help of the Art Production Fund. Taking its title from a 1944 Jackson Pollock painting of the same name, Young enlisted a gang of motorcycle riders to act out the gestures of Pollock's action painting. In the enormous, Coliseum-like space of the Armory, hundreds of invited art-world guests, donning gas-masks, looked down on the performance in the central arena: for seven deafening and noxious minutes, the bikes criss-crossed a 21.9-by-39-metre (72-by-128-foot) plywood stage, their lights cutting through the exhaust fumes and darkness. The wheels burned arabesques in the black surface that revealed layers of fluorescent yellow, pink, orange and red paint beneath. In the aftermath, the floor remained intact as an installation before being dismantled and sold as single or multiple tiles, thus following the trajectory of Pollock's paintings from horizontal, floor-bound panels to completed paintings tacked to walls.

Rudolf Stingel (b. 1956, Merano, Italy) has likewise employed a variety of strategies to make and circulate his work, such as having viewers walk across floors that are then cut up and sold as discrete paintings. A long-time painter of commissioned portraits, in the 1980s Stingel began work that provoked the fundaments of painting as both a medium and a set of conventions. For instance, in 1989 he published an instruction manual for creating an abstract painting. The silkscreen print *Instructions* treats this 'how to' process as a composition, showing paint being squeezed from a tube and applied to a support. For his first show in New York in 1991, at Daniel Newburg Gallery in SoHo, Stingel covered the entire floor with plush orange carpet, which, in an optical contrast, tinged the walls pink, thereby turning the whole room into a painting. Successive undertakings have also moved painting beyond the canvas in order to interrogate it: formally (from carpets adorned with pink-and-blue floral motifs, as installed at the Walker Art Center in Minneapolis and even in Vanderbilt Hall in Grand Central Terminal in New York City, to other monochromes that found their way onto the walls, which had begun as studio drop-cloths), and theoretically, through viewer involvement (later works comprise wall-mounted silver Celotex insulation boards on which people can leave graffiti-like marks, and Styrofoam 'footprint' paintings that register the marks of bodies).

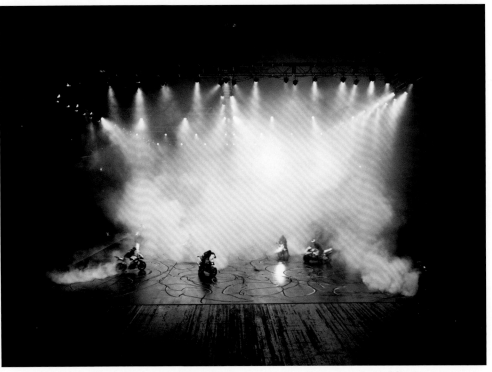

112 Aaron Young, *Greeting Card (Armory, quadriptych)*, performance at the Park Avenue Armory, New York, 2007

Stingel maintains his works' materiality, while asking how a painting, as both image and object, moves through institutional and commercial spaces. This passage can also encompass conversion by other media, such as the compression of electronic files when images are spread through media-sharing and social-networking sites. In *Dispersion*, an influential manifesto drafted in 2001–2 for the catalogue of the Ljubljana Biennial of Graphic Art, later published as an artist's book illustrated with clip art and posted online as a free download, Seth Price (b. 1973, East Jerusalem) discusses the circulation of art by mass-media technologies, which have had an incalculable impact on painting. He writes:

With more and more media readily available through this unruly archive [the Internet]*, the task becomes one of packaging, producing, reframing, and distributing; a mode of production*

113 Seth Price, *Untitled*, 2008–9, from the *Vintage Bomber* series

analogous not to the creation of material goods, but to the production of social contexts, using existing material.

Price's use of appropriation in his work, which often redistributes pirated music and texts in addition to archival footage and data from the Internet, interrupts the functioning of commodity culture and the information systems on which it depends. Much of Price's work, therefore, avoids permanence, as the permanent risks ossifying. This is addressed literally in his *Vintage Bomber* pieces, wall-hung polystyrene panels that bear the outline of their namesake bomber jackets: garments frozen in form by consumer packaging. Yet his point is that even these works remain mobile, circulated through a constant network of objects, images and ideas; they also assume new meaning through their relationship to the legacies of painting, to which they refer most obviously in their wall-bound orientation.

113

Networks of presentation and display, and the shift in meaning that these lend to images, are a key concern of German artists Kerstin Brätsch (b. 1969, Hamburg, Germany) and Adele Röder (b. 1980, Dresden, Germany). The two have worked together since 2007 as DAS INSTITUT, a so-called import/export agency (typically, this service would assist a business in transporting and/or selling their products in a foreign country), and they have collaborated with such groups as the UNITED BROTHERS (Ei Arakawa and his brother Tomoo Arakawa) for a project at the Kunsthalle Zürich in 2012. Brätsch and Röder maintain their own individual art practice, and additionally, they collaborate to funnel work back and forth, importing and exporting files, while also playing with the tools of the digital systems through which data is transferred. Röder makes abstract digital motifs, such as 'Starline-Necessary Couture' and 'COMCORRÖDER', using programs like Adobe Photoshop. These are applied as patterns for a host of products, including wearable and non-usable textiles, a digital knitwear collection, dinner napkins, DAS INSTITUT advertisements, books and Brätsch's paintings on Mylar. In the latter, Brätsch inverts and manipulates her sources in the service of the final composition, and continuing this circuit of production, Röder often uses these alterations in her digital prints. While interrogating presentational conventions across media, the artists also exploit the consumer's desire to express uniqueness through purchase. In an artist statement, Röder exclaims, 'MY FORMS BECOME A MANIFESTATION OF YOUR DESIRE'. Flexibility becomes an expression of economic and creative boundlessness.

As DAS INSTITUT proposes, transitivity can be positive: in artwork relating to digital transformation, software can be employed as both an instrument and a metaphor. Their work is all-encompassing, transforming the immaterial images of the Internet into tangible materials – the aforementioned paintings, textiles and napkins – through which it might become a *Gesamtkunstwerk* (a total work of art in which all art forms are embraced and synthesized). This is by no means the first combination of painting and digital media: both were prominent strands in the work of Michel Majerus (1967–2002), who saw the manipulability of the latter as a way to reconfigure the former. He also extended the space of his large-scale paintings into the room, making a virtual space tangible, and in 2000 he made a functional painting in the form of a skateboard ramp at the Kölnischer Kunstverein. For his last piece before his untimely death, he covered Berlin's Brandenburg Gate with a digital rendering of the Schöneberg Sozialpalast, a 1970s Berlin housing block now covered by graffiti. Analogous to the swift and continual feedback offered by the Internet, graffiti tests mechanisms of call and response, and could be considered a forerunner of the digital forum.

114 BELOW Michel Majerus, *if we are dead, so it is*, 2000
115 OPPOSITE Tom Moody, *sketch_i7a*, 2012

Machine Painting

As these artists propose, post-studio practice involves an intersection of new technologies – alongside the media theory, information science and philosophy that theorizes them – as the basis for rethinking painting digitally. The American artist and critic Tom Moody (b. [unlisted], New York, NY) carried out bright, imagistic paintings earlier in his career, but abandoned these following a bout of turpentine poisoning; he now adapts the animated GIFs on his blog for display and since the 1990s has made cyber art with obsolete programs and equipment, such as MSPaintbrush (the earlier version of MSPaint), photocopiers and consumer printers. Corinne Wasmuht (b. 1964, Dortmund, Germany) procures images from the Internet for manipulation via Photoshop, before using them as the basis for multi-layered paintings on wood panels, which acknowledge their source in their backlit intensity – an echo of the computer monitor glow.

115

116

116 ABOVE Corinne Wasmuht, *Brueckenstr.*, 2008
117 OPPOSITE Harm van den Dorpel, *On Usability*, 2011

117 Harm van den Dorpel (b. 1981, Zaandam, The Netherlands), based in Berlin, appropriates original images and alters them via algorithmic recombination online to make new artworks. Other works are commissioned images that look painterly online but are printed out. Van den Dorpel is best known for running an online gallery in 2008–9, 'Club Internet', which offered a stage for emerging artists to share their work. Now outmoded compared to other social media sites, it nonetheless emphasizes artists' relations to one another. More recently, he has created an online platform on which visitors can view his works, as well as the means by which he finds and aggregates source images for his layered compositions.

 Van den Dorpel's 'Dissociations', an online-only exhibition, is hosted by the New Museum, New York. Posing the question of how an artist's work might be presented to a public, the museum notes on the webpage for 'Dissociations' that:

Possibilities run the gamut from the "white cube" aesthetic donned by gallery websites to the more free-form, anarchic expressions of a Tumblr page, or a simple, home-brewed interface. Through such projects, we can generally see the work in some form (whether sculpture, video, or a Firefox plug-in) as well as what an artist persona looks like online (as opposed to, say, that of a corporation). We can even approximate what an artist's brand might be amid the digital swell of marketing and self-presentation (for instance, evasive user interfaces instead of clean, user-friendly ones). In more experimental modes—think collectively built archives or an artist's blog that doubles as a public sketchbook—artist websites

flout individual authorship and singular finished products that are
closed to the public. And yet the question remains of whether it is
possible to evince more than the artwork itself, to reveal the whole
practice: the research, the influence, and what it's like to make
work over time.

Like the large-scale exhibition system, the Internet acts as
a platform to show works, events or documentation, while
also performing as a secondary system of distribution. This
establishes an alternative audience that may have nothing to
do with the narrowly conceived 'art world'.

 As van den Dorpel's example evidences, artists may also use
in-machine technology to design a composition and print it
out (recall here Wade Guyton, discussed in Chapter 1, p. 66) or
they may even harness technology to do the work of painting.
David Hockney (b. 1937, Bradford, UK), the great chronicler of
domestic intimacies and the California leisure class, returned
to the East Yorkshire of his youth in 2005 to paint landscapes
en plein air, which he then worked up on the computer in the
studio. He also began a corpus of iPhone paintings in 2009,

118 LEFT David Hockney, *No. 522*, 2009
119 OPPOSITE Joshua Nathanson, *David Gets a Cupcake*, 2015

made with the Brushes application on his handheld device. Dragging his finger across the screen, Hockney composed diminutive scenes – self-portraits, portraits, flowers and sunrises – which he modified by hue and the application of details; he then archived the images and passed them on to friends. He has also made paintings without paint using a stylus on his iPad, created sizeable prints with a digital inkjet printer and, applying the playback feature in the Brushes app, turned out videos that reveal their underlying process. While some of these works have moved into physical space, the iPhone paintings remain wholly digital in their generation and presentation, especially as the luminosity of the images is achieved solely by means of the screen.

Joshua Nathanson (b. 1976, Washington, D.C.) also uses computer drawing software. 'Labor Day' at VSF, Los Angeles, 2015, featured a series of paintings based on the beaches of Los Angeles and a popular outdoor shopping mall with a public green and animated fountain. These scenes of small freedoms

from labour recast George Seurat's *A Sunday Afternoon on the Island of La Grande Jatte* (1884) in a Microsoft Paint aesthetic through a process of outdoor sketching, digital working over, inkjet printing and, finally, painting, which takes a cue from Hockney. Decoy-like, the resulting paintings on canvas preserve the textures and Technicolor palette of their digital forbearers in the image-making process.

It is therefore clear that painting on-screen and off are not mutually incompatible; indeed, a combination is often desirable for contemporary artists engaged in process as a concept. This is true of Michael Williams (b. 1978, Doylestown, PA), whose work in this vein can be traced to his *Puzzle Paintings* (2010–17). These emerge from a comparatively traditional method of drawing and painting based on sketches. Williams uses a photocopy of a drawing he already made and sections it into interlocking pieces with a pencil, before cutting it apart and redrawing it, and then sometimes using it as the basis for an oil painting. If these oil paintings physicalize process, the inkjet-printed paintings on pre-primed canvas

that Williams has made since 2012 propose another model of genesis. Decisions are made on a computer or digital-drawing pad and then printed, at which point Williams sometimes layers hand-applied strokes onto the print and sometimes leaves it unaltered. In *Middle Game 1* (2018), the result is a prostrate towel-draped man who appears to merge with an oversized rotary telephone the colour of his skin. Face down in overstuffed pillows, his delineated body hovers off-kilter, an illusionistic mass without weight capable of denting the covers: a wry meditation on the lightness of being in a painting without paint. Another work from the year before, *Truth About Painting 2* (2017), takes another approach to allegorizing the creative act, by showing a group therapy session for paint tubes taking place in chairs in the artist's studio.

In a 2018 show at David Kordansky Gallery, Los Angeles, Williams framed his engagement with the long history of painting as if his works are prosthetics, bolstering, rather than undermining, the authority of analogue painterly practices. He appropriated a quote from futurist and computational neuroscientist Anders Sandberg as the show's epigraph:

120 LEFT Michael Williams, *Truth About Painting 2*, 2017
121 OPPOSITE Simon Ingram, *Radio Painting Station: Looking for the Waterhole*, 2017–18

In the truly long run stars burn out and cease to form (in a few trillion years), so that is the end of normal planet-life. We can likely make artificial heating lasting much longer but over time energy will become scarce. Living as software would give us an enormous future in this far, cold era but it is finite: eventually energy runs out. If not, we still have the problem that matter is likely unstable due to proton decay on timescales larger than 10^36 years—one day there is not going to be anything for humans to be made of. That is likely the upper limit.

Sandberg's analytical appraisal of humankind prolonging a finite existence through adaptation – living as software – is a continuation of the already symbiotic relation between species and technology. Rather than revel in the eschewal of the analogue for the digital, Williams keeps hold of the analogue but tactically re-motivates it, adapting to and embracing the digital age.

 In his longstanding engagement with painting and computer science, Simon Ingram (b. 1971, Wellington, NZ) has made numerous painting machines, ingeniously fashioned from consumer-grade robotics kits, industrial robotic arms and other custom hardware and electronic components. He frames this as an act of collaboration between himself, an apparatus and lived experience. He does not paint directly, but rather builds

121

122 LEFT Siebren Versteeg, *A Rose*, 2017
123 OPPOSITE Obvious, *Portrait of Edmond de Belamy, from La Famille de Belamy*, 2018

machines to do this tactile work: his *Radio Paintings*, exhibited as early as 2011, powerfully express forces channelled through a radio telescope that Ingram developed (and which he displays for viewers, as at ZKM Center for Art and Media Karlsruhe, Germany, 2017–18). A 4.2-metre-tall horn antenna collects spectral emissions from atomic hydrogen in space, and this data is interpreted by electronics and software as a series of brush routines for a painting robot to carry out in oil on canvas, harnessing and visualizing otherwise invisible cosmic radio energy.

Among his many projects, Siebren Versteeg (b. 1971, New Haven, CT) also shares the artist's mark with the computer, using algorithmic programs: one trawls for images online, distorting and compiling them into abstract compositions;

another generates randomized gestural marks and colours, a process that Versteeg pauses at a certain point to print out the result onto canvas. Those achieved by *A Rose* (2017) reveal variations on Jay DeFeo's *The Rose* (1958–66): a silvery mixed-media painting that consumed the artist for the better part of eight years and weighed more than a ton. Versteeg's canvas prints are made more quickly and are comparatively buoyant. Far from hidden in a studio, he, like Ingram, chooses to reveal the mechanisms at play: he exhibits an active program in the gallery together with the rest of the work.

Alongside artists working with technology, the emergence of neural networks has resulted in art made separately from the human. Beginning with the swirling, psychedelic art coming from Google DeepDream (a computer program that uses a neural network to find and enhance patterns in images), technicians and artists have fostered new applications for emergent technology, raising the question as to whether this art is a tool or its product. The latter was claimed in 2018, when, for the first time, a piece created by AI came to auction; it sold at Christie's for $432,500, well over the estimate of $7,000 to $10,000. The *Portrait of Edmond de Belamy, from La Famille de Belamy* (2018) appears to be a portrait of an aristocratic man, but the pictured figure is one in a group of portraits of the Belamy family – a fictional creation of Obvious, a Paris-based

collective anchored by Hugo Caselles-Dupré, Pierre Fautrel
and Gauthier Vernier. Using generative adversarial network
(GAN) machine learning systems that do not find and enhance
but rather generate images, the artists fed the system with
a data set of 15,000 portraits made by human artists between
the 14th and 20th centuries. The GAN machine learning system
then generates the image itself, based on this data. The artists
feed the portrait back into the same system, to see if it mistakes
its own work for a historic portrait. The goal is to create, from
scratch, a portrait so convincing that the system thinks it
is real.

Perhaps unsurprisingly, this work has engendered a robust
conversation about what creativity is, to whom it belongs and
from whence it originates. For the algorithms are effected

by programmers, and a GAN can only perform a certain task using the data through which it was trained. Counterintuitively, then, rather than negating human agency, these changes in technology – to say nothing of information access, retrieval and transference – position the subject, or human agent, at the centre of real and virtual worlds. The artist must not only make sense of this, but also decide whether and how to put it to use, and what they hope to achieve in doing so.

In some ways, the computer age is one of increasing disconnect, as demonstrated by the discussion in Chapter 1 of the problems wrought by taking materials from online sources that are not one's own, and the trumping of interiority for self-presentation that is explored in Chapter 2. Yet the digital revolution still offers a profound possibility for personal connection. In one such example of this being provided through, and not despite, machines, Manuel Solano (b. 1987, Mexico City, Mexico) uses an app to connect with sighted people who can help the un-sighted artist to see paintings in progress. Solano, who at first painted highly detailed oil-on-canvas paintings, became blind in 2014 as a result of an HIV-related infection, and marked a return to painting that same year with a series of deeply personal portraits entitled *Blind Transgender With AIDS*. Memories of 1990s pop culture seen before this event thread through the series, suggesting an ever-widening historical lag. The versions of these personalities in the works emanate from what is for Solano a finite image bank, accessed only in the mind, even as the recognizable people and events abet the possibility of collective recognition. To make the paintings, the artist works by hand, feeling the surface of the canvas and indicating sections with a felt marking system of pins, string, tape and pipe cleaners. Solano relies on someone in the studio (often their mother) to confirm the rightness of a colour or the legibility of a pictorial aspect, and if no one is present, connects to 'Be My Eyes' to establish a video call with a volunteer to accomplish the same thing. Solano's work engages with what it is to be human in a world awash in images, whether experienced first-hand or internalized from elsewhere; either way, we access and interpret these images through the body and subjectivity, memory and consciousness.

124

Chapter 4
The Body

This chapter attends to the body, both imagined and real. In art, observations of the human form can be presented through figure painting or portraiture. The first takes the human form – clothed or naked (elevated in art to the 'nude') – as its primary subject, and the second narrows in on a subject's face or head and shoulders. Such works would ordinarily reveal the subject's form, and also the hand of the artist, but in a period so thoroughly transformed by technology, figurative art is no longer solely the dispensation of humans. The mechanically produced imagery introduced late in Chapter 3, the GAN (generative adversarial network) that contributes to the domain of portraiture by mimicking the data distributed to it (p. 152), announces this profound and extraordinary shift. With myriad forms of mediation now available, when contemporary artists continue to favour observation and the representation of a person, the decision takes on new meaning.

Alongside realism, this chapter explores the refusal of verisimilitude. Such positions are arrived at through various means, including photographic appropriation, the direct scrutiny of a live model and the conjuring of a form from fantasy or memory. The last importantly implicates the lived experience of the artist: think back to Manuel Solano, presented at the end of Chapter 3 (p. 153), who became blind due to illness, and resumed painting – newly reliant on physical cues and the sightedness of others – by recollecting memories of things once grasped first-hand. The artist's body may also be illustrated within the frame, or conversely, registered in indexical traces resulting from the physical procedures of painting. This point holds true even in abstraction (as covered in Chapter 5), which aestheticizes marks of process as part of the composition: an action and its result. But equally, abstraction may help

125 Pamela Rosenkranz, Installation view of 'The Most Important Body of Water is Yours', Karma International, Zürich, 2010

125 artists to avoid anthropocentrism, instead passing agency to bodily surrogates. In a 2010 series, Pamela Rosenkranz (b. 1979, Sils-Maria, Switzerland) made body-prints on bright, monochromatic Spandex grounds, grimly stretched on the wall as if they were flayed hides. She made use of the synthetic fabric – ordinarily used for form-fitting exercise clothing that, more than concealing any corpulence beneath, expands to meet it – to conjure ideas of an otherwise non-existent body. Smeared with flesh-toned residue that evokes makeup, these works sum up figurative painting as so many surfaces of skin.

Rosenkranz's layering of bodily signs atop single-coloured panels rather literally overlaps traditions long held apart. For much of the 20th century, figuration and abstraction were posed as mutually exclusive propositions in Western art. Figurative art had previously primarily been concerned with the Renaissance standard of mimetically reproducing the visible world, stroke by stroke. With the 20th century, this goal of lifelikeness was diverted by the philosophical and aesthetic adventures of cubism. Abstraction even more decisively broke from figuration, rejecting the genres of the studio portrait, nude, still life and landscape – upon which cubism had relied – in favour of formal experimentation

with colour, shape and volume. Moreover, figurative art was contaminated in the 1930s by the uses of the idealized body for Fascist politics, notably in Germany and Italy. Movements including surrealism and pop were the exceptions that proved the rule of abstraction's triumph: after its rise, little figurative art was assumed to count as 'high art' until neo-expressionism. Figurative work persisted throughout, of course, before and after the 1980s; the issue is not one of the category's existence, but rather of its significance.

In a talk titled 'Renaissance and Order', delivered in New York in 1949, abstract expressionist Willem de Kooning claimed: 'Flesh was the reason why oil painting was invented'. His work – particularly his *Woman* series of the early 1950s, comprising paintings of women emerging from oily strokes, with bared teeth and ardently outlined breasts – is a counterpoint to absolutist arguments for a breach between figuration and abstraction. Nevertheless, this sense that the ideas oppose has deep roots in superstitions and religious traditions fearing idolatry and graven depictions, or images that are worshipped like gods (for example, Islam is thought to be an aniconic religion, meaning figurative images are prohibited; iconoclasm in 8th- and 9th-century Byzantium opposed religious images or icons, a stance that was later revived during the Protestant Reformation). This is an important reminder of the coexistence of different genealogies and the beliefs that underpin them.

Throughout, the body has repeatedly proved a site of strife, and contestation of its social and political agency extends to its images. While in the past figurative work had often reinforced the status quo, it has also become a tool to deconstruct it: one such example is through feminist rejoinder to the likes of de Kooning by artists including Jenny Saville (p. 184) and Cecily Brown (p. 185), checking the misogynistic fantasies that he and his colleagues perpetuated. Figurative work has served a great many agendas, including as a vehicle for expressing political sentiment and disparaging regimes, challenging generally accepted history – often crafted by the oppressor – and posing alternate futures.

126 Amoako Boafo's (b. 1984, Accra, Ghana) portraits assert agency in the face of potential dissolution. His quietly dignified, luminous tributes to diasporic identity emerge from an encounter with European racism. Specific to Vienna, Austria (where the artist has lived for several years), and the lives of his peers there who he renders, Boafo's project further connects to a broader history of slavery and migration. Racism persists, enacting a terrible violence on the body, even as race

126 Amoako Boafo,
Reflection 1, 2018

is something more societal and constructed – a product of
and justification for subjugation – than inherent to the body
itself. (For this reason, whilst referenced in this chapter, it is in
Chapter 7 that this subject is regarded more fully, through the
forceful interventions of a number of those artists who actively
address race in their work by revealing the actualities of lived
experience.)

Thus is the space of representation now taken by subjects
who have long been excluded from the privilege of being
portrayed in figurative art on account of their gender, sex or
race. Such priorities have served as an antidote to the process-
based minimalist paintings, conspicuously absent of content,
that were popular in the 2010s (as discussed in Chapter 6,
p. 270). This shift moreover relates to the late acknowledgment
on the part of so many cultural institutions in the West of the
narrowness of their collections – and a compensatory desire
to redress these oversights, through offering (in some cases
for the first time) a less exclusive range of perspectives. For
institutions, this means turning a lens on the vested interests
that led to their formation; it also means considering for whom
they continue to exist and why.

The Body

127 TOP Neo Rauch, *Die Lage*, 2006
128 ABOVE Christoph Ruckhäberle, *Nacht 32*, 2004

Painting History

Bias against representational practices was shaped by Cold War propaganda in the former German Democratic Republic, yet artists from what was the Eastern Bloc have claimed this legacy, whether as the basis for bad painting (see Chapter 2) or otherwise. Artists in Leipzig, in particular, were championed in the mid-2000s for their preservation of academic figurative traditions within a reunified Germany. At the time, many equated their arrival on the international scene with the neo-expressionism flooding galleries in the 1980s: kindred instances of a return to order in the face of pluralism and globalism. Collectors aggressively promoted artists such as Neo Rauch (b. 1960, Leipzig, Germany), David Schnell (b. 1971, Bergisch Gladbach, Germany), Martin Eder (b. 1968, Augsburg, Germany), Christoph Ruckhäberle (b. 1972, Pfaffenhofen an der Ilm, Germany), Tim Eitel (b. 1971, Leonberg, Germany) and Matthias Weischer (b. 1973, Elte, Germany) under the banner of the New Leipzig School, since they studied painting at the esteemed Hochschule für Grafik und Buchkunst and remained in the city thereafter.

There are differences in their work, yet the Leipzig artists are affiliated in education, age and painterly orientation. They formed a league in 2000 and a gallery of the same name, 127 Liga, in Berlin in 2002. Rauch has been singled out for his nostalgic paintings, which juxtapose political posters, forsaken monuments and consumer products in surreal landscapes populated by enigmatic figures. These appear psychologically estranged from one another, despite their physical proximity. Meanwhile, Schnell paints landscapes fractured by perspective, teetering on the edge of decomposition; Eder offers darkly symbolic and often perverse pictures of naked women 128 and fluffy house pets; Ruckhäberle develops a folksy faux-primitivism suited to his single- and multi-figure compositions, in which subjects enact inscrutable scenarios; Eitel places spectators in museums, absorbed in acts of hushed reverie; and Weischer empties rooms, the better to highlight their uncanny illusionism and anticipatory function as stage sets awaiting human presence.

A similar recuperation of figurative work evolved at the same time in China. Following the events of the 1989 Tiananmen Square protests, a number of well-known Chinese artists left the country and began to live and show elsewhere, including Xu Bing, Wenda Gu and Zhang Huan (who worked in more conceptual modes). Although many of the artists who remained worked across all media, there was a marked turn to painting people, encouraging the visibility of certain individuals in art

as a means to improve conditions in general. Zhang Xiaogang (b. 1958, Kunming, China), a member of the avant-garde South West Art Group (a group active in the 1980s, known for frank explorations of personal experience), became interested in representing national character. Beginning in the early 1990s, after traveling in Europe, he completed fictional portraits of Chinese citizens – bespectacled girls in braids and fathers in party attire, all with porcelain-smooth complexions and hauntingly glistening eyes – inspired by the sort of quasi-patriotic studio portraits that were popular in the 1950s and 1960s and largely lost during the Cultural Revolution. Each discrete work in Zhang's *Bloodline* series is connected to the others by a thin, meandering red line of paint that roams across the sitters' faces and torsos in ironic solidarity (a testament to Mao Zedong's 'revolutionary family' of the state), with some also bearing blotches of the same red, or patches of shaded imperial yellow.

129

Yue Minjun (b. 1962, Daqing, China) has also made portraiture central to his practice. He uses his own appearance as the template for repetitive paintings of grinning men, their faces contorted into frozen masks that evoke the Laughing Buddha. These pink-fleshed caricatures reference the icon worship associated with Mao, but instead it is the artist whom they elevate to the status of hero and logo, easily commodified

130

129 BELOW Zhang Xiaogang, *Lovers*, 2007, from the *Bloodline* series
130 OPPOSITE Yue Minjun, *Inside and Outside the Stage*, 2009

and instantly recognizable on the surface of related merchandise available across multiple platforms. The political implications of the forced smiles – so maniacal in their zealotry – here remain allusive, but they gain in significance due to the explicit charge of the work that precedes them: *The Execution* (1995), Yue's post-civil-protest updating of Edouard Manet's 1867 painting of the death of Maximilian, Emperor of Mexico, and his generals, which was itself an updating of Francisco Goya's *The Third of May* (1808).

Yue's work can be read in parallel with that of Fang Lijun (b. 1963, Handan, China), who produced his own emblems: a bald man engulfed in water or buoyed by clouds, and babies endowed with Fang's face. Fang and Yue were associated with what became known as cynical realism, an artistic movement sparked by the events of 1989 in China, in which parodic appropriation of the figuration that was key to socialist realism is used as a form of critique.

Although the events of 1989 were also experienced by Liu Xiaodong (b. 1963, Liaoning, China), and had an irrevocable impact on him, too, his art occupies a radically different position to that of the cynical realists. In his, social and material changes – and their effects on human lives – are addressed head-on, rather than through irony. His realism is

131 Liu Xiaodong, *Time*, 2014

one of collaborative experience, predicated on an attempt 'to see people as they really are'. Liu embraces the particularity of his subjects, whom he travels to meet and paints on site, in a 'social experiment'. After setting up camp, he records the sessions through other means of documentation (photographs and video), which he archives online alongside the completed works. Among the subjects of his paintings are a blue-green algae infestation of a lake caused by industrial pollution, and group portraits alluding to the aftermath of the massive 2008 earthquake in Sichuan province. One trip to Hotan, a town in the Xinjiang region of China, resulted in a series of portraits of Uyghur jade miners in a landscape misshapen by centuries of excavation for emperors and the wealthy.

131 In *Time* (2014), Liu images the 1980 South Korean student uprising in a painting that encompasses twenty canvases, arranged edge to edge in a grid and overlain with a unified composition: a dead man lies rigid on paving stones, red clouds like smeared blood clots looming overhead. The pictured site, now known as the 18 May Democracy Square, is one of the

locations selected for Liu's subsequent *Weight of Insomnia* (2016), for which an automated painting machine translated a digital video feed of intersections, public plazas and assembly lines into canvases painted by a robotic brush (Chapter 3 considers related works; pp. 151–52). This way, time can be traced without the exhaustion of documentary labour, and locations – in Gwangju, as well as Beijing, Shanghai, Jincheng, Berlin, Karlsruhe, Sydney and London – captured without further intervention. Liu sees the works that emanate from this current idiom as types of history painting.

History painting is a genre that developed in the 15th century and remained central to Western art until the 19th century, notably in France, where it was used as a tool in attempts to manage a growing empire of insurgent colonies. These paintings tend to depict an important historical, religious or mythical event by isolating a moment of high tension and emotional impact. (See, for example, Eugène Delacroix's *Liberty Leading the People* [1830], in which the artist commemorates the same year's July Revolution against King Charles X of France through the female personification of Liberty, traversing a barricade, tricolour in raised hand.) Typically monumental in size, history paintings were displayed in vast public spaces and were intended to educate the general population about themes including civic virtue and heroism, and sacrifice for a better world to come. This tradition of highly manipulative machines for swaying public opinion has in recent years been transformed: many of these newer works neither inspire patriotism nor exalt heroism, and are instead outwardly antagonistic, focusing on the unsavoury consequences of inept leadership and misbegotten nationalism, or of exacerbating ideological conflict. Not all such works aim to replicate the scale of their precedents, nor are they stylistically consistent or centred on a single, defining image. As evidenced by Liu, neither are they specific to Europe.

132 Once a sign painter, Chéri Samba (b. 1956, Kinto M'Vuila, DRC) reconfigures history painting for the modern Democratic Republic of the Congo. He incorporates traditional artistic forms and such popular materials as sackcloth into his paintings, alongside fantastic images, word bubbles and depictions of his own face as 'conscience'. A founding member, with Pierre Bodo, of the School of Popular Painting in Kinshasa, he has long been dedicated to exposing the inequities of daily life, political corruption and the ravages of AIDS. Similarly committed to the stories of her people, Swarna Chitrakar (b. 1974, Banpura, India) is a narrative painter and singer, who retains the traditional West Bengali artform

The Body

Patachitra, a combination of scroll painting, song composition and performance, to communicate contemporary events. Chitrakar uses customary materials in her scroll painting (pat) – yellow comes from saffron, rice and clay create white and cow dung makes brown – and the scrolls and the songs she composes about them encompass religious themes, as well as the atrocities that followed in the wake of 9/11 and the 2004 tsunami, the wreckage wrought by deforestation and the neglect of female children in rural India.

Pablo Baen Santos (b. 1943, Philippines) is known for a mode of social realism that he developed in the 1970s as protest against Ferdinand Marcos's corrupt, authoritarian regime in the Philippines. In 1975, Baen Santos was a founding member of Filipino artist group KAISAHAN, members of which aimed to effect social change through their art during a period of martial law. While his critique has therefore been directed at
the government – as is clear in *Baboons in Session* (2008) – it also indicts society's injustices, especially pertaining to labour. By using figuration, he reminds us of the human hand in enacting injustice, and the bodies that bear the brunt of it.

Although Carla Busuttil (b. 1982, Johannesburg, South Africa) has claimed that the content of her work is secondary to its formal aspects, which she evidently relishes, she uses found images of conflict to enact political satire that mocks charismatic leaders in pointed condemnations. For her 2013 show 'Post-National Bliss' at Goodman Gallery, Cape Town,
which featured a series of distorted, seemingly historical figures in lurid colours, she issued the following statement

132 OPPOSITE Chéri Samba, *Problème d'eau*, 2004
133 ABOVE LEFT Swarna Chitrakar, *HIV*, 2004–5
134 TOP RIGHT Pablo Baen Santos, *Baboons in Session*, 2008
135 ABOVE RIGHT Carla Busuttil, *No Country for Poor People*, 2013

The Body

in the press release: 'This world is flat, and its inhabitants are a generation lost: unhinged aristocrats, powerless lawmen, scoundrel children, otherworldly victims—all lurching towards some unrecorded fate. It is a time after history.'

Even more truculent, Vasan Sitthiket (b. 1957, Nakhon Sawan, Thailand) denounces Thai politics and problems in Asia after the economic crash, and the cruel misadventures of American foreign policy, through crudely fashioned, furious and overly sexualized imagery on brightly coloured canvases. One installation, *Thai Nukes* (2012), contains 108 phallic carvings fashioned from wood recovered from the 2011 floods in Northern Thailand, while paintings like *Bomb for Liberty* (2017) equate the phallus with missiles and bombs, often wielded by a US president or, in this instance, the Statue of Liberty. The phallus has long been used as a visual metaphor for power, and when included in such clearly lampooning works, such power is rendered comical and grotesque. Earlier works depicted George W. Bush – himself now recognized as an 'outsider

136

artist', through his painted portraits of dogs and others – but Vasan also indicted Barack Obama for his perceived greed.

Engaging with violence in a different manner, Teresa Margolles (b. 1963, Culiacán, Mexico) has spent years researching morgues in Latin America, trying to understand the crimes that lead to the deaths to which her research bears witness – mostly of people belonging to lower classes – and the implications of these deaths for those left behind. In one

particularly arresting piece, *Flag I* (2009), a large piece of fabric, soaked with blood and stained by soil, limply hangs from atop a tall flagpole. The form obliquely suggests a deposition from the cross in its swathes that might cradle a body, or a loosened painting, suspended by its vertical frame. It more obviously memorializes those murdered near the northern border of Mexico: an anti-monument to the human cost of drug cartels that control smuggling routes and passage to the United States.

From the other side of that border, Kara Walker (b. 1969, Stockton, CA) lays open the intractable legacy of the American antebellum South in shaping the country's politics of race, immigration and incarceration, among so many others. She often works with the populist art form of the cut-paper silhouette, a black profile of the sitter against a light

136 OPPOSITE Vasan Sitthiket, *Bomb for Liberty*, 2017
137 RIGHT Teresa Margolles, *Flag I*, 2009

138 Kara Walker, Installation view of 'After the Deluge', The Metropolitan Museum of Art, New York, 2006

background. Walker has met serious critique for her work, including (but not exclusively) from within the art world and African American communities, with detractors accusing her of perpetuating the circulation of representations of the injured and indignant Black body, an enormous archive of which is already a part of popular visual culture. Rather than attempt to rectify this record by explaining her decisions, Walker powerfully made an argument about the disproportionate effect of catastrophic events on precarious

138 populations through an exhibition, 'After the Deluge', which she curated at the Metropolitan Museum of Art, New York, in 2006, in which she interspersed pieces of her own with art from the museum's collection.

As has become even clearer in the last decade, political and social crises are ever-more commonly precipitated by environmental causes as the planet warms: water rises, drought entrenches and fire rages, causing mass migrations of people fleeing the impossible conditions of changing climate (including food shortages, sectarian violence and limited access to care). 'After the Deluge' was created in the aftermath of Hurricane Katrina in 2005, in response to the media that circulated following the storm's landfall, showing profound abjection. Alongside these images of 'water, sewage, and excrement' – which for Walker re-inscribed 'all the stereotypes about the black body' – she selected others that connect centuries of art picturing poverty and race and their deep-seated, seemingly intractable connections, the dispossession and brutality of which the hurricane again exposed.

Mediating Presence

The discomfort inspired by images of violence is countered by some, who tend towards creating positive images, posing these as tonic. The issue is that these actions can lead to the erasure of the brutal truths of history and, indeed, the present. Refusing the consolation of moralism, the Dutch artist Ronald Ophuis (b. 1968, Hengelo, The Netherlands) paints horrific scenes of brutality, often presented from the perspective of the perpetrator. *Sweet Violence* (1996) was one of a group of canvases he exhibited at the Stedelijk Museum Bureau Amsterdam in 1999, under the title 'Five Paintings about Violence': deemed pornographic for its depiction of a child rape scene and removed from the exhibition, the painting was reinstalled following a petition spearheaded by the artist. Though not subject to the same level of censorship, other projects have been equally challenging, especially given Ophuis's tendency to situate gruesome acts of sodomy and torture in contemporary surroundings (in contrast to his early paintings, which followed the model of 19th-century history painting, with subjects donning antique clothing in some indeterminate past). Travel to Srebrenica in 2003 yielded the *Srebrenica* series (2004–8), which memorialized the genocide there, while a 2010 trip to Sierra Leone resulted in portraits of child soldiers. Ophuis also stages scenes in his studio; this use of actors and reconstruction of events on makeshift sets serves as an extension of his interest in ideas of fictitious testimony and

139 Ronald Ophuis, *The Death of Edin, Srebrenica July 1995*, 2007

the way in which, while based on falsehood or misremembered detail, it nevertheless triggers emotion.

While some artists commemorate historical moments, it is this process of memorialization and collective memory that is examined by Pablo Alonso (b. 1969, Gijón, Spain), who has used the technique of frottage to transfer the surfaces of public monuments to other supports. This repossession of public sculptural and architectural markers characterizes *Illegal Settlement* (2004) – a reconstruction of the Arch of Titus in the Roman Forum, erected to mark the conquest of Jerusalem and the Jewish diaspora that resulted – and other works that question the relationship between power and representation. These imply the presence of the body: through the actions involved in rubbing the surface, or as a result of the viewer being forced to crouch under the arch's diminutive bow to view it. Other works, such as the series *You've Never Had it So Good* (2003), use cut-out, skewed or decapitated images of the body as a way of undermining the realism of their source materials (these paintings originate in German newspaper excerpts: *FAZ*, *Der Spiegel*, *Süddeutsche Zeitung*), which Alonso photographed, projected onto canvas and then painted. While the content of

140

140 OPPOSITE Pablo Alonso, *You've Never Had it So Good 1*, 2003
141 RIGHT Miguel Aguirre, *Ana Martín Fernández*, 2008, from the series *In Memoriam*

the clippings influences interpretation, their inclusion also raises questions of piracy and manipulation; some instances of this can be more obvious than others, given Alonso's tendency to force multiple elements into a single frame.

Many of the artists discussed in this section build paintings around found images. Following the important archive-based example of Gerhard Richter (b. 1932, Dresden, Germany) – specifically his *Atlas* series (1962–present), an encyclopaedic collection of over 4,000 photographs, drawings and diagrams that spans post-war German history and frequently provides the sources for Richter's photo-based canvases – Miguel Aguirre (b. 1973, Lima, Peru) has amassed a personal repository of his own. This consists of images obtained from CCTV, home videos and the printed press, all of which are used for reproduction as paintings. The resulting series, *DD/MM* (2007–10), brings together diverse acts of malice, from children being kidnapped to public slaughter. Bearing down on a single event, *In Memoriam* (2008) is a series of twenty-two paintings of the victims of the 2004 Madrid commuter train bombings. Aguirre selected snapshots revealing their private lives from the Spanish newspapers *La Vanguardia* and *El País*, maintaining

141

the newspapers' formatting while deleting the texts. In carefully preserving each image but presenting it out of context, Aguirre proposes that an image's legibility does not equate with clarity of meaning – historical, political or otherwise.

Since the late 1970s, Luc Tuymans (b. 1958, Mortsel, Belgium) has used comparable sources for his pale, thinly layered paintings that are reminiscent of faded, colour-leached photographs and film stills, and often register a missing body. In part due to the artist's rule of completing each painting within the course of a single day, Tuymans's works look unfinished, though this trait lends them a banality all the more discomfiting for his grave subject matter. If history painting once condensed narrative into a decisive moment, Tuymans alights on seemingly insignificant, even innocuous details that are anything but: a swatch of floral embroidery comes from a chair on which a man was murdered; an empty room discloses itself as a gas chamber traced with faeces and blood; a hazy grey field swallowing a lamppost is the concrete-become-ash of the World Trade Center. Even when the reference is clear, as in *The Secretary of State* (2005), a cropped headshot of Condoleezza Rice wearing an intense expression, Tuymans's position is not.

A headline for *The Art Newspaper*, detailing his 2019 installation at the Palazzo Grassi, Venice, Italy, proves an exception: 'Luc Tuymans: "People are becoming more and more stupid, insanely stupid."' The accompanying text discusses a large-scale floor mosaic of pine trees based on a painting Tuymans made outside a German labour camp at Schwarzheide, north of Dresden, and, more generally, themes of memory and history and the deceptions of both; he is quoted as saying that 'the consequences of that specific era [stretch] all the way to what we are living now. The fact that anti-Semitism is cropping up in France; that there is a parade in Belgium that portrays Jews like they were portrayed in Nazi Germany.'

The question, for Tuymans, is what the role of art might be in relation to this. For Bracha L. Ettinger (b. 1948, Tel Aviv, Israel), an artist, theorist, analyst and psychologist, the answer is nothing short of a moral imperative: 'the artistic has a potential for humanizing because only there aesthetics breeds ethics'. She herself paints coruscating fields of colour within which figures – often mothers and children – emerge, like holographs or phantoms. Through this process of remembering at a distance, Ettinger more viscerally accesses emotions relating to atrocities from her family history, notably the massacre of Jews in the Ponary forest in Lithuania in 1941. She also uses World War II and Holocaust images, through which she sees, feels and materializes suffering.

142

143

144

142 TOP Luc Tuymans, Installation view of *Turtle* (2007), Palazzo Grassi, Venice, 2019
143 ABOVE Luc Tuymans, Installation view of *Schwarzheide* (2019), Palazzo Grassi, Venice, 2019. Marble mosaic realized by Fantini Mosaici, Milan

The Body

144 Bracha L.
Ettinger, *Eurydice
n. 53 – Pieta,*
2012–16

Other European artists, particularly those from the former
Eastern Bloc, have created paintings that stylistically resonate
with their source materials, photographs. They use photography
to reanimate the legacy of social realist painting, and likewise
to acknowledge and stylize the ways political propaganda and
145 information spread in the Eastern Bloc. Serban Savu (b. 1978,
Sighișoara, Romania) confronts the present legacy of past trauma
in scenes of daily routines, lives lived in public plazas and derelict
spaces. He works from photographs, some sourced from the media
and others taken himself, which he then manipulates in Photoshop
to form the visual basis for his paintings. Source photography is
146 also significant in the work of Alexander Tinei (b. 1967, Căușeni,
Moldova), who takes a photo found in the media as his starting
point each time he sets about making a new painting. He depicts
figures, often tangled in awkward embraces, with blue paint
running across their limbs and elsewhere, like viscous tattoos.
Tinei equates bodily graffiti with degraded environments, and
allies subjects with their surroundings, portraiture with landscape.

145 TOP RIGHT Serban
Savu, *Blue Shadow*, 2010
146 RIGHT Alexander
Tinei, *Uncle J*, 2006

Thus can source imagery be combined with figuration to provide insight into a subject, and it can also offer the possibility for rich layers of meaning to accrue within an image. Njideka Akunyili Crosby (b. 1983, Enugu, Nigeria) makes paintings of people in interior spaces, using collage and photo-transfer to create a hybrid space of combined references to contemporary life in Nigeria, where Crosby was born, and the United States, where she now resides. The resultant works offer a glimpse into personal relationships and moments of intimacy, in a life lived across borders.

Others use source imagery for different ends, to express different kinds of body politics. To this point, Ghada Amer (b. 1963, Cairo, Egypt) enforces a defensive barrier between viewer and viewed. Her nudes are sewn rather than painted, their tangled threads hanging from canvases in dense, colourful masses of knots and bundles that obscure the erotic subject of her images (including kissing, coitus and

147

148

147 BELOW Njideka Akunyili Crosby, *Ike Ya*, 2016
148 OPPOSITE Ghada Amer, *The Woman Who Failed To Be Shehrazade*, 2008

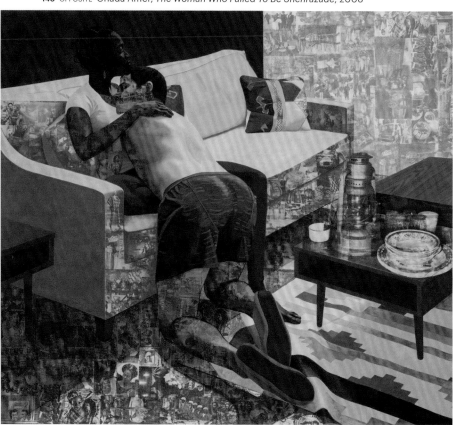

masturbation). While Amer's reclamation of craft nods to
a feminist prehistory (she eschews paint for its identification
with maleness and mastery), these pornographic images
present challenges to that lineage from within, as is also true
of formative works concerning domestic chores of childcare,
cleaning and cooking. Equally, the prevalence of nudity,
especially in the service of female pleasure, will to many
viewers seem at odds with the artist's Arab Muslim background.

Amer confronted this reaction in an earlier installation,
Encyclopedia of Pleasure (2001); she created a set of cream-
coloured fabric boxes, ornamented in gold embroidery with
quotations from the erotic medieval Islamic encyclopaedia of
the same title, which concerned the sacredness of sex. With the
text translated into English, the piece hints at concerns over
censorship, intimating that taboos still resonate in Western
culture and are illicit, even criminal, in other parts of the
world. Indian filmmaker and painter M. F. Husain (1915–2011)
spent the last years of his life in voluntary exile in Doha and
London after he received death threats from religious zealots
for his nude paintings of Hindu goddesses. And indeed,
diminishing censorship in one area is no guarantee of

acceptance elsewhere. Weaam Ahmed El-Masry (b. 1976, Cairo, Egypt) worked during the rule of Hosni Mubarak in Egypt, who enforced a law allowing for the censorship of the press: prohibited images included those featuring poverty, corruption and sexuality. In the wake of the 2011 revolutions, part of the wider Arab Spring, these policies were loosened, and Mubarak fell from power. As a result, work by such artists as El-Masry, who paints superimposed figures in lustful embraces, was no longer so strongly restricted at home – and yet even then, she was rebuked when an issue of *Newsweek Asia* in which she was featured was deemed offensive by Malaysian censors.

Thus does context matter, particularly where the body is concerned. For Elizabeth Peyton (b. 1965, Danbury, CT), an artist who did much to revitalise the genre of portraiture in

America in the mid-1990s, the fact that her work arrived during the country's AIDS epidemic lends new meaning to her recovery of pure, adolescent desire. In thinly washed, colour-saturated, small-scale works, she transforms the looked-at or wished-for subject under her gaze. Without irony or apology, or the need for exegesis, but with a self-conscious romantic idealism, she paints friends, artists, musicians, actors and public figures, both contemporary and historical (eclectically ranging from Marie Antoinette and Abraham Lincoln to Rirkrit Tiravanija, Sid Vicious, Susan Sontag and Andy Warhol), the images of whom she often sources from found images and photographs.

Others' engagement with their source imagery is more conceptual; Anna Bjerger (b. 1973, Skallsjö, Sweden) remains most interested in working through the ethics of appropriating material that is not one's own, foregrounding the role of authorship in claiming others' familiarity. Bjerger paints from found family snapshots, which she engages as access points to memories that are both irretrievable and affectively potent, and obsolete sources of information, such as antiquated reference books, magazines and instruction manuals. In *Toxic/Rock* (2018), time and physical appearance fluctuate from reality, just as they do in our memories. The solid, ancient rock formations

149 OPPOSITE Weaam Ahmed El-Masry, *The Embrace*, 2011
150 BELOW Anna Bjerger, *Toxic/Rock*, 2018

are rendered in pink, and the seated couple emphasize the scale and stillness of the image, as though outside the realm of time.

151 Source imagery is also vital to the work of Chantal Joffe (b. 1969, St Albans, VT), who culls photographs of women from various contexts – pornography, fashion magazines and the history of art – for use in compellingly awkward portraits fashioned in thick impasto, in the tradition of Alice Neel's astute, sometimes raw, observation. While strikingly perceptive, and at times forthrightly empathetic, Joffe's paintings are rarely faultless or sentimental.

Artists like Joffe challenge ideals of beauty and the crude use of women's faces and bodies to sell products, lifestyle and sex. This stance stands in stark contrast to that forged in the work of Richard Phillips (b. 1962, Marblehead, MA), a painter of glossy, high-key celebrity portraits, who has spoken of an infatuation with 'wasted beauty'. One subject who has engaged his interest is the actress Lindsay Lohan, with whom he has collaborated, and whose bikini-clad presence in an art video and a suite of paintings serves as an endorsement for his other endeavours: a smug hawking of product, for both artist and muse. More egregious still is the art-world sexism so flagrantly

152 on display in Phillips's *Frieze* (2009), a realistic interpretation of a visibly wincing woman on her back, legs parted, with a thick issue of the art magazine *Frieze* awkwardly inserted into her vagina.

Kathe Burkhart (b. 1958, Martinsburg, WV) has challenged power dynamics and gender roles in male-dominated culture for decades, both in her paintings and public persona. Her *Liz*

153 *Taylor Series* (1982–ongoing) comprises a self-portrait project in which the violet-eyed, raven-haired actress, who passed away in 2011, operates as the artist's double. In 2019 Burkhart posted a Facebook comment, which she also allowed to be published elsewhere online. She was fed up, not only with salacious imagery such as Phillips's, but also with outright discrimination against women in the art world. Foremost in her mind seems to have been a spate of shows unscrupulously retrieving careers of older women – like the Whitney Museum of American Art's 2016 retrospective of Carmen Herrera (b. 1915, Havana, Cuba), her first museum exhibition, granted at the age of 101. This kind of recognition comes far too late, and is an attempt on the part of museums not only to save face but also to capitalize on years of labour performed by these artists. As Burkhart posted:

151 OPPOSITE ABOVE Chantal Joffe, *Blonde in a Black Sweater*, 2015
152 OPPOSITE BELOW Richard Phillips, *Frieze*, 2009

153 Kathe Burkhart, *Fuck Off*, 2015, from the *Liz Taylor Series* (*Raintree Country*), 2015

It's international women's day. I'm asking all curators and gallerists today to step it up and make some change, by not making women artists wait too long for the support that they deserve. Don't treat older women like "old ladies" and pit them market wise against young women with lower prices and more estrogen. In so doing, you reify discrimination and oppression. Don't dump women artists into a mass grave between the ages of 35–65 and then fish them out one by one if they survive. Don't wait until the artist is so sick, or old and frail that you make it a strain for them to enjoy their success. That is cruel. Don't wait until you're in the know about someone's terminal prognosis to do something for them...don't let your institution become known for that—there is no glory in chasing ambulances. And finally, don't give your highly valuable "cookies" out to the same few over and over and over again.... And the rest of us? Don't make us fight for crumbs. It's gross.

Retribution and Inclusivity

In the years since 2009, and especially since 2017, with the viral spread of #MeToo and the testimony of so many survivors of sexual violence, the art world has experienced a belated awakening on issues of sexual and gender discrimination. This has led to the resignation or firing of certain prominent museum professionals and utter intolerance for predatory acts perpetrated by artists. Chuck Close (b. 1940, Monroe, WA), whose photorealist portraits are usually based on gridded photographs that he translates and aggregates into massive panels, has been the subject of critique as a part of the still-growing movement. In 2018, media reported that the National Gallery of Art, Washington, D.C., was to postpone an exhibition of Close's work indefinitely because of allegations of sexual harassment involving potential portrait models. The accusations were not as yet heard in a court of law, though the jury of public opinion was swiftly accusatory. Framed within a cultural conversation around issues of benefit, entrée and allowance for breaches of conduct on the part of those in power, the discussion around Close was also distinctly industry specific.

Some trying to support Close noted, one cannot help but feel unconstructively, that Baroque painter Michelangelo Merisi da Caravaggio was accused of murder, or that Pablo Picasso was a prodigious womanizer – as if to normalize their behaviours. The mythology around the white male artist as genius has held tenaciously despite the criticisms raised by feminism and appropriation art (as discussed in Chapter 1); so too have the accused's obligatory defences often been bolstered by a performed contrition, irrespective of the injurious act. It is important to register the extent to which these private studio activities involving female models and male artists historically exploited the least privileged bodies.

More publicly, the tradition of history painting was predicated on male models in life-drawing classes, which also kept women from an education: obstructed from the outset, left to forms of amateurism and craft kept apart from the precincts of high art and its institutions. In what is considered a founding document of feminism in art history, Linda Nochlin's groundbreaking 1971 essay 'Why Have There Been No Great Women Artists?', she argues that the drawing of the male nude, which was considered an essential skill to master from the Renaissance through to the 19th century, was critical for the achievement of the highest art forms. (It structured the ranking of genres, with history painting at the apex above portraiture, genre scenes, landscape and still-life painting, respectively.)

154 ABOVE Jenny Saville, *Fate I*, 2018
155 OPPOSITE Cecily Brown, *Paradise to Go 1*, 2015

154 As Jenny Saville (b. 1970, Cambridge, UK) remarked, looking back on her own training in the late 20th century: 'When I got to art school I just naïvely didn't realize that there were not great female artists—in the past I just didn't know it. I had an epiphany in the art school library and said, "Well, where are the girls?"' *Propped* (1992) was her response to this realisation. It formed part of her degree show in Glasgow the same year, with a mirror hung opposite the work, but it was most publicized in collector Charles Saatchi's 1997 exhibition, 'Sensation: Young British Artists from the Saatchi Collection' at the Royal Academy of Arts, London, in which the mirror disappeared but the potency of the image remained. In the nude self-portrait, the artist sits uncomfortably atop a tall stool, pendulous breasts

squeezed together by the crossed arms that grip and knead her fleshy thighs; she gazes out, veiled by a quote from the French feminist Luce Irigaray theorizing that women function as mirrors for male narcissism.

Since this debut, Saville has worked from live models in her studio, photographing them in numerous poses and painting them, with exaggerated physicality, later. These subjects have included people undergoing plastic surgery, women pregnant or deflated after childbirth, transgender bodies and her own children, in paintings of mutability and selfhood that analogously look to be left unfinished in perpetuity. This is especially true of 'Ancestors', her 2018 show at Gagosian Gallery, New York. She described it as a response to #MeToo and an occasion to contemplate her own decades of production: she finally understood so much artwork of her own to be part of a usable past, which she mines alongside the historic images made by other artists.

Cecily Brown (b. 1969, London, UK) also responded to the legacy of traditional figure painting with a fierce drive for self-determination. She has said: 'My male painter friends.... say they spent their art school years trying to paint [Willem] de Koonings, but they could never get away with what I did.

156 TOP Mickalene Thomas, *Origin of the Universe 1*, 2012
157 ABOVE Ellen Altfest, *The Penis*, 2006

As white American males they couldn't paint like an Abstract Expressionist because it was too close, too recent, too American and too macho, but as an English girl I could.' Much of Brown's early work involved imagery of sexual acts: less pornographic than evocative of preceding erotic analogies between oil paint and flesh. This is a convention-become-misogynistic cliché: take Pierre-Auguste Renoir, who crudely conceived the paintbrush as a penile extension, or Wassily Kandinsky, who dramatized the act of painting as a rape scene, all the way to de Kooning's *Woman* series, and far beyond.

In Brown's repertoire, which is marked by numerous examples of art-historical appropriation, she inverts this centuries-old dynamic of women being the cipher for male artists. In her *Black Painting Series* from the early 2000s, she has women experiencing pleasure for themselves: modelled after Francisco Goya's nudes, now consumed in orgasm, winged phalli swarming around like angels or bees. Fleshy forms emerge from the dynamic field of colour in *Paradise to Go 1* (2015), made the year she returned from New York to her native England.

155

In Mickalene Thomas's (b. 1971, Camden, NJ) tactile paintings – formed by the layering of oil, acrylic and rhinestones – she uses art history to address the politics of representation, in magpie-like overlays of modernist idioms. Initially working from photographs that she takes of her muses in fantastic built environments, which recall both the fabric backdrops of West African studio photography (exemplified by Malick Sidibé and Seydou Keïta) and patchwork redolent of period decor from her childhood, Thomas makes oversized portraits of accessorized and painted black women. Her *Odalisque* series (2007) recasts the artist-model relationship, so crucial to her project, as a function of – and positive expression for – same-sex desire, elsewhere the exclusive purview of the male gaze. Thomas's multiple versions of Gustave Courbet's infamous painting of a female model lying with legs splayed open, exposing her crotch, *L'Origine du Monde* (1866), feature herself and her female partner as the recumbent figure swaddled in dirty linens, while her tendency to plaster genitalia with glittery encrustations – sparkly fig leaves – simultaneously converges on and conceals markers of sex.

156

Where Brown and Thomas dissolve bodies into paint or assemble them in an accumulation of materials, Ellen Altfest (b. 1970, New York, NY) upholds painterly verisimilitude, built by looking incredibly intently at the thing to be transcribed. Altfest paints from life, concentrating on the minutest details – single strands of hair, individual pores, follicles or fine veins – and

framing them at near range. She lavishes equal notice on her male subjects, often presented in poses that mimic those of classic female nudes, or single body parts presented for

157

inspection or delectation, as in the trompe l'oeil *The Penis* (2006).

158

Since 2016, Ivy Haldeman (b. 1985, Aurora, CO) has been exhibiting proxy nudes: crisp, absurdist acrylic renditions of anthropomorphic hot dogs, resting like pin-up girls between pillowy buns. These phallic sausages with exaggerated lips and femme attributes originate from an advertisement the artist saw in Argentina, showing a hot dog donning high heels and eyelashes. Haldeman has since extended the critique of sexual persona into the realm of sartorial trends, taking the 1980s power suit and high heels as an emblem of the codes through which women entered the corporate workforce. In this, her work connects to the stiletto-heel imagery in the paintings of Ulrike

159

Müller (b. 1971, Brixlegg, Austria), who examines the body within social structures, critiquing the trope of a professional woman and her costume. Müller has worked in important collaborative contexts, including New York's LTTR, a feminist, genderqueer artist collective. She also initiated the *Herstory Inventory*, a project through which she engages feminist history by re-drawing archival images. (The contemporary embrace of collectives and collaborative practice is explored more fully in Chapter 5.)

Working from life models is another example of interactivity in art. Paradoxically, perhaps, given social media's fostering of

158 OPPOSITE Ivy Haldeman, *Full Figure, Open Book*, 2018
159 ABOVE Ulrike Müller, Exhibition view of 'Container', Kunstverein für die Rheinlande und Westfalen, Düsseldorf, 2018–19

intimacy at a distance, the Internet has aided the organization of life-painting groups and hiring of models for a group to work from, together, as it were, in the flesh. The set designer and artist Mark Beard (b. 1956, Salt Lake City, UT) runs a longstanding drawing salon that attracts gay artists. He works via alter egos including Bruce Sargeant, a play on John Singer Sargent, in an attempt to make the homoeroticism implicit in his work the subject of un-closeted analysis. Seeking to redress the absence of pre-Stonewall LGBTQ history within histories of art, Beard perpetuates an academic realism through muscular bodies of gymnasts and wrestlers, and shows the centrality of the idealized male nude, from Greek statuary through the Renaissance, to sublimate homosexual desire. Creating backstories and networks for his personas, and adopting the style of the moment in history at which he conceived each of them living, Beard's resultant works are fictitious documents from a painter who never existed. They nonetheless heuristically pose important practical questions about how contemporary

160

The Body

160 ABOVE Mark Beard [*Bruce Sargeant (1898–1938)], Seven Gymnasts on The Ropes*, n.d.
161 OPPOSITE Nicole Eisenman, *Sloppy Bar Room Kiss*, 2011

art might come to include non-heterosexual or non-binary positions. To this end, Beard supports the work of those in his salon, promoting it to collectors.

The American artist Nicole Eisenman (b. 1965, Verdun, France) signposted this method of working from the model in the company of others when she organized a figure-drawing atelier for the 2012 Whitney Biennial, with workshop exercises for sketching shadow, contour, shape and finding the essence of forms; and, in 2014, Andrea Bowers (b. 1965, Wilmington, OH) spent a week at The Drawing Center, New York, teaching Suzanne Lacy (b. 1945, Wasco, CA) to draw, in lessons that were in part performed with life models. Eisenman has staged important interventions into Queer aesthetics (since 2005 she has worked with A. L. Steiner [b. 1967, Miami, FL] on the curatorial initiative Ridykeulous, convening conversations as well as organizing projects involving exhibitions, performances and publications), and her inventive and often mordantly funny paintings harbour historical references, while addressing themselves to current concerns, chief among them the characterization of women as 'butch' or 'femme' and the trials of motherhood. Public sites of sociability – beer gardens and barrooms – additionally offer moments of affection; in *Sloppy Bar Room Kiss* (2011), a lip-locked couple slump on a wooden table.

161

Although Eisenman has been clear about her hesitancy to define or speak for others, she has served as a key mentor for younger artists who too understand, as Eisenman has put it, that 'representing bodies is complex. What looks masculine in a painting could be a self-determined gender mutineer, or trans, or something completely off the spectrum.' Figures by Christina Quarles (b. 1985, Chicago, IL) consist of rubbery limbs and liquefied bodies, pieced together from quick lines and washes of acrylic thinned to the consistency of watercolour, or thickly applied to be carved with a paintbrush handle or comb. In their mutability of conjuring they perform an expansive, polymorphic sensuality and its process of becoming.

Louis Fratino (b. 1993, Annapolis, MD) is regularly compared to Eisenman on other grounds, namely the expression of openly gay experience (more so than the presentation of non-binary bodies, as in the case of Quarles as well as Drea Cofield, who is discussed in the introduction on p. 23). He paints quotidian scenes of men eating breakfast or getting a haircut, or more

162 LEFT Christina Quarles, *Moon (Lez Go Out N' Feel Tha Nite)*, 2017
163 OPPOSITE Louis Fratino, *Andrea in Gambara*, 2018

163

evocatively, gathering on a moonlit beach or sharing a sleepy moment in bed, attending both to the overall mood and to the details – an earlobe or patch of hair, a softly swelling paunch or contoured cheek – that give each canvas a specific gravity. They are odes to friendship and sexual understanding, the latter often explicit in visualizing penetration or detumescent aftermath. *Andrea in Gambara* (2018) poses the nude in a position of recline, dreamily looking elsewhere. While some of Frantino's pieces depict personal experience, others appropriate source material; *Andrea in Gambara* additionally references the Milanese nobleman in the short story *Gambara* (1837) by Honoré de Balzac, who attempts to save a misunderstood genius, seducing and growing tired of his wife in the process.

Jonathan Lyndon Chase (b. 1989, Philadelphia, PA) also works with expressionist figuration, painting queer black men. His points of reference include the 1990s fashion and pop culture of his youth, afrofuturism and science fiction – all of which he applies to Black and Queer narratives. The bodies he renders blend into one another in orgy and union, punctuated here and there by accoutrements like sneakers, athletic apparel

The Body

164 ABOVE Jonathan Lyndon Chase, *dimonds all over my body*, 2018
165 OPPOSITE Didier William, *M vle santi w andelan m*, 2018

and heavy crosses. Many of the paintings – fashioned on cotton bedsheets, as if to materially redouble the ground of the depicted scenes – afford glimpses of unbridled pleasure, some with erogenous zones simultaneously and improbably turned up to the picture plane (as in those with a mouth and anus facing the same direction). Yet there are many others that admit the complexities of negotiating identity relative to social norms. The figure in a blue dress in *dimonds all over my body* (2018) is notable in this regard, their face – frozen confronting the viewer – belying the seeming exuberance of the rhinestone-dappled picture.

Didier William (b. 1983, Port-au-Prince, Haiti) is even more explicit about the aggression of the gaze in a series of works that were partly inspired by the artist's immigration to the United States and the circumstances of diasporic identity as

a queer Haitian man. For a 2018 double-presentation of mixed-media paintings in 'Curtains, Stages, and Shadows, Act 1' and 'Curtains, Stages, and Shadows, Act 2' (at James Fuentes Gallery, New York, and Anna Zorina Gallery, New York, respectively), William exhibited paintings filled with amorphous bodies blending into others and extending into curtains, and left their titles untranslated in Haitian Creole, as in *M vle santi w andelan m* (2018). Through an intricate technique involving woodcarving, collage, ink and acrylic, William offers bodies without identifiable race or gender, filled edge to edge with small, accusatory eyes that unblinkingly stare back at the viewer.

Chapter 5
Beyond Painting

The claims for representation explored in the previous chapter parallel the rise of participatory art in the 1990s and 2000s (a strand that became all the more acute within the burgeoning 'experience economy' of the 2010s: just like businesses that operate within this economy, participatory artists place emphasis on experience over product). Relational aesthetics, as this participatory art is known, is a concept developed by French art critic Nicolas Bourriaud to give form to a radical opposition to traditional object-making and attempt to reorient interactions between artists, viewers, institutions and collectors. Bourriaud defines relational aesthetics as comprising a 'set of artistic practices which take as their theoretical and practical point of departure the whole of human relations and their social context, rather than an independent and private space'. The ensuing experiential art aims to precipitate a makeshift community, the camaraderie and agency of which might productively outlive any brief event.

Yet the fact that Rirkrit Tiravanija cooked Thai food in the gallery (see p. 11), instead of making a standalone artwork and leaving it behind for display, did not mean that the meal was a social service destined to reach underserved populations. In short, his shows were not soup kitchens, but rather were performances for a self-selecting audience, just as Carsten Höller's (b. 1961, Brussels, Belgium) *Revolving Hotel Room* – an art installation in the Guggenheim Museum, New York, for 'theanyspacewhatever' (a 2008–9 survey of relational work), which took the form of a hotel room in which guests could stay overnight – was not intended as a homeless shelter. Commentators quickly challenged the validity of art created for such selective social contexts. Art by Thomas Hirschhorn (b. 1957, Bern, Switzerland) and others was further maligned

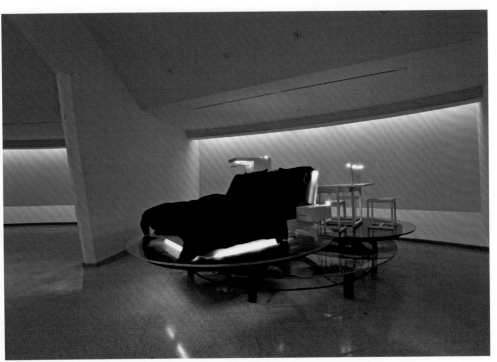

166 Carsten Höller, Installation view of *Revolving Hotel Room* at 'theanyspacewhatever', Solomon R. Guggenheim Museum, New York, 2008–9

for being made using unpaid labour sourced from the under-resourced communities in which artists increasingly extended their efforts, as in Hirschhorn's 2013 *Gramsci Monument*, an outdoor sculpture at the Forest Houses (a New York City Housing Authority development in the Bronx) that was primarily fabricated by its residents.

Relational art projects might therefore mimic, without altering, the implicit hierarchy of production: the artist remains in charge, and benefits disproportionately from the exertion of the unnamed parties. This resonated with neoliberal policies; creativity was being applied to industry 'disruption' yoked to capitalist expansion. Social practice picked up where relational aesthetics left off, with a turn to more explicit activism and community-based art. These transformations – both outside and within art – have confirmed and precipitated certain ways of working within painting. Furthermore, they have led to explorations of the way the artist exists within networks of ideas and information, and less abstractly, across widespread geographies.

This last point is also tied to the increasing number of large-scale exhibitions that attempt to address the artistic and cultural phenomenon of globalization. The expansion of biennials and triennials across the globe – something unheard of before 1989, with the exception of the Venice Biennale (established in 1895) and the São Paulo Art Biennial (established in 1951) – made many artists peripatetic travellers who created site-specific installations (as introduced in Chapter 3). Making-on-demand has been extended to the now ubiquitous art fairs that pop up around the world every month, in the course becoming less distinct from non-commercial biennials in that they regularly feature curated sections, commissioned projects, performances and talks. Such transformations have also led to questions regarding the status of painting: not just what a painting is, but where and when it becomes one or ceases to be a singular object.

The idea of the prop is predominant, in that it indicates a move away from understanding painting as a discrete and complete entity, even when it looks to be exactly that – a vital point raised in the *Surrogate Paintings* that Allan McCollum (b. 1944, Los Angeles, CA) began in the late 1970s. Some are fabricated from wood and museum board, others from plaster cast from rubber moulds, and all have black centres

167 Richard Aldrich, Installation view of 'Once I Was...', Bortolami Gallery, New York, 2011

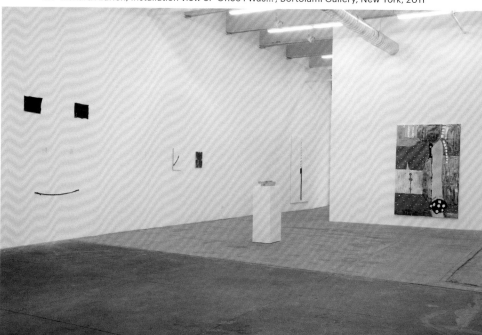

where there could be an image. As McCollum stated in 1982: 'My paintings are designed as "signs" for paintings, or as surrogates; they are meant to function in a way similar to that of a stage prop, but in the normal world of everyday life.'

Extending this line, Richard Aldrich (b. 1975, Hampton, VA) emphasizes that his mostly abstract paintings reflect on their own genesis. A 2011 press release for his show 'Once I Was...' at Bortolami Gallery features a 2007 quote from the artist:

These paintings are meant to become props in an ongoing production that aims to present a series of systems that interact with one another. They are not metaphor, nor allegory, but prop. The objects created are specific in themselves, but that specificity is not pertinent to the workings, that is the form of the interactions that can take place, of the systems. These systems are not about a balance or a thought, a final idea or an idealized end, nor a perceived direction, but rather a body in which things are happening.... What is important is that the work sets up a sort of stage in which the viewer is responsible for navigating themselves around.

Aldrich is keen to supply his paintings with a written component, something like a caption situating it from without; the above is an example of his manipulations of the format for the obligatory gallery press release (and the jargon writing spied therein, an industry-specific dialect that David Levine and Alix Rule dubbed 'International Art English'). In so doing, Aldrich registers how meaning can be extraneous to the material object of the painting, a condition of this chapter's titular 'beyond', as typified by installation, performance and social engagement.

Painting in and as Installation

Installation comprises temporary, three-dimensional works that are designed for a particular place, usually for a show. After the exhibition closes, such projects might be destroyed, or they might be recreated elsewhere, reconstituted in response to the altered context. Although this manner of working may seem at odds with painting's boundedness and relative material stability, artists have used painting to make installations. They have also used spatial situations – immersive environments that call attention to the three-dimensionality of paintings as objects – to foreground the very thing-ness of painting, denaturalizing the idea that a painting is an immaterial image.

This consideration of the painting as object is critical in the work of Robert Ryman (1930–2019). He was long involved with the pragmatic testing of materials, especially their mutually

determining relationships: primer and paint, paint and support, support and edge, edge and wall, wall and room, room and institution, and so on. Though Ryman's paintings are often described as 'white', his work is in fact rich with colour, found in the range of matte and reflective surfaces and on the paintings' grounds, each with a different texture, resulting in an endlessly oscillating appearance. He painted directly onto walls, moved fasteners – tape, staples, steel and other brackets – to the front of canvases, and projected paintings outwards from their wall planes at right angles, incorporating the shadows that these table-like paintings produce as part of their compositions.

Ryman insisted that his works were realist, which is to say that they were materially honest. He did not make images or illusions, nor did he paint people or narratives, revelling instead in the physicality of painting as a made object that existed in an institutional and material 'situation'. He once avowed: 'My paintings don't really exist unless they're on the wall as part of the wall, as part of the room... and once it's down from the wall... the composition is lost and the painting is not alive.' When *No Title Required 3* (2010), a single

168 BELOW Robert Ryman, Installation view of *No Title Required 3*, Pace Gallery, New York, 2010
169 OPPOSITE Pieter Vermeersch, *Untitled* (2009) at 'Beyond These Walls', South London Gallery, London, 2009

painting composed of ten individual panels, was hung in the
Pace Gallery in New York, the squares were spaced at regular
distances, traversing a corner.

Alongside and after Ryman, there has been a preponderance
of work that takes apart the fundamental components of
painting, showing them to be simultaneously self-referential
and entrenched within the sensory world. Pieter Vermeersch
(b. 1973, Kortrijk, Belgium) forgoes the support altogether
and annexes the wall as a paint surface for murals of colour
gradients that seem to dissolve the wall plane even as they
cling to it, while Clément Rodzielski (b. 1979, Albi, France)
leans his structures against the building, and Adrian Schiess
(b. 1959, Zürich, Switzerland) lays his 'flat' paintings – large
and reflective aluminium panels – on the ground. But as with
Ryman's example, these projects illustrate that in moving off
the wall, painting does not cease to be painting; instead, the
questioning of painting's fundaments – its material history and
conventions, its reliance upon architecture and institutional
framing – expands what painting might be and how it might
relate to the world beyond itself (explored further in Chapter 6).

169

170

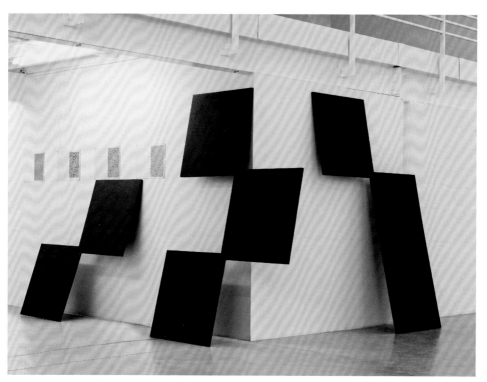

170 ABOVE Clément Rodzielski, Installation view of *Untitled*, Pace Gallery, New York, 2008
171 OPPOSITE Angela de la Cruz, *Deflated XVII (Yellow)*, 2010

Steven Parrino's (1958–2005) so-called 'misshaped paintings'
also stand for a rethinking of the properties and function
of the support. Known for furious-looking works that might
be described as modernist monochromes ripped from the
stretcher, or folded, torqued, punctured or cleaved in sections
to highlight the intervals between canvas and frame, Parrino
has become increasingly important to other artists in the years
following his untimely death. His entropic, sagging works open
a space between painting and sculpture by manipulating weight
and mass, and they also suggest an extension into popular
culture, particularly heavy industry, motorbikes and guitars,
a fact not unrelated to the fact that Parrino played the electric
guitar in several bands, the final one being Electrophilia,
a two-person group that he formed with artist Jutta Koether
(p. 217) as keyboardist.

The deconstruction of painting has been furthered in
171 the work of Angela de la Cruz (b. 1965, A Coruña, Spain),
who makes paintings to be destroyed. Since experiencing

an epiphany caused by removing a stretcher and seeing the emotional impact of the collapsed painting – a monumental medium so easily undone – she has ripped and dangled works from their frames or propped them in corners. They inhabit a position between destruction and existence, carrying the same vulnerability as the human body. Indeed, such works involve shadows of anthropomorphism; it is latent in Parrino's output, and is suggested by the moniker 'person-objects' that de la Cruz uses to describe her paintings, as well as by her works' titles, which name emotions. Although it is tempting to relate these acts to the artist's biography (she suffered a massive stroke in 2005, the details of which were obsessively recounted when de la Cruz became a finalist for the Turner Prize in 2010), she in fact worked in a similar vein well before this event. In an earlier piece, the tragicomic *Self* (1997), an oversized painting was crammed into a seat opposite another painting on a wall.

Dan Rees (b. 1982, Swansea, UK) also incorporates furniture into painting (both he and de la Cruz might be said to recall

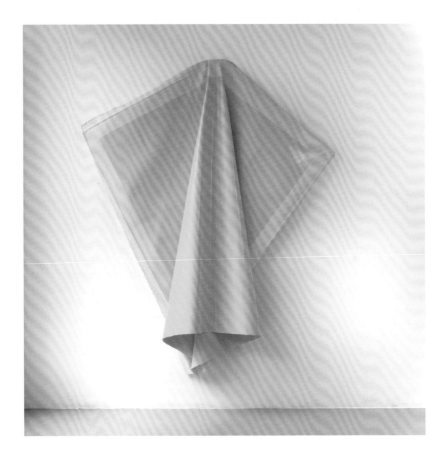

172 ABOVE Dan Rees, *Payne's Grey and Vermillion*, 2010
173 OPPOSITE David Ostrowski, *F (Between Two Ferns)*, 2014

John Armleder's 'Furniture Sculptures', which conjoin abstract art and functional objects, treating them equally as trifling decor [p. 91]). For *Shaker Peg Painting (Triptych)* (2011), Rees hung canvases on wooden peg rails, like disrobed clothes, to emphasize their status as objects. In another engagement with the physicality of painting, Rees's Rorschach-like *Payne's Grey and Vermillion* (2010) works as a site-specific, acrylic monoprint: a canvas with two hovering coloured forms provides the stamp for a mirror image hung on the adjacent wall, making evident the causal chain that produced it.

172 (margin)

Process is comparably manifested in the work of David Ostrowski (b. 1981, Cologne, Germany), who paints quickly, and

leaves in place such features as runny cobalt trails dripping
down supports as pictorial evidence of this method. These
model the canvas as a kind of sketchpad, the receptacle
for an unforced informality of line and gesture that is
nonetheless the product of careful study and execution.
A student of Albert Oehlen (p. 84) at the Akadamie in
Dusseldorf, Ostrowski lost the work that he had made during
his studies to an electrical fire in his studio in 2009. What
followed were paintings that were less laboured and less
layered than the earlier ones, but no less aesthetic. By calling
one *F (Between Two Ferns)* (2014), he nods to comedian Zach
Galifianakis's celebrity-interview series, while also pointing

173

1/4 Jennifer Bartlett, *Recitative*, 2009–10

to where his own work might end up: between houseplants, maybe above a couch. This is an acknowledgment that painting is liable to end up as furnishing – a continuation of the modernists' fears that the 'apocalyptic wallpaper' of meaningless abstraction would lead to the unwelcome fate of decorative irrelevance (for further discussion of which see Chapter 6, p. 270). The *F* in the title of the ongoing series stands for *Fehlermalerei*, German for 'failure painting', prompting questions as to the nature of the failure: is it within the painting or the ways in which it is ultimately put to use?

As much as the preceding artists conceive their work in installations, they do not seek to assimilate it into existing architecture, even when the work uses it as a buttress or exuberantly swells to cover a great deal of it. This strategy finds a point of contrast in Jennifer Bartlett (b. 1941, Long Beach, CA), who has described *Recitative* (2009–10) as an unending painting without edges. Running to nearly 49 metres (160 feet), it covers three walls and comprises 372 enamel-coated steel plates. *Recitative* groups together abstract notations – coloured dots, lines of different lengths and widths, hatch marks and brushstrokes, all of which might be infinitely recombined – before trailing off in a loopy black line. In dispersing an entity across so many constituents, Bartlett revisits her groundbreaking *Rhapsody* (1975), which she exhibited at the Paula Cooper Gallery, New York, in 1976. *Rhapsody* follows abstract and figurative panels with images of houses, mountains, trees and oceans through varying colour patterns and configurations. It pluralistically

174

encompasses aspects of period styles including photorealism and Pattern and Decoration.

In conflict with the conceptual orthodoxy of the California Institute of the Arts, where she studied in the 1990s, Laura Owens (b. 1970, Euclid, OH) is invested in the possibilities for painting. She fills canvases with lush landscapes and playfully wonky abstractions, employing a variety of techniques and media, ranging from impasto to silkscreen; she sets paintings freestanding in space, where they might be cast in the shadow of an inflexible architectural feature, and has added clock hands to others so that they may tell the time. Early works include multiple versions of paintings with wooden supports, one painted as though the viewer is looking at the back of the painting, and four others cropped to reveal the corners as though they could create a composite when placed together. After years of organizing and contributing works to other shows, in 2013 Owens presented twelve large-scale paintings covered with bold, computer-generated motifs in a warehouse near downtown Los Angeles. She had taken the site over as a studio, and it soon became 356 Mission (2013–2018), a venue for curated exhibitions (including Ruth Root's 2017 show, discussed on p. 55), programmes and the art bookstore Ooga Booga, as well as a studio for other artists.

175 In 2016, Owens made 'Ten Paintings' at CCA Wattis in San Francisco. An immersive installation, it featured a single 5-by-46 metre (16-by-150-foot) painting that covered three walls with silkscreened, flocked, painted, and hand-printed wallpaper. To make the work, Owens scanned a crumpled-up piece of white paper and converted the image into a bitmap (an image

175 Laura Owens, Installation view of 'Ten Paintings' at CCA Wattis Institute, San Francisco, 2016

that looks like a grid in which each square is a pixel of a single colour): literally making wall paper. Together with motifs lifted from her earlier paintings – chequerboard patterns and strokes from a digital paintbrush – were classifieds from the likes of *Berkeley Barb*, an underground newspaper published between 1965 and 1980, tarots and horoscopes, and other instances of California countercultural effluvia that have been overwhelmingly lost to the regional high-tech revolution. The installation was emphatically interactive: viewers could text questions to local phone numbers that appeared in the work and receive answers that boomed through nearby speakers. Further breaking down boundaries between the work and the space, wooden beams extending down from ceiling rafters correlated in places with the images of lumber bisecting the gridded panels of the mural itself, visually incorporating the existing shafts into the painted field.

Other artists might work to purposefully remove painting's autonomy by hiding it between walls, or more frequently, using it to cover walls or floors. Miquel Mont (b. 1963, Barcelona, Spain) makes painted surfaces that he hides between thick walls, boards or canvases. These could be shown on yet another wall, on the floor or sandwiched into an architectural crevice

176 from which the paint oozes. For a 2019 project at Hammer Museum, Los Angeles, Yunhee Min (b. 1964, Seoul, Korea) explicitly engaged with the architecture by layering abstract forms on the central staircase, in the first project at the museum to be oriented on the floor rather than the adjacent walls.

177 Katharina Grosse (b. 1961, Freiburg, Germany) wields an industrial spray gun to paint directly onto walls, floors, ceilings, windows or facades, as well as objects. She has applied this spray technique to found sites, including a whole house in New Orleans that was left behind after Hurricane Katrina, although Grosse typically creates landscapes composed of dirt, found objects and clothes, together with abstract, tectonic shapes made in wood, Styrofoam or plastic, and uses these as the ground for the sprayed paint. Since the colour – intense fluorescents and acidic synthetics – continues unabated irrespective of what it is covering, it produces a superficial continuity of forms. To achieve this effect, Grosse works very quickly, using a compressor to keep the pigment flowing. She also dons an impermeable Hazmat suit, in what might be described as a performance without an audience; though the works are completed on site, this happens prior to the show's opening.

176 OPPOSITE ABOVE Yunhee Min, Installation view of *Hammer Project*, LA, 2019
177 OPPOSITE BELOW Katharina Grosse, Installation view of *One Floor Up More Highly* at Massachusetts Museum of Contemporary Art, 2010
178 ABOVE Alex Hubbard, Installation view of 'El Cafecito', House of Gaga, Mexico City, 2016

Grosse's decision to keep the execution of the work unseen contrasts with artists who incorporate actions into the work. Alex Hubbard (b. 1975, Toledo, OH) performs for the camera in his studio, producing short, single-channel videos of his manipulation of objects on a tabletop. The fixed vantagepoint of the camera aligns the representational frame with the flat plane of its subject: a stand-in for the painted surface. This becomes an area of destruction through the very act of creation, as Hubbard's manipulation of the objects in the frame extends to overpainting and knocking items off the tabletop as work progresses. The resultant paintings concretize this action as artefacts, which he recuperates and exhibits on walls. One collage-like example flaunts a balloon from *Cinépolis* (2007), a video in which Hubbard haphazardly paints around a projection screen before using the support as a ground for a set of Mylar balloons, which he torches, tars and feathers with the insides of a disembowelled pillow. A 2016 presentation at House of Gaga, Mexico City, implied a different kind of conversion from one state to another. It featured a series of *Bar Paintings*, in which paintings fronted wall-mounted boxes that resembled medical cabinets but were stashed with alcoholic drinks like a bar. To see the painting, the interior must remain hidden;

178

when open, that cavity revealed the paintings' roles as props: 'theatrical gestures that yield secret space', as per the press release that accompanied the show.

Theatricality also informs the work of Mika Tajima (b. 1975, Los Angeles, CA), who, with curator and artist Howie Chen (b. 1976, Cincinnati, OH), co-founded collaborative group New Humans in 2003. The group produces sound work (using physical materials, piercing drones, static and low bass frequencies) within the parameters of Tajima's own shifting multimedia practice. The elements she includes in her works are paintings, props, stage markers and functional structures. A notable case is *The Double* (2008), presented at The Kitchen in New York and at the Center for Opinions in Art and Music in Berlin. Tajima conceived of a room bisected by double-sided freestanding panels on wheels, which in their planarity suggest painting and in their dimensionality sculpture, while also referencing Robert Propst's 1960s Action Office designs (commonly known as the cubicle). Propst's designs were commissioned by Herman Miller to foster productivity and conviviality in the workplace; in fact, they have become markers for alienated labour, and thus this reference is also a comment on the false promises of relational practices.

Tajima has repurposed the modular units elsewhere. In *The Extras* (2009) her wooden painting panels are surrogates

179

179 BELOW Mika Tajima, Installation view of *The Extras*, X Initiative, New York, 2009
180 OPPOSITE Sigrid Sandström, *Projection I*, 2018

for humans waiting for their star turn, in a scene reminiscent of a production set, while for a 2011 show at Elizabeth Dee Gallery in New York, she juxtaposed workspace dividers, ergonomic kneeling chairs, spray-painted wall-bound decoration and a performance by two contortionists; the last strained against the ciphers of efficiency, while at the same time demonstrating the marks of a punishing routine. In concert with Charles Atlas (b. 1958, St Louis, MO), Tajima occupied the main space of the South London Gallery for 'The Pedestrians' (2011). Over a ten-day period, the exhibition area became a rehearsal venue, film set and installation, supporting a programme of performance, music, video, lecturing, painting and sculptural tableaus – all of which were negotiated by viewers, who were guided through the space on a designated walkway.

Sigrid Sandström (b. 1972, Stockholm, Sweden) works with formal abstraction, applying paint in varied texture and quantity to give the appearance that paper, or other foreign items, have been added to the surface of her paintings; trompe l'oeil tape marks and controlled swathes of smeared paint further register the visual cues of collage. She has leaned large paintings against a wall, set them across from

mirrors to exaggerate their already optically disorienting and physically confounding effects, and hung small panels near to the ground. For 'Föreställningar' at Västerås konstmuseum, Västerås, Sweden, in 2018, Sandström responded to the walls of the cube-like gallery: painted grey, they set the stage for an ambient play of theatrical coloured light beams of perfect lavender, chrysalis pink, follies pink, slate blue, dark steel blue and daylight blue. Spots hit the relatively achromatic *Projection I* and *Projection II*, both 2018. These transitory marks added an extra layer to the paintings' surfaces, activating dry paint (the residue of once-active handling) and querying when the activity of making ceases.

180

Painting and Performance

Beginning with her use of ultraviolet pigments in 2005, Jacqueline Humphries (b. 1960, New Orleans, LA) posited that light might exist separately from colour. Backlit through translucent fabric supports, synthetic fluorescents turn on and off. When on, these paintings unite the ambient setting and its viewers, creating a psychedelic room-scape in which everything is incorporated: dust, lint and fingernails all glow, along with teeth and the whites of eyes. Her silver paintings also act as agents of destabilization, shifting from bright silver to dark grey depending on the ambient light and the position from which one views them. To achieve this receptivity, Humphries

181

181 Jacqueline Humphries, Installation view at Carnegie Museum of Art, Pittsburgh, Pennsylvania, 2015

182 Mary Weatherford, *from the Mountain to the Sea*, 2014

primes a canvas before using a clay-like black as the ground
for colours applied wet-on-wet, followed by a monochromatic
spread of silver, which she scrapes, re-paints, strips and gouges.
The brute physicality necessary to force the dense black
paint out of the tube, and the various implements required to
manipulate it, attest to the resistance of the materials and to
the exertion required of the technique.

Humphries's paintings insist that both making and
viewing are bodily. While the body is most obviously
represented in figurative work, it is no less essential to
gestural abstraction. Non-objective paintings may refer to the
maker's activity, visually registering, often deliberately, its
traces in preserved marks or manipulated surfaces. (One such
example is Katharina Grosse's work, p. 209.) As discussed in
Chapter 2, expressive, physicalized strokes do not necessarily
communicate the interiority of the maker, but they do, by and
large, evidence the manner of wresting material into form. In
a related externalization, paintings might also insist on the
centrality of the body perceiving them.

182 Mary Weatherford (b. 1963, Ojai, CA) creates atmospheric,
colour-washed paintings featuring giant tubes of neon affixed
to their surfaces. These epic linen canvases are evocations of
place but also meditations on illusionism; they draw attention
to where the viewer is positioned relative to the burning light,

183 Julia Dault, *Sure You Can*, 2011

reminding them of their physical presence and existence in time and space. The energizing of the relationship between viewer and painting need not, however, stop here. As paintings come off the wall, or create environments that we can walk into, the spectator's engagement becomes increasingly physical.

Such physicality is palpable in the work of Julia Dault (b. 1977, Toronto, Canada). Though her sculptures of commercial detritus – arced, folded and improbably tethered to the wall – contain no illustration of the individual who made them, they too reveal the presence of the artist through the brute strength necessary to coerce unwieldy sheets of Plexiglas and Formica for each site-specific installation. This is a power that one cannot help but sense, and perhaps even fear, as the forms threaten to undo themselves imminently, with a significant force. Less aggressive are her 'drapes', mutable paintings that hang from a nail or pin, bunched and folded in casual wall-

bound arrangements. They oblige further remaking with each hanging, in the important tradition of Sam Gilliam (b. 1933, Tupelo, MS), whose *Drape* paintings of the late 1960s hung without stretchers, as if they were curtains. Even in her more traditionally formatted paintings, Dault submits herself to restraints – such industrial implements as metal rulers and door handles, and jerry-rigged utensils such as branches and manipulated brushes – that control her gestures while still evidencing the spontaneity of her body's movements across the work's surface.

Perhaps above all, Jutta Koether (b. 1958, Cologne, Germany) has been influential in emphasizing the dialectical relationship between painting and performance. In the vein of her friend Martin Kippenberger (p. 86), Koether has achieved near-cult status for acting out the mentality of bad painting, with supports that might be festooned with cheap jewelry, encased with resin or coated with washes of pigment. This is to say nothing of her installations – replete with curtains of Mylar ribbons, silver walls, shiny, oversized fitness balls or pulsing strobe lights – and still less her theoretical writing and criticism or work for the music and pop-culture magazine *Spex*. The dedication and frequency with which she works with other artists and performers is remarkable: as a performer, she has collaborated with Kim Gordon and Thurston Moore of Sonic Youth, Tom Verlaine, Tony Conrad, John Miller, Mike Kelley and others, in alternative or underground scenes in Europe and America. With Gordon and Rita Ackermann, as the group Freetime, Koether experimented with collective paintings, and she has worked in collaboration with other artists – Josef Strau (p. 137) and Emily Sundblad (p. 218) among them – and under a variety of names, such as JXXXA, Mrs Benway, Reena Spaulings and Grand Openings.

Though Koether exhibits her paintings as completed objects (meaning once made they are not subject to subsequent transformation into another physical state), she incorporates them into scenarios in which they are activated from outside: so-called viewing sessions for her work to be seen in different light conditions, or appointments for giving her live feedback on paintings. She also allows for a multiplicity of uses, by herself and others. For example, her *Mad Garlands* (2011–12), a series of painted planks inspired by the tradition of the garland motif from ancient Roman wall paintings, have been shown as wall-bound objects at Campoli Presti in Paris, as components of a dance contest at the Museum of Modern Art, New York, and as illustrations of a presentation at a conference on art and subjecthood at the Frankfurt Städelschule. Before these,

'Lux Interior', her 2009 show at Reena Spaulings Fine Art, New York, presented just a single painting, which hung not on the gallery's walls but on a freestanding support in the centre of the room. (Koether repeated this strategy in 2011, avoiding the walls of Galerie Daniel Buchholz, Berlin, as if their very use might render the work ornamental.) *Hot Rod (after Poussin)* (2009), her homage to Poussin's *Landscape with Pyramus and Thisbe* (1651) – the sole item in 'Lux Interior' and the basis for poetry and performances around it – was theorized by the critic David Joselit as exemplifying the 'behavior of objects within networks by demonstrating...their transitivity', by which he means their open-endedness.

Reena Spaulings is an endeavour much in the spirit of art expanding beyond the canvas: Reena Spaulings Fine Art is the name of a gallery, and Reena Spaulings is a pseudonym under which a number of anonymous collaborators create work and an eponymous fictional character of a 2004 novel, collectively authored under the name Bernadette Corporation. Cofounder of the gallery Emily Sundblad (b. 1977, Dalsjöfors, Sweden) occupies a range of positions, from dealer and artist to actress and singer, and asks the same flexibility of her art. For 'Si me dejas te destruyo' ('If you leave me I will destroy you') at House of Gaga in Mexico City in 2010, she acted in the capacity of artist and dealer and more: hanging paintings in a restaurant next to the empty gallery, playing music in the streets and, courtesy of

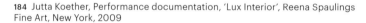

184 Jutta Koether, Performance documentation, 'Lux Interior', Reena Spaulings Fine Art, New York, 2009

185 Emily Sundblad,
Installation view
of '¡Qué Bárbaro!',
Algus Greenspon
Gallery, New York,
2011

Michael Werner Gallery, New York, exhibiting Francis Picabia's painting *Woman in Blue Scarf* (1942) in Mexico City via an I-chat live feed visible in the gallery during the show.

185 For '¡Qué Bárbaro!' at New York's Algus Greenspon in 2011, Sundblad worked with the gallerist Amy Greenspon and prop stylist Matt Mazucca to design the interior for the opening: gold folding chairs set up on a champagne carpet bathed in coloured lights, while canvases referencing friends and influences hung on nearby walls. She began the show with a cabaret performance of music orchestrated by Pete Drungle, who played a grand piano alongside a seven-piece band, during which Sundblad sang in a gown designed by Lazaro Hernandez and Jack McCollough of the American fashion brand Proenza Schouler. After the first night, the costume came to rest on the wall, alongside newly designated paintings of flowers and clocks, abstractions and framed pages from an auction catalogue, which had, after the opening performance, been released from their purgatorial duty as props and claimed as artworks. The changing status of an object between painting

and prop continued; in parallel with the gallery presence, Sundblad sent a self-portrait/announcement for the show directly to Phillips de Pury, to be auctioned in its sale of contemporary art on 13 May 2011. As she wrote in the materials for the show: 'The time of the artist's emergence and their work showing up at auction is shockingly brief. With this painting I decided to cut to the chase.'

Ei Arakawa (b. 1977, Fukushima, Japan) also epitomises the position of making art as reflexive social spectacle. *Mid-Yuming as Reconstruction Mood* (2004), a half-hour-long performance in which Arakawa and his collaborators built and disassembled a temporary platform, was based on the rapid construction and dismantling of the stage for the National Football League's famous Superbowl halftime show: a coordinated effort involving hundreds of people working together to complete the task within the allotted time of a commercial television break. In doubling back on itself, the work also related to the makers, who, like Arakawa, had been immigrants. When performed under the sign of 'homelessness' at the Yokohama Triennale in 2008, Arakawa implied that the lives that we build are contingent on circumstance and always at risk of dispossession. He likewise challenged the parameters

186 Ei Arakawa, Performance of *I am an Employee of UNITED, Vol. 2*, Overduin and Kite, Los Angeles, 2012

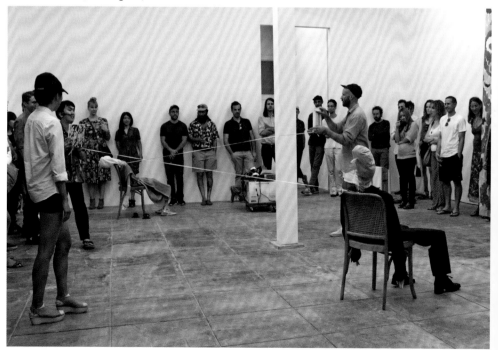

of spectatorship by failing to indicate the beginning of the performance. Consequently, the action looked like a work being installed by handlers, with bodies moving around a construction site and materials shuffled into and out of place. As soon as forms began to connect, whatever had been erected was undone in a deferral of finality, which was only fulfilled after the materials had been tucked away behind a false wall.

Arakawa's *Towards a Standard Risk Architecture* (2006) further incorporated the public as participants, however unwittingly. The artist and his associates endlessly shifted construction materials, vacuumed and otherwise distracted gallery-goers at Reena Spaulings Fine Art, New York, who were thereby stymied in their efforts to see the wall-bound works – the art that was seemingly on view. Arakawa more explicitly invited audience interaction when, following a dance routine carried out by art students from the Hochschule für bildende Künste Hamburg, people were encouraged to dance in the streets around the venue. This piece, the opening of 'BLACKY Blocked Radiants Sunbathed' at Kunsthalle Zürich in 2011, featured Arakawa and his brother Tomoo Arakawa (under the name UNITED BROTHERS) in collaboration with DAS INSTITUT and the fashion designer Nhu Duong.

As with collaboration, travel is a mainstay for Ei Arakawa, forming the basis of 'I am an employee of UNITED, Vol. 2' at Overduin and Kite, Los Angeles, in 2012 ('Volume 1' took place at Galerie Neu in Berlin in 2010). As the press release stated:

> With their expanded organizational skills, they [Arakawa, Nikolas Gambaroff and Shimon Minamikawa] *manage to fly 100,000 miles (160,000 km) in a calendar year, all operated by one airline alliance. Museums and galleries covered all of the expenses. The collective is now Premier 1KTM.... Since 2005, their performances have been all over: Jan: Tokyo, 14,000; Feb: Berlin, 7,000; Mar: London, 7,000; Apr: Paris, 7,000; May: Seoul, 14,000; Jun: Basel, 7,000; Aug: Milan, 7,000; Sep: Sao Paulo, 9,000; Oct: London, 7,000; Nov: Warsaw, 8,000; Dec: Hong Kong, 14,000; total: 101,000. This is typical of a performance artist today.... Inside our carry-ons, each under 14 inches x 9 inches x 22 inches (23 x 35 x 56 cm), there are objects not claimed as art. Those objects are almost like tools, yet too precious and fragile to send them over by FedEx.... The objects are scanned and explained at the security gate (officers don't really care what they are). We take care of those objects as if smugglers.*

Given the global climate crisis, this position is untenable, or at the very least, irresponsible – a glaring example of the industry

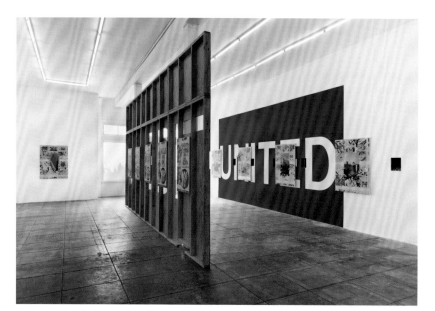

187 Nikolas Gambaroff, Installation view of 'Tools for Living', Overduin and Kite, Los Angeles, 2012

culpability in this area, and a reminder of how, until recently, such copious travel indicated status and success predicated upon jet-set mobility.

Assuming the role of contemporary artist as cultural service provider, Arakawa explored themes of transit and exhaustion more critically through a performance involving painted panels inserted into wall niches, and mannequins, which were for the remainder of the show left to sit in wooden chairs and contemplate a wall painting. In treating the aftermath of performance as nascent installation, Arakawa suggested the convertibility of these materials and the possibility of repurposing infrastructure. The scenario served as the basis for the show of Nikolas Gambaroff (b. 1979, Frankfurt am Main, Germany) at the same gallery two months later, who reclaimed aspects of Arakawa's display, and transformed them into backgrounds for mixtures of paintings and collage that he supplied. In this act, Gambaroff established a kind of game of exquisite corpse (the surrealist parlour game in which a group of participants create a drawing without seeing one another's contributions, resulting in a composite creature). As in his other projects in which performance acts as a support for painting, he simultaneously treated process as form, and form as process. Here, process refers not just to the creative

187

act; Gambaroff also examines the administrative system that is involved in the staging of art, titling a show at Balice Hertling, Paris, '2008 8864 3362 2250 Z1 CDGRT' after the FedEx tracking number attached to the abstract oil paintings he sent to the gallery.

Social Studies

Math Bass (b. 1981, New York, NY) moves between performance and object-making, with the residues of early performances retained in other formats. Notably, since 2013 Bass has worked on *Newz!*, a series of brightly coloured shapes and recurring hard-edged images – including a plume of smoke, binoculars, a Scottie dog, a cigarette, a matchstick and an open-jawed crocodile – set into frieze-like motifs on raw canvas. The passage of their work from one format to another is evident in these paintings, some more directly than others. The smoke icon recalls both Bass's 2010 solo performance *Another Country*, in which their voice was projected live, together with a pre-recorded soundtrack, while a scooter ran and filled the room with carbon monoxide, as well as the 2011 performance piece *Dogs and Fog*, 2011, in which Bass filled a gallery with dogs and fog, before singing with friends, standing atop cinderblocks arrayed in a circle.

Further, Bass poses that a prop for artmaking may become a sculpture, or an exhibition a performance event, indicating that anything can lend itself equally, if not simultaneously, to multiple roles. A sculptural ladder might be climbed (another

188 Math Bass, Installation view of 'Off the Clock', MoMA PS1, New York, 2015

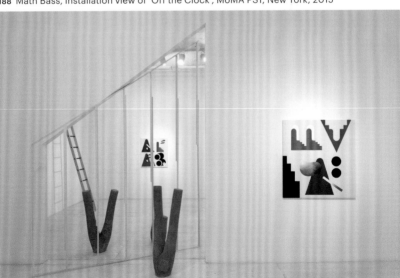

recurring feature, and one that Bass now fabricates in walnut to indicate its evolution from studio tool to aesthetic product), as in *Brutal Set*, performed at the Hammer Museum in 2012 as part of 'Made in L.A.'. Or its role might be subverted, as in *Body No Body Body* (2012), in which Bass fitted sewn, striped canvases over unfolded steps, coaxing oddly affective bodily decoys from the inanimate things. Bass's title for a solo show at the MoMA PS1 in 2015, 'Off the Clock', also implied that things could moonlight as something different.

Bass leaves the props in place after the performance ends, allowing viewers to carry out their own choreography in moving through the spaces, effectively asking whether they are enacting a performance of their own. Others prevent stasis in their work through different means. Vanessa Maltese (b. 1988, Toronto, Canada) literalized the connection between process and form in a 2018 installation at Night Gallery, Los Angeles, where she displayed a series of reimagined surrealist parlour games, cartoons for the viewer to complete. Through this, she effectively cued the manipulability of the graphic geometric paintings that surrounded them. Each of the paintings has a powder-coated steel frame with moveable pieces: magnetic, acrylic-coated wooden shapes (short lines, half-spheres, jaunty arcs), the physical presence of which complicated the plays of illusion within the compositions.

The Taiwanese artist Michael Lin (b. 1964, Tokyo, Japan) makes elaborately painted, day-bed-like platforms, furniture and cushions, from which viewers can absorb work installed nearby, and in so doing, become part of a moving tableau. In 2016, he wrapped the walls of Manila's Museum of Contemporary Art and Design (MCAD) in bright floral prints appropriated from textiles from his native Taiwan. For *Untitled Gathering, Manila*, in the main gallery, he extended the flowers to cover 240 wooden stools – low seats found commonly on Southeast Asian sidewalks – in a shifting puzzle, the individual components of which were to be reassembled by viewers. In another instance of refusal to administer and determine social space, Mary Heilmann (b. 1940, San Francisco, CA) produces painted-wood and polypropylene-webbed Clubchairs on casters from which to view her paintings. With them, she encourages people to idle and roll the chairs about to form conversational groups.

Sarah Crowner's (b. 1974, Philadelphia, PA) collage-like, sewn geometric paintings make over schemes from Victor Vasarely, Lygia Clark and others; their part-by-part seamed constructions wrap tautly around their stretchers like vernacular quilts. Large-scale and often immersive, they serve as backdrops for

189 Vanessa Maltese, *Duped by the grapes*, 2018

Beyond Painting

190 TOP Michael Lin, Installation view of 'Locomotion', Museum of Contemporary Art and Design, Manila, 2016
191 ABOVE Mary Heilmann, Installation view of 'To Be Someone', Orange County Museum of Art, Newport Beach, California, 2007
192 OPPOSITE Sarah Crowner, Installation view of 'The Wave', Nicelle Beauchene Gallery, New York, 2014

unscripted actions in the gallery, with some even suggesting theatre curtains opening to an empty stage. Referencing futurist stage sets, such as those by Fortunato Depero and Giacomo Balla, 'Ballet Plastique' at Galerie Catherine Bastide in Brussels (2011) featured a raised plywood stage on which visitors had to climb to inspect the paintings at closer range. For 'Acrobat', a show of the same year at Nicelle Beauchene Gallery in New York, Crowner exhibited small wooden sculptures, envisioned as proposals for subsequent theatrical incarnations. Indeed, this was borne out in her painted backdrop for a Robert Ashley opera at the Serpentine Gallery, London, in 2012 – a project that has inspired others, including Crowner's 2018 contribution of scenery and costumes for the American Ballet Theatre.

Crowner has also been working with hand-glazed ceramic tiles that she fabricates in Guadalajara, Mexico, which, when complete, she lays out in patterns on the floor or wall as though composing a painting. These may extend from wall to wall or layer over a platform (a room within the room), though in either case, Crowner refuses the illusion of totality (the *Gesamtkunstwerk*, or total work of art) by ensuring there are positions from which the outside of the scenario remains in view. 'The Wave', Crowner's 2014 show, also at Nicelle Beauchene Gallery, featured a shimmering turquoise parquet, a mosaic of more than a thousand tiles set into a Wiener Werkstätte herringbone pattern. Five

192

193 ABOVE Marc Camille Chaimowicz, Installation view of 'Your Place or Mine...',
The Jewish Museum, New York, 2018
194 OPPOSITE Elise Adibi, Installation view of *Persian Rose Monochrome*, with plants,
from *Respiration Paintings*, The Frick Pittsburgh Greenhouse, 2017

paintings hung on the adjacent walls and two were supported
by freestanding structures at the floor's perimeter. When
standing behind these, viewers could see the backs of the
two unattached paintings, strings hanging, easel skeletons
conspicuous. These multiple perspectives show perception
to be corporeal, contingent and durational, forcing an active –
if irresolvable – mode of beholding the work.

Marc Camille Chaimowicz (b. 1947, Paris, France) offers an
even more encompassing environment in which viewers engage
with the work and space – and with other viewers doing the
193 same. His major 2018 show, 'Your Place or Mine...', iterates
a decades-long project in which he designs decorative objects
and art in relation to his apartment, which originally served
as his performance site. The setting of this installation at the
Jewish Museum, New York, a French Gothic style landmark
built in 1908, extended this logic. Within it, an array of work
from throughout his career was grouped as if displayed in
domestic interiors. The pastel period rooms evoke a somewhat
indeterminate past. Chaimowicz used curving pathways to
connect the galleries of patterned wallpaper and framed art,
furniture and small sculptures, creating a meandering route
that mimicked the circuitous trails through the neighbouring
Central Park.

Creating an interior world that is continuous with the exterior, Elise Adibi (b. 1965, Boston, MA) showed her *Respiration Paintings* – abstractions with grids and pours of pigments mixed with essential plant oils – in the Frick Greenhouse in Pittsburgh, Pennsylvania, from April to October 2017, in a profound meditation on transience and the reciprocal relations between people, art and nature. Subject to changing seasons and fluctuations in temperature, humidity and light levels, and beset by torrential rains that rushed through the century-old glass structure, the paintings on canvas changed during the installation as elements activated the organic matter in her paintings and mould took root.

Adibi courts direct engagement with the material of painting, exploring the role of accident. As well as activating the canvas itself (Adibi works with a precise shade of pistachio green that brings forth the otherwise imperceptible red in the unprimed beige fabric), in many pieces she uses the grid as a foundation for emergent patterns. Despite the priority of the grid and its regularized matrix, the combination of multiple paint layers and human slips means imperfections and misalignments predominate. Adibi pushes this bodily connection with her work further by choosing organic materials, incorporating the plant-oil pigments, as well as rabbit-skin glue, graphite and even her own urine. The last seeps into the thick ground, streams down its surface in rivulets or radiates outwards in stains that suggest cosmic nebulae, and the imagery 'develops' as the urine interacts with a copper-based paint that coats the support like an emulsion. For another show in 2018, 'The Outermost Painting' at Allegheny College, Pennsylvania, Adibi

195 TOP Firelei Báez, Installation view of *19.604692°N 72.218596°W,* 'En Plein Air', High Line, New York, 2019–20
196 ABOVE Paul Branca, Installation view of 'Couch Crash', Golden Parachutes, Berlin, 2010

left a single copper painting that she had oxidized with her urine outside, exposed to the elements, and brought people together around it, even in the dead of winter.

195 Attempting to rethink public art as such, in 2019, a group show of paintings was unveiled on the High Line, New York – a 2.4-kilometre-long (1.5-mile) elevated park on a former New York Central Railroad spur that cuts through the Chelsea gallery district on Manhattan's West Side – to be on view outdoors for a year. Ei Arakawa, Firelei Báez, Daniel Buren, Sam Falls, Lubaina Himid, Lara Schnitger, Ryan Sullivan and Vivian Suter all contributed works that relate to the tradition of open-air painting, in concert with the show's title, 'En Plein Air' (which refers to the mid-19th-century practice of painting in the landscape instead of the studio, a custom made possible by the invention of paints in portable readymade tubes).

For many, performance implies an even more direct engagement with audiences, less as witness to an event or its aftermath – or viewers within an indoor or outdoor installation – than as participants in its realization. Think back to Marina Abramović performing *The Artist is Present* (2010) at the Museum of Modern Art, New York, as discussed in Chapter 2 (p. 73). Or to give another example of a performance involving direct contact, for *Museum Museum: XX* (2007), executed as part of the Performa Biennial in New York, David Adamo (b. 1979, Rochester, NY) stood in front of John Singer Sargent's *Madame X (Madame Gautreau)* (1883–4) at the Metropolitan Museum of Art, New York, for a whole day, communing with the art and interacting with others. If this work asked how interpretation might come from discourse, and relationships from both, a subsequent performance at the Bergen Kunsthalle in Norway in 2011 involved Adamo spending a night in the museum, improvising on a piano in total solitude.

Paul Branca (b. 1974, New York, NY), too, develops explicitly relational projects. He has painted images on phone cards for use by immigrants, and in 2010, set up a 'painting distribution project' at Golden Parachutes in Berlin. There, Branca hung nineteen monochrome paintings in the colours of the German 196 flag, emblazoned with Google-translated lines about travel and displacement. The title 'Couch Crash' nodded to staying with friends, and, more broadly, suggested the realities of artists travelling from place to place on a low budget and the networks that make this possible. Branca invited his friends in Berlin to take a painting as a gift on a first-come, first-served basis: once they removed their respective paintings, the nails were left behind as markers of the accepted offerings. In an alternative

197 Oda Projesi, *Picnic*, Galata, Istanbul, 2004

kind of exchange, the only paintings for sale, which remained on view after the others were taken home, were three works composed of materials left over from making the presents. In holding the relational and transactional strands of his work in tandem, Branca refuses the approach of so many relational projects of the preceding decade, which proposed that gifting upends capitalism, rather than providing it with another point of entry.

Still others use paintings as pretexts for even more directly activist projects predicated on social engagement. This is discussed more fully in Chapter 7, but a few key cases of this direct commitment are as follows. In 2000, Özge Açıkkol (b. 1976, Istanbul, Turkey), Güneş Savaş (b. 1975, Istanbul, Turkey) and Seçil Yersel (b. 1973, Istanbul, Turkey) founded the collective Oda Projesi, or 'Room Project', in Istanbul, using an apartment in Galata (one of the city's oldest neighbourhoods) as the site for communal activities and a gathering place for artists, musicians, scholars and nearby residents. Engaging directly with local children and their families on a regular basis through, among other things, a Sunday programme, Oda Projesi's members shared art supplies, and used clotheslines to display artwork and streets as sites of production and pedagogy.

197

Galata became gentrified rapidly, and Oda Projesi lost their lease in 2005. This initiated a comparatively mobile way of working, in which capacity the collective continues today.

More recently, Theaster Gates (b. 1973, Chicago, IL) commenced Dorchester Projects, a major urban renewal project on the South Side of Chicago, where, due to the subprime mortgage crisis, he was able to buy buildings in disrepair. These are being put to use for concerts and performances, and they serve as repositories for art and architecture books, 19th- and 20th-century glass-lantern slides and the archive of John H. Johnson, who founded Johnson Publishing Company, famous for the magazines *Ebony* and *Jet*. As Gates remarked in an interview: 'I started to recognize that if there was not direct intervention by normal people, black space in the United States would not be saved. It would simply spiral down, without a whole lot of investment from outside.'

These urban renewal projects might be compared to others in the US, including Edgar Arceneaux (b. 1972, Los Angeles, CA) and Rick Lowe's (b. 1961, Eufaula, AL) Watts House Project in Los Angeles, itself modelled on Project Row Houses,

198 Theaster Gates, *Land Ownership on Conspiracy Blue*, 2016

Houston, a previous venture by Lowe in the 1990s, which gave shelter to single mothers and set up artist residencies and exhibitions. Watts House Project is a non-profit that gathers artists, designers and residents of the eponymous post-industrial neighbourhood to renovate homes. But Gates goes further in 'recirculat[ing] art world capital'. For the cultural activities at Dorchester Projects are financed by the sale of artworks fashioned by materials – marble, wood, roofing paper – salvaged from the structures he purchases. The decommissioned fire hose in particular has become important to Gates for its additional reference to the hosing of civil rights demonstrators in Birmingham, Alabama, in 1963 (that served a very different end for Kelley Walker, as discussed in Chapter 1, p. 38).

198 Gates has also made paintings in 2016 and 2017 based on sociological studies on the advancements of Black Americans in the decades after the Civil War. There is a tension between the nature of these works as determined by context and their self-sufficiency as discrete objects. Gates renders statistical data as hard-edged shapes, stark geometries without captions that act as a guide for the charts that are absent from these paintings but exist in the original pages of the studies. These paintings pose a core issue of representation: what is communicated in the field of the image, and what reading and learning must be brought to bear on it. The works do not so much inject 'content' into modernist abstraction as insist that the context for making and circulating such canvases is necessarily a social field. But this field is subject to misrecognition, as Gates acknowledges elsewhere (productively achieved in his fire hoses, which harness the historical baggage of painting by presenting materials that are politically freighted and from outside the artistic tradition to look as if they are modernist abstraction). The next chapter considers this from another angle. By acting on painting, as opposed to using it to transmit clear content, to represent narrative, and so on, is to endow it with a self-reflexivity: it allows the artist to produce a painting about painting. The risk in so doing is that this may also produce a solipsism or return art to the status of a merely decorative picture on the wall.

Chapter 6
About Painting

Contemporary artists may question where, when and under what circumstances a painting becomes legible as a painting, or ceases to be so considered. As demonstrated in Chapter 5, painting no longer exclusively implies an image on a flat picture plane, framed on a wall (even if it may well sometimes be that, too). And as will be posited in this chapter, external circumstances 'beyond' the painting motivate the medium anew, with the institution (its physical architecture, but also its power in authorizing work for display, and the meaning ascribed through its selection) playing a crucial role in the course of painting's de- and re-definition. Questions as to what painting is – and what good painting is – are answered provisionally with each work that comes to be shown. In this way painting exists productively as an investigative tool to explore not only how we see, but also how the institution filters this act of reception in the first place.

In what is perhaps an extreme case in point, Maurizio Cattelan (b. 1960, Padua, Italy) installed 128 of his works of art – representing the near-entirety of his output since 1989, from preserved animals to framed photos and paintings – at the Solomon R. Guggenheim Museum, New York, in 2011, for his retrospective 'All'. The works did not hang on the walls, but rather from ropes lowered from the museum's ceiling; viewers circled the ramps around the central cavity to see the art. This proved an especially strange unmooring for some pieces, such as *Untitled* (2009), a painting pinned to a wall by a broom, the upright stick of which pokes and distorts the canvas surface.

If Cattelan shows just one position for painting as an object – and a potentially inert one at that, hanging listlessly, as if from a noose – his work is also indicative of the ways in which artists have extended their forebears' institutional

199

199 ABOVE Maurizio Cattelan, Installation view of 'All', Solomon R. Guggenheim
Museum, New York, 2011
200 OPPOSITE Heimo Zobernig, Installation view of 'Ohne Titel (In Red)', Kunsthalle
Zürich at Museum Bärengasse, 2011

critique in the service of painting. The Guggenheim's history itself provides examples of past attacks of this kind, by the likes of Hans Haacke (b. 1936, Cologne, Germany) and Daniel Buren (b. 1938, Paris, France): both called foul on the institution while manoeuvring within it, pointing to the museum's operations as well as to the burden of architecture. In 1971, Haacke's solo show at the Guggenheim was cancelled and the curator fired when the artist refused to pull works such as *Shapolsky et al. Manhattan Real Estate Holdings, a Real-Time Social System, as of May 1, 1971*, which details the real-estate holdings of a then-trustee's New York empire built on slums. Earlier that same year, Buren's *Peinture-Sculpture*, a giant, vertically striped banner unfurled from the skylight crowning the rotunda, was removed from the museum's 'Sixth Guggenheim International Exhibition' after fellow exhibitors complained that Buren's installation blocked sight of their works. Though other artists wrote protesting this act of censorship, the painting was not reinstalled.

The Buren episode remains a potent instance of institutional critique registered through painting. It prefigures more recent work that challenges institutions' claims on art, even as the work depends heavily upon the institutions for economic support and visibility. For example, Heimo Zobernig (b. 1958, Mauthen, Austria) collaborated with Albert Oehlen (p. 84) in 1994 for a show at the Vienna Kunsthalle, where he installed red fluorescent lighting: an

incandescent haze through which to see Oehlen's canvases. Zobernig reprised this strategy at the Museum Bärengasse in 2011, where, as before, the circumstances of display transformed the objects on view (in this case, Zobernig's own work). There it deliberately amplified the museum's lighting problems, recuperating these institutional shortcomings for Zobernig's purposes.

Given the broadening of the scope of 'painting' that has already been considered in Chapter 5, Chapter 6 emphasizes painting that more straightforwardly deconstructs the history and conventions of painting as its own institution. This idea of 'institution' is defined as established practice and custom. A subset of abstract work that is conceptual in this vein has, over the last few years, ironically come to appear so absent of meaning as to return painting to 1980s-like debates around the empty commodity. This perceived frivolity of formal innovation loosened from consciousness of the times was unceremoniously tagged 'Zombie Formalism', and the reaction against it serves as the basis for Chapter 7; in response to assertions of the medium's decorative frippery, such works see a return to painting as something much more socially engaged, even useful.

The Institutions of Painting

Considering painting about painting, Stephen Prina (b. 1954, Galesburg, IL) has described his output as 'system specific', a reflection on how exhibition spaces relate to art discourse. *The Painter's Studio, Real Allegory, Resolving a Phase of 153 Years in My Artistic Life: A, No. 1* (2001), an off-white, screen-printed canvas with the initials 'SJP', honours his commitment to painting as subject and practice. Each of Prina's pieces is related in some way, and develops in a series of long-term projects that often mutate within different contexts – informed by personal associations as much as they are by circumstantial factors like the limitations of existing exhibition architecture – in a chain of reference that leads back to previous shows and sources. He has even made paintings in primary colours on commercially produced linen window blinds, merging art and architecture in a new variation on collaborating with site.

Prina's best-known project is his *Exquisite Corpse: The Complete Paintings of Manet* (1988–present), a reinterpretation of each of the 556 items of Edouard Manet's oeuvre listed in a now-outdated catalogue raisonné. Rather than reproducing the extant paintings, Prina pairs a lithograph of a particular work (reproduced in the exact size and format of the original,

201 Stephen Prina, Installation view of *Exquisite Corpse: The Complete Paintings of Manet, 135 of 556: L'Execution de Maximilien de Mexique III (The Execution of Maximilian of Mexico III), 1867,* Kunsthalle Mannheim, 1990

but without attempting to figure the paintings or reproduce Manet's pictorial content) with a charted overview of Manet's body of work, executed in ink wash or watercolour on rag paper. When cited in full, each of the individual titles refers to an original painting and its location, including the places and collections through which it has passed: e.g. *Exquisite Corpse: The Complete Paintings of Manet, 41 of 556, Nymphe Surprise (The Startled Nymph), 1861, Nasjonalgalleriet, Oslo,* 1988. Prina has asserted that he chose Manet as the subject of this exercise precisely because of Manet's status as the artist who many consider to be the first modernist, as well as that of the first 'museum artist' – that is, an artist who assumed the museum would be the eventual home for his painting, according to the philosopher Michel Foucault. As discussed at greater length in Chapter 3, this formulation shows paintings to be implicated in institutions and dispersed across fields of information, even before they are painted.

202 Scott Lyall,
*Nanofoil (SLStudio.
clone_1/1/3), 2018*
(detail)

 This anticipation of the gallery as the destination for
painting, broached in Prina's project, has been investigated in
other instances. Scott Lyall (b. 1964, Toronto, Canada) weaves
between examinations of material, the gallery and his areas
of research. For a presentation at Sutton Lane, Paris, in 2011,
he exhibited composites of digital files containing thousands
of different colours, applied to canvas and vinyl in successive
layers. If the work is neither solicited for subsequent showing,
nor purchased, Lyall retires the code on which it is based. He
has described his installations as scenography, relating to
the staging and managing of parts into a theatrical whole.
His 2019 show 'Superstar' at Miguel Abreu Gallery, New York,
comprised near-holographic paintings made with Nanomedia,
a technology developed by a team of optical physicists at

Simon Fraser University in British Columbia, with whom Lyall collaborated to apply the technology in an artistic context. In the resultant series, *Nanofoils*, the colour is neither chemical nor pigment, but rather the actual appearance of scattered light; the viewer does not look at a static image, but a performance initiated each time the eye interacts with the artwork.

Cheyney Thompson (b. 1975, Baton Rouge, LA) also explores the subject of networks of invention and display. 'Quelques Aspects de l'Art Bourgeois: La Non-Intervention' (Certain Aspects of Bourgeois Art: Non-Intervention), a 2006–7 show at Andrew Kreps Gallery, New York, consisted of a series of twenty-five colour offset lithographs depicting the gallery's art storage bay, clustered in groups of five; four large, abstract oil paintings in greyscale, derived from blurred photocopies; and eight lightweight folding tables on which were displayed sixteen imageless photographic prints progressing from white to black. A viewer following the diagonal path of the tables would traverse the gallery to arrive at the storage bay pictured in the lithographs, completing the narrative circuit. However repetitive the loop, the folding tables – neutral presentational devices but also explicit symbols of the portable economy of the street – led back outside, further extending the reach of the objects and their relations. More recently, 'Bird Shells and Chambered Wings', at Raucci/Santamaria in Naples, Italy in 2016, featured Thompson's abstract images as a kind of painting by the yard: items were displayed at identical height but adjusted in width in proportion to the walls. The resultant works will always reflect their origins, even when exhibited elsewhere, precisely by not fitting in as seamlessly anywhere but their original site of display.

Merlin Carpenter (b. 1967, Pembury, UK) is a former assistant of Martin Kippenberger (p. 86), as well as a writer, and he is co-founder of Poster Studio, an artist-run space in London, which he started in 1994 with Dan Mitchell, Nils Norman and Josephine Pryde. His work repeatedly engages in institutional critique, from the gallery to conventions of painting, such as authorship; for example, in 2011, Carpenter gave away a gestural painting that he had created in 1990 and signed with a stencil, in exchange for twenty copies of it, painted by the recipient and also signed with a stencil. He has exhibited paintings produced in galleries just in advance of, or even during, exhibition openings: these canvases bear slogans such as 'BANKS ARE BAD', 'Kunst [Art] = Kapital', and 'DIE COLLECTOR SCUM', and have been presented in galleries in New York, Zürich, London and Brussels, as well as in a car showroom and a fashion

boutique in Berlin. For 'A Roaring RAMPAGE of Revenge' in 2005, he enlisted his gallerists as assistants at Reena Spaulings Fine Art, New York, to make brushy paintings of the World Trade Center on 9/11, in the style of Josh Smith (p. 133). Over these he superimposed gallery press materials, one Xerox per canvas, resulting in a portrait of the gallery at the time of exhibition. (The gallery's promotional materials that were used for this work – the complete gallery press pack for 2005 – chart the ascension of the Chinatown gallery in the wake of the 9/11 attacks.) At the Frieze Art Fair in London in 2008, Carpenter exhibited Burberry throws, both genuine and knock-off, displayed on stretchers, in a comment on commercialism and authenticity.

As these works illustrate, Carpenter's paintings are suited to the spaces they critique, especially, perhaps, his holistically conceived 'TATE CAFÉ' at Reena Spaulings Fine Art, New York, in 2012. The gallery is run by John Kelsey and Emily Sundblad, who are also members of the artist collective that works under the guise of fictional artist Reena Spaulings, a separate entity to the gallery (Sundblad and Reena Spaulings are discussed

203

203 BELOW Merlin Carpenter, Installation view of 'TATE CAFÉ', Reena Spaulings Fine Art, New York, 2012
204 OPPOSITE Nick Mauss, Installation view of *Concern, Crush, Desire*, Whitney Biennial, New York, 2012

Espresso Bar

Exhibition Shop

further in Chapter 5, p. 218). 'TATE CAFÉ' was created in
response to Reena Spaulings (the artist collective) contributing
a work of Carpenter's to the Tate gallery in London for its 2009
pop-art blockbuster, 'Pop Life', despite him refusing permission
for them to do so. 'TATE CAFÉ' was built to replicate its
namesake's recognizable furniture, counter area and comment
cards, and even featured a photomural of the venue's view
of the Thames. A bookstore stocked with books associated
with the artist and the gallery provided a setting in which
viewers could read an interview between Carpenter, Kelsey
and Sundblad, which discussed the event and raised questions
about the roles of artists and museums, many of which remain
unanswered. Like a snake eating its tail, one could speculate
that perhaps the paintings Carpenter included will one day end
up at the Tate.

 Nick Mauss (b. 1980, New York, NY) addresses the gallery as
a social structure within which painting operates, initiating
a dialogue with the space of display. For the 2012 Whitney
Biennial, Mauss built an antechamber to the cosmetics
company Guerlain's first Institut de Beauté spa in Paris (dating
from 1939), designed by Christian Bérard. Instead of supplying

204

205 Nasrin Tabatabai and Babak Afrassiabi, Installation view of 'Two Archives', Tensta Konsthall, Stockholm, 2013

his own drawings or silver paintings, Mauss installed objects from the Whitney's collection on the makeshift walls. A small screen embedded in one of the walls of the stage-set-like chamber reverse-projected slides of Mauss's studio, fragments of text and abstractions, which set off further associative chains to be reconciled (or not) by viewers. More recent painted mirrors reflect the people who pass before them; while static, the images that dance across the surfaces are not. In this way, Mauss's work directly implicates the spectator in the construction of value initiated by the institutions themselves.

A branch of conceptual art that began in the late 1960s, institution critique prioritizes the scrutiny of institutions, especially those that take the presentation of art as their primary task and subject matter (museums and galleries, biennials and fairs, but also publications and publicity materials as part of an expansive media ecosystem). Such critique is manifold, but it includes a focus on the institution's

part in conferring value onto artworks and artists, its involvement in securing funding from compromised sources, and so on. This relies on a fundamental division in which, in a David and Goliath-like battle, the artist opposes the mighty institution. This dynamic continues to play out in many forms: from near-comically meta (as with the Carpenter projects, p. 241), to research-driven and analytical (as with the Thompson, p. 241), to viewer-contingent (as with the Mauss), to more directly activist works.

Nasrin Tabatabai (b. 1961, Tehran, Iran) and Babak Afrassiabi (b. 1969, Tehran, Iran) take political constraints as the subject of their painting, installation and video work: those constraints that result in paintings being moved across borders, and into or out of sight. Since 2004, the two artists have collaborated under the name Pages, publishing a bilingual (Farsi and English) magazine; in 2011 they began a series involving intersecting archives in the UK and Iran, one industrial and the other cultural. The modernization that took place in Iran is recounted in the archive of British Petroleum (formerly the Anglo-Persian Oil Company, and then the Anglo-Iranian Oil Company), which contains documents relating to the company's operations in Iran from 1908 to 1951 (when the oil industry was nationalized). Their second case study, the collection of modern Western art by the Tehran Museum of Contemporary Art during the late 1970s, continues the former project on different terms, since it was rising oil prices that made possible the acquisition of Western works. Following the Islamic revolution in 1979, the collection was withdrawn for twenty years and put back on display only intermittently thereafter. Tabatabai and Afrassiabi's images of storage racks further this sense of artistic exile, while simultaneously exposing the situation.

Much more direct in their accusations is Decolonize This Place, 'an action-oriented movement centering around Indigenous struggle, Black liberation, free Palestine, global wage workers and de-gentrification', in their own words. The shifting group of collaborators who work under this name has rallied around issues of decolonization at the Brooklyn Museum, New York, in 2018, protesting the hiring of a white woman as consulting curator for African art, and that same year began weekly picketing of the Whitney Museum of American Art, New York, calling for the removal of a trustee whose wealth comes from manufacturing defence supplies, including tear gas that was believed to have been used against a migrant caravan along the US-Mexico border. Around the same time, Prescription Addiction Intervention Now (P.A.I.N.)

staged disruptive events at the Metropolitan Museum of Art, New York, and the Solomon R. Guggenheim Museum, New York, objecting to the continued patronage of the Sackler family, who contributed to a public health epidemic by peddling the addictive opioid OxyContin. In part as a result of P.A.I.N.'s campaign, The National Portrait Gallery in London and the Tate art galleries (which include the Tate Modern and the Tate Britain in London, and smaller outposts in Liverpool and Cornwall) announced they would not accept money from the family, and the Louvre Museum in Paris stripped the Sackler name from one of its wings.

Other actions against museums have encompassed protests over what should be seen and how unsettling material should be framed (this is also discussed in Chapter 7). One notable instance came in 2017, when New York resident Mia Merrill circulated a petition against the Metropolitan Museum of Art, New York, asking the museum to reconsider the way it displays *Thérèse Dreaming* (1938) by Balthus (Balthasar Klossowski). The painting shows the titular Thérèse – the artist's young neighbour, who often modelled for him – leaning back against a pillow, her legs raised and bent, exposing her underwear, as a cat laps milk from a saucer on the floor below her. For Merrill and the thousands that signed the online petition, the nascent, precocious sexuality of the girl poised between childhood and adolescence provoked fears of habituated libidinal aggression, implied if not actualized. The uncomfortable image had been subject to censure before, but it was in the context of 2017 and the rise of #MeToo that the institution was held newly accountable. The Met did not remove the painting or revise its display to include additional contextual information.

In response, Michelle Hartney (b. 1978, La Grange, IL) set a performance in motion in 2018, titled *Correcting Art History: How Many Crotch Shots of a Little Girl Does It Take to Make a Painting?*. She wrote a plaque highlighting Balthus's obsession with young girls and noting that the artist later took almost 2,000 polaroids of a different child in highly sexualized positions; he photographed her once a week for eight years. Hartney placed this plaque next to the Art Institute of Chicago's official signage for Balthus's *Girl with Cat* (1937), which, like *Thérèse Dreaming*, features a pubescent model exposing her underwear. Hartney carried out additional performances in the series, which she called *Separate the Art from the Artist?*, at the Metropolitan Museum of Art, where she placed plaques with feminist content of her own authoring next to the official signage for artists including Paul Gauguin and Pablo Picasso, providing contextual information as to how these artists

206a
206b

206a–b Michelle
Hartney, *Separate
the Art from the
Artist?*, 2018

treated women in general as well as how they treated the
specific subjects of their paintings.

In 2019, a show that had originated at the Wallach Art Gallery
in New York under the title 'Posing Modernity: The Black
Model from Manet and Matisse to Today' opened at the Musée

207 Kara Walker, *Dredging the Quagmire (Bottomless Pit)*, 2017

d'Orsay, Paris, where the included works (mostly 19th century French paintings) were renamed to honour the black sitters they picture, rescuing them from historical anonymity. This admits the enduringness of white ignorance when it comes to the experiences of people of colour – as has been exacerbated by white painters who have historically 'used' images of black people as tools to serve their painting – and an attempt to address (if not to redress) it.

Taking on matters of self-representation, Kara Walker wrote a press release for a 2017 show at Sikkema Jenkins & Co., New York, which garnered more public response than the art on view in the gallery. This was especially striking given the six-metre-long painting that was its centrepiece: *Dredging the Quagmire (Bottomless Pit)* (2017), a tableau recalling the atrocities of slavery in vignettes of a woman carrying a corpse and another split over a tree, in the midst of which a man stands knee-deep in water, bearing witness to the unending tragedy. An excerpt of Walker's written testimony, which she titled 'Sikkema Jenkins and Co. is Compelled to present The most Astounding and Important Painting show of the fall Art Show viewing season!', is as follows:

207

COLLECTORS OF FINE ART WILL FLOCK TO SEE THE LATEST KARA WALKER OFFERINGS, AND WHAT IS SHE OFFERING BUT THE FINEST SELECTION OF ARTWORKS BY AN AFRICAN-AMERICAN LIVING WOMAN ARTIST THIS SIDE OF THE MISSISSIPPI. MODEST COLLECTORS WILL FIND HER PRICES REASONABLE, THOSE OF A HEARTIER DISPOSITION WILL RECOGNIZE BARGAINS! SCHOLARS WILL STUDY AND DEBATE THE HISTORICAL VALUE AND INTELLECTUAL MERITS OF MISS

*WALKER'S DIVERSIONARY TACTICS. ART HISTORIANS WILL
WONDER WHETHER THE WORK REPRESENTS A DEPARTURE
OR A CONTINUUM. STUDENTS OF COLOR WILL EYE HER
WORK SUSPICIOUSLY AND EXERCISE THEIR FREE RIGHT TO
CULTURALLY ANNIHILATE HER ON SOCIAL MEDIA.... GALLERY
DIRECTORS WILL WRING THEIR HANDS AT THE SIGHT OF
THRONGS OF THE GALLERY-CURIOUS FLOODING THE
PAVEMENT OUTSIDE...*

In trumpeting the 'astounding' nature of the works on
view – many of which partake in the same visual idioms with
which she has long been engaged – Walker sets up a kind of
false expectation for something that will shock her audiences.
Damning the 'Make it New!' ethos of the art world – which
builds upon and exacerbates accelerated obsolescence – the
press release speaks of the pressure imposed by the institution
in the hopes of eliciting on every occasion incrementally more
awesome and excruciating material from a black woman,
and the exhaustion that this kind of pressure begets. Walker
furthered this writing with an artist's statement, in which she
expresses frustration at serving as a role model, 'a featured
member of my racial group and/or my gender niche', and
speaks about the resurgence of 'supremacist goons'. As with so
much of Walker's past visual work, this too proved a lightning
rod, with some artists publicly bemoaning what they took
as an abdication of responsibility (regarding the role-model
comment). On the other hand, *Ebony* magazine dubbed the
press release an 'incidental masterpiece' that can be accessed
far from its original site even as it grows out of areas of
privilege; Walker used it 'to make a statement (and relay an
eloquent eye roll) on thoughtless and clichéd consumption
of artistry'. It is additionally useful to consider how Walker's
writing enlists – and incriminates – so many in the process of
framing art's significance before it ever gets seen.

Modernism with a Difference
To complicate the earlier model of institution critique (in which
artists scrutinize where and how art is presented, who funds
these institutions, and so on, and take this as the basis for
their art), in 2005 the artist, writer and teacher Andrea Fraser
(b. 1965, Billings, MT) proposed another way of thinking about
the problem. She argued against contemporary institutional
critique as a practice of challenge to specific people, places
or organizations from outside of them. Instead, she wrote in
'From the Critique of Institutions to an Institution of Critique',
published in *Artforum* in 2005:

[The institution of art is] *internalized in the competencies,*
conceptual models, and modes of perception that allow us to
produce, write about, and understand art, or simply to recognize
art as art, whether as artists, critics, curators, art historians,
dealers, collectors, or museum visitors. And above all, it exists
in the interests, aspirations, and criteria of value that orient our
actions and define our sense of worth.

For Fraser, the institution is already inside those who are
part of the social field; in turn, the social field is formed and
reshaped by each participant. As Walker's press release-cum-
manifesto shows, this still sparks antagonism. It may also serve
as the basis for considering the fundaments of practice, and
one's over-determined relation to them.

 The institution at issue is not so much the museum, gallery
or the writing around it, but the individual and one's relation
to the history and practice of painting as an institution of
its own, among other things. In this way, painting is taken
apart, or deconstructed, which is to say that it is analyzed
by artists to expose its internal logic and the assumptions
that have maintained its sanctity over the last many decades
(and appreciably longer, as exemplified by the Renaissance
invention of linear perspective). In this way, the deconstructive
act challenges painting from the inside. Recall the example
of Robert Ryman given in Chapter 5 (p. 199): by continuing
to paint, one might break down painting's constituent
parts – paint, support, edge, wall and also authorship (he made
the signature a compositional feature, sometimes enlarging it
across the surface or repeating it as a though it were a staccato
mark) – the better to reinterpret the whole. Critique is not
just an act of negation; it is also a way of making works and
imagining new possibilities that precisely relate to the world in
which they are emerging.

 While Cheyney Thompson did engage the gallery in his
institutional critique, as discussed (p. 241), he also examines
painting in and of itself, and helps to clarify this difference.
In 2009, Thompson completed two projects, *Chromachromes*
and *Chronochromes*, which addressed painting and its systems
directly by exploring the materiality of canvas and the formats
it has taken historically. For these works, Thompson scanned,
enlarged and reproduced the grid of a section of raw linen on a
series of new canvases of different shapes and sizes; the circular
format of one echoes a Renaissance tondo, while another
wry piece is 61 by 2.5 centimetres (24 by 1 inches), dimensions
that register as even more absurd when viewed in relation to
the other shapes. Each canvas is composed of a pattern that

208

208 Cheyney Thomson, *Chromachrome (S6/SPR) (Tondo)*, 2009

replicates the actual weft of its material support, oriented either horizontally or diagonally. Though Thompson relies on mechanization – recently even using an algorithm to dictate the amount of pigment applied in each gestural stroke – the paintings are still hand-painted in an array of complementary hues based on the American painter, teacher and inventor Albert H. Munsell's colorimetric system, which Thompson has extended through the use of specific colours on certain

days (even the colours' tones are based on the hour of their painting, with noon calling for absolute black and white). This acknowledges an assumption of an audience that has the art-historical knowledge to 'get' that the work is about the history of painting in the first place.

209 Anna Betbeze (b. 1980, Mobile, AL) is even more forthright. She eliminates the canvas altogether, using woollen Flokati carpets as grounds to be razed: saturating the rugs with acid dyes and burning them; pulling or shearing their tufts; or washing them before hanging them on the wall, sometimes with their matte undersides facing out. For these works the convention of the support is critical; no matter how much force Betbeze enacts on it, it remains paradoxically unscathed. The support is a mental habit as much as a physical structure, as
210 demonstrated by Sergej Jensen (b. 1973, Maglegaard, Denmark), who makes abstract paintings without paint, constructed from

209 LEFT Anna Betbeze, *Gutter*, 2016
210 OPPOSITE Sergej Jensen, *Golden Shower Chanel Strip*, 2019

found textiles, the imperfections of which nod to their prior lives – which are recuperated as pictorial effect.

Instead of treating the canvas as a ground to be covered, Dianna Molzan (b. 1972, Tacoma, WA) reveals it, as well as the paint and stretcher, in strikingly physical ways. Her sliced, twisted, unravelled and draped canvases expose the wooden structure underneath, and behind it the wall, which the paintings actively frame. She has dressed the support in ruched fabric, strung cans from its framework, and draped velvet ropes across its face. A painting from 2019, shown that year at Kristina Kite Gallery, Los Angeles, sags as individual strands from the stretcher's upright posts, as Molzan has removed all the vertical threads. Addressing both the norms of painting and the often cyclical trends that determine their understanding at specific

211

211 Dianna Molzan,
Untitled, 2019

moments, Molzan titled one 2013 show 'La Jennifer', using
the American name, once ubiquitous and now out of favour,
to reflect upon the historicity of surges of interest.

Paintings about painting become a site for both material
and conceptual elaboration for others, like Molzan's peer
Lesley Vance (b. 1977, Milwaukee, WI). Differently engaged
with historical conventions, Vance photographs still-life
arrangements of shells, horns, coral or a ceramic jar, which
she turns into abstract compositions over the course of a single
sitting. Her earlier still lifes of flowers and bivalves betray self-
consciousness in heavily worked passages where the brush has
lingered and gone sketchy, thereby obscuring some detail that
it might have clarified; more recent abstractions foreground
material process – how the work came into being, rather than
to what it refers. Knowing that a still life is the point from
which a non-objective image originated offers little help in
identifying its references, even if in rare instances a shape or

212

212 Lesley Vance,
Untitled, 2017

colour hints at a source. Instead, Vance highlights the role of
the paint and her approach to painting, to call attention to,
rather than conceal, the nature of her art.

This is also true of Josephine Halvorson (b. 1981, Brewster,
MA). Her small oils of newspapers, book spines, tombstones,
machines and domestic and industrial surfaces embrace
the lost tradition of the American still life, creating tightly
cropped records of the material world depicted through close
observation. Making an object by hand is, for Halvorson, 'a
radical act with ethical implications', by which she means that
the investment of time with the object during the painting
process initiates a sense of togetherness with it. The materials
she renders are often overlooked: post-industrial, ephemeral
or otherwise unappealing in a traditional sense. Like Vance,
she usually completes a piece in one stint, with looking and
painting coincident. Halvorson paints on site, although her
titles do not connect canvas and place. It is her lushly applied

213 TOP LEFT Josephine
Halvorson, *Sign Holders*, 2010
214 LEFT Nathlie Provosty,
Visions, 2017

paint, speckled with globs and textured with bugs stuck to the
213 wet surface – as in *Sign Holders* (2010), which displays a viscous
mingling of gnats and paint – that marks the time and place
of creation. Many of Halvorson's newer paintings crop surfaces
into illusionistic openings, and often include rectangles, which,
in a form of reflexive mirroring, can be understood as allusions
to the shape of the canvas. These are paintings about paintings,
but also about how the medium trains us to see.

214 Nathlie Provosty (b. 1981, Cincinnati, OH) uses oil on linen,
slowly building up alternately matte and luminescent surfaces
that shift according to the physical position of the viewer
before them. To be sure, they incorporate the viewer (within
the reflective paint), and also the room, effectively posing how
the painting may serve as an extension of human actuality.
Often monochromatic, Provosty's paintings nevertheless
reveal forms including a curved shape that she initially called
'doubleu' (after the name for the letter 'w'), which emerge
through sustained looking over time, as though in relief
from the ostensible and imposing blankness. The viewer
comes to see tinges of colour in black or white paint that
divide the surface into a pattern of superimposed geometries.
This disambiguation demonstrates how something that
was previously unacknowledged, because unseen, can be
recognized as our attention shifts.

215 A restructuring of the way in which we see things remains
the bedrock for work by John Nixon (b. 1949, Sydney, Australia);
he is interested in its utopian dimension, in the possibility that
by reframing the way we see things, we can rebuild society. An
early proponent of minimal painting in Australia, he examines
the possibilities of the monochrome and its social dimensions
in a continuation of the Russian avant-garde's revolutionary
belief that basic geometry and fidelity to materiality could
offer a site of transcendence, as well as Josef Albers's
pedagogical – and, ultimately, ethical – idea that colour
could abet perceptual retraining. (At Black Mountain College,
North Carolina, in the 1930s and 1940s, Albers encouraged
his students to execute their own colour studies based on a
series of exercises that led them to discern the differences in
hues, tones and intensity, not as definitions and diagrams to
be learned by rote, but by comparison and through trial-and-
error experience that would cultivate sharpened perception.)
Working from such specific points of reference, Nixon uses
the cross, square and circle, questioning their meaning in the
course of re-motivating them.

If painting offers the potential for social change, the other
side of that coin is a separation of painting from what came

215 LEFT John Nixon, *Black Monochrom (Ruler)*, 2019
216 OPPOSITE Ian Davenport, *Puddle Painting: Dark Grey (after Uccello)*, 2010

216

before. For some, this differentiation of painting now from its historical precedents becomes what the art is about (a potentially tautological loop, as explored in 'Other Formalisms', p. 270). An example of formalism can be seen in the work of Ian Davenport (b. 1966, Sidcup, UK), who denies traditional composition and premeditated application of strokes, instead regarding the paint spill as both chance-based method and iconography. He makes many works by pouring or using a syringe to squeeze household gloss paint onto a tilted surface, avoiding the sentimentality of the hand and assuming that gravity will take care of the rest. In this departure from more longstanding artmaking traditions, however, Davenport still seemingly returns to modernist strategies – the liquefied paint spill deliberately invokes the mid-century drips of Jackson Pollock, the stains of Helen Frankenthaler and the pours of Morris Louis – and priorities of self-definition, each medium defining what is unique and specific to it, which was central to

the formalist theories of the influential American modernist critic Clement Greenberg.

Such artists engage in auto-critique, of their work and the categories of art. But if this was a direction established by Greenberg in his argument for medium specificity, their use of it now evidences a profound difference of orientation. Greenberg famously espoused that medium specificity meant upholding and even exaggerating the distinction of what is unique to each medium, such as flatness in painting, and excluding all else. Contra his vision of progressive refinement, the artists who now work with auto-critique are not world-averse. Many no longer consider the conditions of self-criticism to be painting's distinction from other media; instead, they centre it around painting's connection to other media, as well as to its surroundings and to the lives of others, and – as the work explored in Chapter 5 regarding installation and performance makes clear – its relation to space and time. Working in this vein is Gaylen Gerber (b. 1955, McAllen, TX), who designates artworks to serve as the backdrops for others: his grey monochrome became the support for an intervention

by Stephen Prina, who deposited the contents of an entire can of spray paint onto its pristine surface. Prina has repeated this action with Wade Guyton (p. 66) in performances that display paintings for a single night.

This means artists often work to show their opposition to the autonomy of painting; some, like Molzan (p. 253), achieve this by literally taking painting apart. In so doing they might make evident support structures, piercing surfaces to achieve sightlines (or glimpses of the backing wall) through holes or connections to the exterior. To this last point, the world

beyond the gallery is implied in works by Ida Ekblad (b. 1980, Oslo, Norway). Her sculptures are often accumulations of metal and other materials salvaged from the street or scrap yard, welded together and painted in monochromatic coats of lacquer that treat fragments of cars, train tracks or ironing boards as aesthetic objects. She also makes so-called 'sculpture missions' on location – from New York's Rockaway Beach to London's Clapham Common – to source materials for

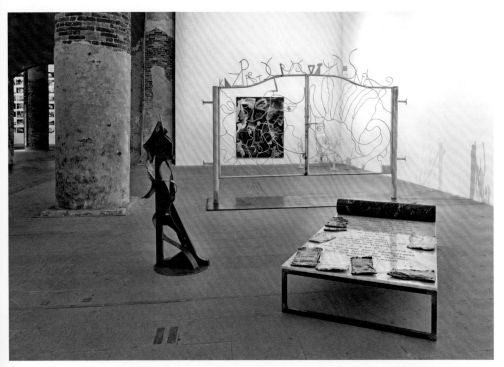

217 OPPOSITE Stephen Prina, *PUSH COMES TO LOVE, Untitled, 1999–2013,* 2013
218 ABOVE Ida Ekblad, Installation view of 'ILLUMInations', 54th Venice Biennale, 2011

works that are then presented in these cities. In some cases, Ekblad has fashioned freestanding gates, which emphasize the portal-like nature of her gestural paintings, and lead into and out from the canvases. Within the latter, she works within the limitations that are inherent to the picture plane, even as she is complicating and recapitulating this pursuit through her addition of various media.

Ekblad's play of space within the picture depends and draws on modernism: Wassily Kandinsky and Joan Miró, Henri Matisse and Asger Jorn. Like so many other artists, she mines this past with an unburdened openness. In this respect, she is comparable to Matt Connors (b. 1973, Chicago, IL), who appropriates a host of individual precedents (many of which overlap with those visually cited by Ekblad). These artists may not free painting of its historical precedents, but Connors also moves, in his own words, towards 'a kind of inward progression so that materials, processes, the studio, and my own actions have all started to qualify for me as origin points in and of themselves'. Using mostly raw canvases, he pours paint,

219 ABOVE Matt Connors, *Table II (16 Cups)*, 2010
220 OPPOSITE Fergus Feehily, *Grey Foxed*, 2009

which the fabric absorbs like dye, and has also imprinted one canvas with another and with the traces of their surroundings. Connors seems to go out of his way to make clear the reasoning behind his compositional choices and methods of execution, whether cockeyed forms, overpainted designs or rings left 219 behind from paint cans, jars or coffee mugs (containers he was using at the time to hold paint, gesso and brushes).

In a clear engagement with traditions in the presentation of painting, Connors also brings our attention to picture frames. *Picture Corners* (2010), a relatively small panel, employs three devices to emphasize the frame: large black triangles fixed to the corners of the canvas, just shy of its edge; an unpainted 220 perimeter; and, close to this, a thin blue line. Fergus Feehily (b. 1968, Dublin, Ireland) also relies on the frame as a primary component in small paintings composed of wood, paper, fabric and paint, sometimes to bind a stack of such materials together.

In so doing, these artists highlight institutions of display, reshaping patterns of habituation around them in the process.

A further engagement with the virtual space of the picture plane can be seen in the work of Robert Janitz (b. 1962, Alsfeld, Germany), who paints large-scale gestural abstractions with wide horizontal and vertical strokes thickened with cold wax and flour. In the repetitive movement of these substances over a support, exquisitely visible gestures that survive across distinct bodies of work, Janitz finds affinity with repetitive actions of domestic labour – window washing, spackling or grouting – and the less physically demanding act of buttering toast. (In the *Twisted Box* paintings, shown at Anton Kern, New York, in 2018, these gestures conjure optical puzzles of tower-like shapes torqueing in on themselves, sometimes alone, sometimes regarding another in a duet, and in *Field Paintings*, shown the same year at CANADA, New York, they are layered in wide vertical strokes.) He leaves corners unpainted to reveal rainbow gradients of underpainting and allows the giant sweeps to remain diaphanous. Through this, the paintings seem to solicit optical regression, but they avert this except at the periphery; they maintain the possibility of illusionism and pictorial depth, even as they prevent it. In 2019, Janitz showed designed benches at König London: a place to sit

221 BELOW Robert Janitz, Installation view of 'Uptown Canvas', Anton Kern Gallery, New York, 2018
222 OPPOSITE Markus Amm, *Untitled*, 2017

and observe the aftermath of the process, in a self-referential acknowledgment that the application of paint to a ground yields something worth regarding.

222

Posing questions of what one is seeing and how it was made, Markus Amm (b. 1967, Stuttgart, Germany) has been described as a 'modern alchemist' for small-scale monochromatic, process-based oil-and-gesso paintings that look like photograms. In fact, Amm fixes the image by pouring extremely thin layers of paint onto a prepared surface, one at a time. Deeply analytical, he was part of a generation of European painters included in the defining 2004 exhibition 'Formalismus: Moderne Kunst, Heute' (Formalism: Modern Art, Today), curated by Yilmaz Dziewior at the Kunstverein Hamburg – a show that recast process-based artmaking after conceptualism and ushered in many ways of making paintings through increasingly baroque techniques. These are seen in the works of Ruth Laskey (b. 1975, San Luis Obispo, CA) and Tauba Auerbach (b. 1981, San Francisco, CA), among others.

About Painting

By focusing on process in this manner, many artists revaluate painting as both a manual and conceptual activity. This is achieved by some through exploration of the ethical dimension of craft, albeit in very different ways. After becoming dissatisfied with more traditional painting materials, Ruth Laskey began to make paints from scratch and to weave her own canvases. She now uses a loom to make her pieces, the individual threads of which she paints and then laces into the structure of the canvas. The resulting effects – which follow preparatory sketches (each titled *Study for Twill Series*) on graph paper to ensure mathematical exactitude for her colour fades and designs – show figure and ground to be inseparable as part of the woven matrix. Once complete, Laskey's intricate woven paintings recall the maligned 'women's work' of fireside embroidery.

223

Tauba Auerbach engages with the materiality of the canvas in a different manner. Having worked with diagrams of the semaphore alphabet and patterns derived from the binary language of digital technology in her earlier work, in 2009 she began her *Fold* paintings. These appear three-dimensional,

224

223 BELOW Ruth Laskey, *Twill Series (Robin's Egg Blue/Yucca/Light Green)*, 2007
224 OPPOSITE Tauba Auerbach, *Untitled (Fold)*, 2012

but are, in fact, after-images of their pre-stretched state; the folded, crumpled canvas was spray-painted with an industrial gun before being re-flattened on the stretcher. Functioning as charged clues to prior configurations, each crease is both illusionistic and literal: a 1:1 relationship exists between the surface and its image. In her *Weave* paintings, form is developed not from the surface but from the support beneath: strips of canvas bound into geometrical patterns imitate the architecture of the wooden stretchers. Taking the corner as her starting point, Auerbach unfurls a field of intersecting planes to create an undulating monochromatic pattern in which two overlying grids intersect at an angle.

In comparable plays between materiality and immateriality, Paul Sietsema (b. 1968, Los Angeles, CA) dispassionately

225 ABOVE Paul Sietsema, *Swipe painting (Chase)*, 2016
226 OPPOSITE Tomma Abts, *Weie*, 2017

incorporates trompe l'oeil images into thickly painted works,
keeping hold of the device's illusionism but simultaneously
showing it to be an illusion. His paintings invite suspension of
225 disbelief: take the enamel-on-linen *Swipe painting (Chase)* (2016),
which features a credit card gliding across the paint its passage
looks to erase. This feat was a pleasurable hallmark of pre-
modern picture making, which aspired to achieve a realism so
convincing that it appeared not a semblance of the thing,
but the thing itself (in the Classical story of the artist Zeuxis,
he painted grapes so lifelike that birds were wont to peck at
them). Yet Sietsema also unmasks this mode of picturing for
what it is, giving the means and the end in one fell swoop.
 In contrast to this mischievous engagement with
226 illusionism, Tomma Abts (b. 1967, Kiel, Germany) shuns
references to nature, her body and identity, and, indeed,
anything that lies beyond the canvas, aiming for work that
'becomes congruent with itself'. Her compositions – all

approximately 48 by 38 centimetres (19.8 by 15 inches), vertically oriented and titled with proper names from an obsolete German dictionary – emerge from the give-and-take that comes with numerous layers of paint. In some works, interlocking linear elements float across densely layered fields, while in others, the surface is bisected by delicate webs of faintly protruding ridges, which give them an oddly sculptural effect at close range. This somewhat protracted process reveals Abts's commitment to creating the object and giving it an identity, but she stops short of making her intentions directly accessible. Rather, in insisting upon the primacy of form, she asks whether abstraction can negate, or at least obstruct, meaning. Many critics consider this to be the case for other process-based abstract painting; they came to find in it only insular, self-referential exercises, resulting not only in painting that negates meaning, but also in painting that never presumed to have it in the first place.

Other Formalisms

In the 2010s, abstraction became ubiquitous: flourishing
again in its separation from medium specificity, and without
ideological underpinning or progressive ideal. Critic and
artist Walter Robinson penned 'Flipping the Rise of Zombie
Formalism' in 2014, which coined an 'ism' (a rarity now,
after nearly two centuries of avant-gardism and successive
modern movements). He defined Zombie Formalism as 'a
straightforward, reductive, essentialist method of making
a painting' that 'brings back to life the discarded aesthetics of
Clement Greenberg'. When Jerry Saltz entered the discussion
with 'Zombies on the Walls: Why Does So Much New
Abstraction Look the Same?' he added to the monikers, noting
colloquial instances of 'Modest Abstraction, Neo-Modernism,
M.F.A. Abstraction, and Crapstraction. (The gendered variants
are Chickstraction and Dickstraction.) Rhonda Lieberman gets
to the point with "Art of the One Percent" and "aestheticized
loot."' Perhaps it is unnecessary to say that these are all
pejorative labels, ways of panning painting made on spec:
a trophy for, but also a symptom of, an art world awash with
money and absent of financial regulation.

As explored above, many artists who engage the institution
of painting (and the more local history of modernism) do so
in substantive ways. But Robinson was provoked to write the
initial piece after reading an interview with Los Angeles art
flipper Stefan Simchowitz, in which Simchowitz bragged about
purchasing lots of inventory; getting friends and clients to buy
the same artist (often as a result of his ruthlessly promoting
them on social media and distributing images of camera-
friendly paintings online); raising the price for that artist; and
getting rid of the work before the artist's market crashes. While
Robinson took issue with the structure of these interventions,
and the qualitative impoverishment of the work Simchowitz
had championed, it is Saltz who most forcefully extended the
critique of work made as high-end interior decor, by posting
pictures of gridded, monochromatic, chicly muted, smudged,
covered, printed or stencilled paintings that he took at galleries
and art fairs over the course of a year. The point of such
clickbait is the paintings' visual equivalence within sub-groups
(paintings with splatters, say), a striking demonstration of their
fungibility (interchangeability of units of the same commodity)
in the market.

Lucien Smith (b. 1989, Los Angeles, CA), Jacob Kassay (b. 1984,
Lewiston, NY) and Oscar Murillo (b. 1986, Valle del Cauca,
Colombia) are the three artists most closely associated with
these considerations, particularly because of their prioritization

227 Lucien Smith,
*Southampton
Suite #3*, 2013

of process and the ways in which their markets developed.
Beginning in 2011, Smith began making the series of works
227 that would make him so collectable: the *Rain Paintings*, which
he made by putting paint into fire extinguishers and spraying
it across an unprimed canvas in a torrent of tiny beads that
accumulate into fields of varying density. A mechanized version
of a Jackson Pollock drip painting – and according to Smith, an
exploration of loneliness (as in comic books, where characters
walk through rain when sad) – these paintings could be made
quickly while still referencing a precedent, thus guaranteeing
their significance.
228 Kassay made a substantial body of elemental, chemically
produced abstract paintings, using a photographically derived
electroplating technique that produces a silvery, mirror-like
surface, capable of reflecting the space around them. Murillo
rubbed his canvases on the studio floor so that they could
sop up dirt, before making the first mark, often using a

broomstick (he also condensed debris from the ground into balls with pulped drawings, thread, cement dye, copper and dust), engaging the location of creation and establishing a basic level of formal consistency. The presumption that paintings that look similar are similar might be considered a kind of pseudomorphism, a term referring to the way we consider things that look alike to be connected, allowing formal likeness to obscure the differences in positions behind their conception and intent. As the moment of their creation and the initial discourse surrounding Zombie Formalism recedes, their differences become more apparent.

Nevertheless, so caricatural had these styles and procedural chronicles become that in 2015, Seth Price (p. 139) published a polemic in the form of a novel masquerading as a memoir, *Fuck Seth Price*, which addressed the topic of creativity under adverse conditions. They served as the target of easy contempt: 'tepid compositions, hesitant and minimal in appearance, kind of pretty and kind of whatever, loaded with back-story. The main thing to remember, both in executing this work and in appreciating it on the wall, was to be knowing...' This returns us to issues of taste and attitude explored in Chapter 2, while also showing that any style of art is subject to the new machinations of the Internet-fuelled art world. While this domain was previously presided over by experts, with the profusion of social media, art is now more broadly consumed and shared by the public, supplanting more formal, journalistic or academic criticism. Thus does a review all too often pale in comparison to a shot of an artwork posted by a social media influencer.

This development of social media might sound non-hierarchical – and to be sure, its pluralism of expression (if not access) is often characterized as such. Still, as Chris Wiley astutely noted in 2018, Zombie Formalism 'altered the fabric of the art world. The reins of aesthetic power, which had for decades traded hands among critics, curators, and various moneyed interests, now belonged solely to the global collector class'. In the aftermath, the London-based Murillo has proved an interesting case. To Price's point about backstory, Murillo has emphasized his Colombian origins, titling his first show in London, at Carlos/Ishikawa in 2013, 'Dinner at the members club? Yes! i'll have a black americano first pls', and even offering packs of ground coffee at the gallery for visitors to take home. His incorporation in the art world on these terms, which outlived and ultimately outweighed his association with Zombie Formalism, demonstrates how alterity is increasingly fetishized by the market, too, and even more recently, by museums. This makes the moments when Murillo points back

228 Jacob Kassay, Installation view at 'EXPO 1: New York', MoMA PS1, 2013

to himself, as when he plays the part of the 'black americano', particularly relevant to conversations about race and a history of colonial and nationalist exploitation.

These interests are exposed in much work made in the years that followed Zombie Formalism (see Chapter 7), in a historical juncture at which painting's relation to the market intersects with signs of identity politics and social justice, especially as these factors come to be imagined as running counter to this strain of abstraction. Nevertheless, it is worth noting the extent to which other artists during these same years took responsibility for how their work was made, while insisting that abstraction might harbour or materialize content.

Gary Hume (b. 1962, Tenterden, UK) created a series called *Door Paintings*, some fifty big, rectangular slabs, the dimensions of which mimic precisely those of their subject: the swing doors in a derelict, state-funded London hospital. These were shown to great acclaim in the generation-defining 'Freeze' show curated by Damien Hirst in 1988. Hume's idea for the series originated from an advertisement for private health care amidst funding cuts to the UK's National Health Service carried out by Margaret Thatcher's government, and at the same time, the doors offered a template adaptable in colour and design

229 ABOVE Gary Hume, *Water*, 2018
230 OPPOSITE Tomashi Jackson, *Avocado Seed Soup (Davis, et. al. v County School Board of Prince Edward County) (Brown, et. al. v Board of Education of Topeka) (Sweatt v Painter)*, 2016

but consistent in their reference to the tradition of painting as a rectangle on a wall. They also operated as a metaphorical window to another realm, which Hume made literal in a painting of a window composed in 2002, a decade after painting the final door. The panes of Hume's window, however, are blacked out, presenting a flat plane and refusing transparency.

In a 2018 show at Matthew Marks, Los Angeles, Hume took on forced migration and the global refugee crisis. He worked an image of a life jacket into a repeating design that floated across the slick, watery surfaces of mural-scale horizontal paintings, which were executed on paper so thickly covered with paint on both sides that they became rigid. The forms summon so many similar items awash on beaches throughout Europe, buoyant but absent of bodies, or gruesomely, still carrying them lifeless to shore. *Water*, 2018, a colour-shifting blue-green monochrome, deftly captured that suspense, imaging nothing but writhing waves in an improbable elegy.

229

In another powerful instance of abstraction that carries meaning, Tomashi Jackson (b. 1980, Houston, TX) uses the history of colour theory in art making in work including *Avocado Seed Soup (Davis, et. al. v County School Board of Prince Edward County) (Brown, et. al. v Board of Education of Topeka) (Sweatt v Painter)* (2016). This giant mixed-media painting deals with the history of American school desegregation and its lingering effects on public life. While studying at Yale University, Jackson discovered that the language Josef Albers used in his 1963 educational text, the *Interaction of Color*, to decry the wrong way to see colour – as static and fixed instead of relative to what is next to it – mirrored the racialized language of segregation that appeared in the

230

transcripts of education policy and civil rights court cases fought by Thurgood Marshall and the NAACP Legal Defense and Educational Fund. Marshall is best known for challenging Plessy v. Ferguson, the court-sanctioned legal doctrine from 1896 that called for 'separate but equal' structures for white people and black people in what was an upholding of the constitutionality of racial segregation. As Jackson states in an interview: 'I recognized terms about how "colors" interact from Albers's text: colored, boundaries, movement, transparency, mixture, purity, restriction, deception, memory, transformation, instrumentation, systems, recognition, psychic effect, placement, quality, and value.' Thus does she argue in her paintings that it is through boundaries, such as school and voting district, that race is created and segregation maintained in the United States.

Jackson's paintings happened alongside the making public of another startling revelation: in 2015, researchers from Russia's State Tretyakov Gallery were studying a version of Kazimir Malevich's *Black Square* (1915) under a microscope when they discovered a shocking handwritten inscription, reading 'Battle of negroes in a dark cave'. This would place it in conversation with French writer Alphonse Allais's *Combat de Nègres dans une cave pendant la nuit* (Negroes Fighting in a Cellar at Night) (1897), a horizontal black rectangle with the title conspicuously printed below it, in what one cannot but

understand to be a racist joke. (The latter was published in an album of monochrome prints of colours, each outlined and keyed to a supposedly humorous, caustic title, e.g. the red one is titled *Tomato Harvest by Apoplectic Cardinals on the Shore of the Red Sea*.) This discovery irrevocably recasts the whole of modernist abstraction, the consequences of which remain to be seen.

Chapter 7
Living Painting

By way of a conclusion, this briefer final chapter addresses work that jettisons investigations of medium and instead opens to lived experience. For Juan Uslé (b. 1954, Santander, Spain), who applies paint in pulsing brushstrokes keeping time with his own heartbeat, repetition becomes a form of translation, and a way of exemplifying his own life force. His small-scale *In Kayak* works (2012–present) achieve parity between method and theme, as his technique – bands of dark, narrow strokes laid side by side – reflects the repetitive movement of oars. This broaches the question of how artists use painting to process, reflect on and characterize present circumstances, and also how painting might, in this manner, evidence a way of coming to know the world – and perhaps of intervening in it. While more direct social action is addressed in turn, it is first essential to assert that painting as a practice is ongoing: it goes without saying, but it preceded Zombie Formalism and survives it.

The Practice of Painting
In the early 1970s, Peter Dreher (b. 1932, Mannheim, Germany) began painting a single empty water glass. The series now contains over 5,000 individual paintings of the subject, within the same surroundings and from the same angle, sometimes during the day and sometimes at night. Within this serial structure, differences – in light or reflection, or the artist's touch – assume subtle if profound meaning in the context of the whole, which Dreher has named *Tag um Tag guter Tag* (Day by Day, Good Day, or Every Day is a Good Day). An ode to the banality of living, it optimistically proposes that as long as there is another day, there is always another surface, another support onto which more paint can be applied, and another painting to be made.

231 ABOVE Juan Uslé, *In Kayak (Silente)*, 2012
232 OPPOSITE Peter Dreher, *Tag um Tag guter Tag Nr. 2685 (Night)* (Day
by Day, Good Day), 2013

In 1965, the Polish-French painter Roman Opałka (1931–2011) began to paint consecutive numbers, starting at one, with the impossible goal of stretching to infinity. As though writing on a sheet of paper, he began in the upper left-hand corner of a canvas and worked his way in horizontal rows to the lower right; with each new work, he continued from the number with which he had finished the previous painting. Opałka referred to each new painting as a detail, standardizing their size to the dimensions of his studio door and their title to *1965 / 1—∞*, to indicate an unending project. He soon incorporated a tape recorder into the process, speaking each number into the microphone as he painted it, and also took passport-style photographs of himself standing before each completed canvas. Changes materialized over time within Opałka's prodigious

233 LEFT On Kawara, *SEPT. 19, 2013*, 2013, from *Today* series, 1966–2013. Acrylic on canvas, 20.3 × 25.4 cm (8 × 10 in.)
234 BELOW Vija Celmins, *Night Sky #24*, 2016

output, from white numbers painted on a black background, to a grey background, to a background progressively lightened with each successive detail. In the last stages of the project, the numbers were no longer legible, as Opałka was writing them in white on a white.

Like Opałka, On Kawara (1933–2014) worked in a serial format, marking the course of time through the production of paintings. From 4 January 1966, he sustained the *Today* series, monochromes on standard-sized horizontal panels, on each of which he wrote the date it was made, in the language and calendrical norms of the country in which he was working. He fashioned a storage box for each: a time capsule lined with a cutting from a local newspaper procured that same day. If a work was not finished by midnight, it was destroyed. Though this was a continuous process for Kawara, viewers see a single marker of each day, or the erratic lapses between them: such are the conditions of collection and display, as well as of history.

By contrast, the paintings of Vija Celmins (b. 1938, Riga, Latvia) are cumulative: the vast photorealistic deserts, seascapes and nocturnes that she has been making since the late 1960s are achieved through a slow accumulation of marks, over hours that become years. Each mark contributes to the surface of the work, and also to the mythology of the artist as something like a modern-day version of the Greek mythological figure Penelope, making and unmaking in a succession of near-infinite labours (just as Penelope was said to have woven, unwoven and rewoven a shroud in a repetitious cycle). People tend to imagine the studio as a productive site, and indeed, the lengthy process by which an image of the heavens becomes *Night Sky #24* (2016) – a velvety oil on canvas on which each fleck of light puncturing its opacity is a physical cavity, an obdurate, minutely realized wormhole – suggests the multi-year spell of its creation. Yet Celmins's work also powerfully proposes that labour is but a means to an end: a visible registration of the capturing of time, soliciting a mediation on one's place before it.

Dashiell Manley (b. 1983, Fontana, CA) has also gained notice for focused, labour-intensive techniques and processes that reflect on temporality. His *The New York Times* and *Financial Times* series feature transcribed front pages from days-old editions of the papers, so that words like 'Ebola', 'Ferguson' and 'ISIS' emerge from the would-be abstractions. The topical content is decelerated, seemingly stilled in layered and smeared materials, where it remains.

Finally, Adam Pendleton (b. 1984, Richmond, VA) is vital to this conversation about the salience of current events to

painting, and the notion of obligation in a work of art. He wrote the manifesto 'Black Dada' for Manifesta 7 (2008), invoking Hugo Ball's 1916 Dada manifesto as well as the 1964 poem 'Black Dada Nihilismus', written by LeRoi Jones (who was later christened Amiri Baraka, the name by which he is best known as a key figure in the Black nationalist movement). Since then, Pendleton has been engaged with Black Dada, a multi-part project encompassing paintings – deep, crystalline black-on-black monochromes with words: black or dada or both – drawings, and more recently, a literary anthology of sources pertaining to Black consciousness. By appropriating specific cultural forms, such as the press photograph, he dismantles dominant discourses, enacting a position whereby political struggle can accomplish much for art, beyond what art reciprocally may do for active political struggles. In all of this, Pendleton uses aspects of modernist style and directs his paintings towards utopian social configurations, still unrealized. This is his basis for using art to imagine, for one thing, a United States liberated of mass incarceration, slavery by another name.

235 Dashiell Manley, *The Financial Times, front page, Jun 15 2019. jun152019, 2019*

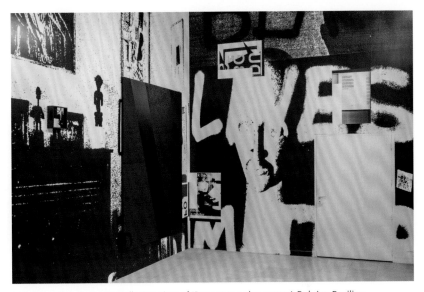

236 Adam Pendleton, Installation view of 'Personne et les autres', Belgian Pavilion, 56th Venice Biennale, 2015

236

In 2015, Pendleton began incorporating language of new protest, bringing the message of Black Lives Matter to Pace, London, and later that summer to the Belgian Pavilion of the 2015 Venice Biennale, with black-and-white paintings and large-scale vinyl text-based works that read 'Black Lives Matter'. Pendleton's paintings are fierce, accusatory, communicating much in the space of the image, but they are also careful and slow. Their superficial present-ness is a red herring; the works are Janus-faced, both retrospective and anticipatory, even as they exist where and when they were made. In a 2016 *Brooklyn Rail* interview, Pendleton answered to a prompt about the popularity of Black Lives Matter being 'fashionable':

It was about bringing a different kind of rhetoric and attention to the language, to the moment, to the movement.... I showed these paintings in a show at the Museum of Contemporary Art Denver in 2015 and the local art critic came around and said, "Oh, yes, these are nice paintings but this is so yesterday. Six months ago maybe this would have meant something, but it just seems so old." There is the case in point—"this is so old"—when actually these are things that as a country we have been grappling with for hundreds of years. It is neither new nor old.

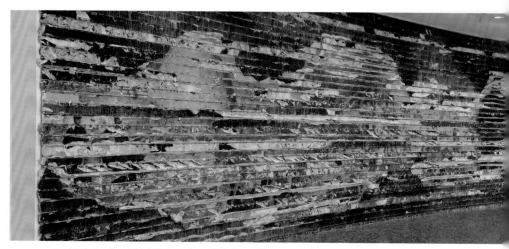

237 Mark Bradford, Installation view of *Pickett's Charge*, Hirshhorn Museum and Sculpture Garden, Washington, D.C., 2017

Painting and its Publics

Pendleton's remarks also raise a very different problem: the way in which fashion has moved on from production-heavy art or minimal paintings, and claimed art of political fervour – some of which is opportunistic. As a result such practices often involve virtue signalling without any sustained commitment, and in so doing unfortunately trivialize the work that so many artists are doing in communities, to say nothing of in the institutions of art (as considered in Chapter 6). Mark Bradford (b. 1961, Los Angeles, CA), for one, operates in multiple sites simultaneously, using painting as a means to achieve – and fund – other projects. He began by painting signs at his mother's beauty shop, before seizing her supplies, like endpapers used for perms, for his art. His large-scale, map-like paintings of city grids are collaged out of posters and detritus repurposed from the street. In the beginning, these included advertising for a fringe economy (in which houses are sold for cash and immigration papers are expedited) and were attached to fences encircling still-desolate sites that had been burned out during the 1992 Los Angeles riots that followed the acquittal of police officers seen on video brutally beating Rodney King.

237

Bradford has continued to make increasingly epic paintings, notably the architectural *Pickett's Charge*, a commission for the Hirshhorn Museum, Washington, D.C., that encircles the round building like a contemporary cyclorama (it is based on Paul Philippoteaux's 19th-century cyclorama depicting the final charge of the Battle of

Gettysburg in favour of the Union: a critical turning point of the Civil War and of American history thereafter). Bradford's own work is a kind of deconstruction of this imagery, full of cut and torn, drawn and photographically reproduced images from the original panorama. Alongside his artmaking, in 2015 Bradford co-founded Art + Practice (A+P) in South Los Angeles as a neighbourhood art centre and a partner in social services for local foster youth, where he has worked to build robust programmes.

In a different form of social practice, Aliza Nisenbaum (b. 1977, Mexico City, Mexico) has been collaborating with undocumented persons from Mexico and Central America who live in the United States. When working with Cuban artist Tania Bruguera's (b. 1968, Havana, Cuba) Immigrant Movement International – a long-term art project in conjunction with the Queens Museum of Art, New York, which provided social services to the large and multilingual immigrant neighbourhoods in the immediate vicinity – Nisenbaum discovered the intimacy of portraiture as a means by which to connect with the person she faced; she paid her subjects for their time and participation. The conscientious depiction of others led her to portrait-making workshops for those in the area – an endeavour she then memorialized in *Wise Elders Portraiture Class at Centro Tyrone Guzman, 'En Familia hay Fuerza', Mural on the History of Immigrant Farm Labor to the United States* (2017), a painting picturing the students holding portraits that they drew.

238

Nisenbaum's project additionally tracks with recent claims for the therapeutic value of art. Doctors in Canada can now prescribe art for their patients through free access to a museum, and many medical schools in the United States are piloting curricula in which students are learning diagnostic skills – aiding in the ability to formulate careful, unbiased visual observations – and possibly even realising greater empathy through looking closely at art, or in other cases, by making it. Nisenbaum's project also acknowledges the transformative potential of artmaking for the participating artists, sitters and viewers, in what becomes a proliferation of painting culture for many more stakeholders.

239 In a kind of reparative realism, Jordan Casteel (b. 1989, Denver, CO) paints large-scale oil portraits of family and friends, as well as strangers who she meets on the streets near her home in Harlem and her students in New Jersey. She casts a palpably benevolent eye over black men engaging in quotidian situations: posing on a couch, looking up from a phone or reading a book. She pays keen attention to the environment in which she shows them and has been outspoken about her desire to transform how such subjects as these are elsewhere depicted. This work, like that of Tschabalala Self (b. 1990, New York, NY) and Janiva Ellis (b. 1987, Oakland, CA) owes

240 much to Kerry James Marshall (b. 1955, Birmingham, AL), whose

238 OPPOSITE Aliza Nisenbaum, *Wise Elders Portraiture Class at Centro Tyrone Guzman, 'En Familia hay Fuerza', Mural on the History of Immigrant Farm Labor to the United States*, 2017
239 TOP Jordan Casteel, *Three Lions*, 2015
240 ABOVE Kerry James Marshall, *Untitled (Studio)*, 2014

Living Painting

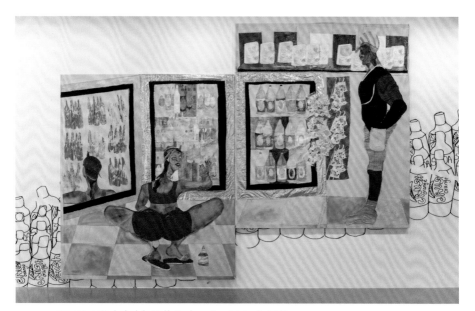

241 ABOVE Tschabalala Self, *Bodega Run Diptych*, 2017
242 OPPOSITE Janiva Ellis, *Open Pour Reality*, 2017

precedent has been overwhelmingly important, especially since his travelling exhibition 'Mastry', a retrospective of the prior thirty-five years of his career, which opened at MCA Chicago in 2016. He has for these decades painted only African Americans, and in the darkest ebony black, systematically occupying each genre of art – portraits and landscapes, domestic scenes and history paintings – with sensitivity and technical precision, as though to redress centuries of having been excluded from their hallowed ranks. His work is about the indignities of representation, in the face of which he erects an archive that bestows beauty and self-possession where it had long been denied.

241 Tschabalala Self uses paint and discarded fabric to fashion bright, lively portraits of black females, over-sexualized figures with round bottoms and breasts, whom she describes as avatars. Self's exaggerated images dramatize the perverse fantasies historically attached to the black female body, providing an alternative to the extant archive of racial stereotypes, such as imagery of black nursemaids and nannies to white children and prints of Saartjie Baartman (a South African Khoikhoi woman who was exhibited at European 'freak shows' in the nineteenth century, and is best known by her colonial stage name, the 'Hottentot Venus'), among so much

else. Rather than negating or sublimating this archive, Self uses these artefacts of racism to construct new possibilities for representation.

Janiva Ellis paints tortured-looking figures, riots of colour that nevertheless communicate with startling gravity the isolation and pain of the subjects' experiences: a dark face zips off to reveal a darker face underneath, or organs erupt from the chest of a woman at a farmers' market. At times rendered with hints of cartoonish levity, according to Ellis these metamorphosing figures form 'a language that functions like a gloved hand, muting its individuality yet exaggerating its gesture'. As with Kara Walker's press release (p. 248), such works critically respond to being categorized as a 'type' of artist (black, for example), attendant to limitations on the wider experience of race and subjectivity.

Their work discloses the ways signs of 'otherness' and their intersection – here, Blackness and womanhood – are managed: how they have become big business and cultural flashpoints. In what might be described as a sort of convergence of interest, it has now become desirable to art-world stakeholders for underserved and ignored populations (including people of colour) to be represented in municipal institutions, galleries

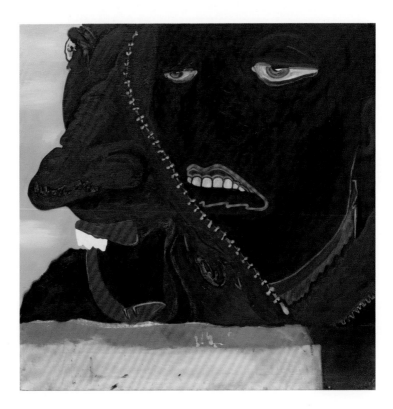

and the market, and for related imagery to be highlighted in painting. Likewise, social media support has bolstered painting that had previously been ignored because of systemic prejudice. Viewership's influence on contemporary painting has made for a larger audience, and one ever more diverse than before, generating out of 'sharing' and 'liking' – or the galvanizing force of not liking – individual but also co-produced reactions to art without necessarily simplifying their point of view.

The 2017 Whitney Biennial offers a case in point, showing representation to be vital in terms of undoing the damage that has been wrought by a history of art in which many demographics have been drastically under-represented – but, at the same time, revealing that representation can perpetuate this same damage. Fundamental questions must be asked as to who has a claim to people's narratives, and what an artist's motives are in engaging them. One exhibited work was by **243** Henry Taylor (b. 1958, Oxnard, CA), who works in the tradition of artists like Jacob Lawrence and Romare Bearden, crossing folk art with elements from modern Black life to portray an American landscape of mass migration and lingering oppression. Taylor counts friends, relatives, acquaintances from the art world, strangers, sports stars and politicians among the subjects of his sizeable and unremittingly personal accounts of vernacular activity – barbequing or talking on a stoop, getting a haircut – painted in a single sitting on canvas or on cigarette packs, cereal boxes or suitcases.

At the Whitney, he showed a monumental painting commemorating the fatal shooting of Philando Castile, a thirty-two-year-old African American man, by a Minnesota police

243 Henry Taylor, *Split*, 2013

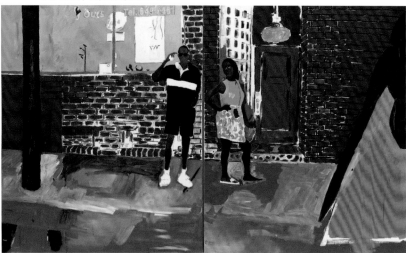

officer in 2016. In *THE TIMES THAY AINT A CHANGING, FAST ENOUGH!* (2017), the victim is shown slumped back in the car he was driving, seatbelt still buckled in this makeshift tomb. Another painting, exhibited rooms away, was by Dana Schutz (b. 1976, Livonia, MI), an artist already well known for narrative-based figurative work, which involves pairing subject matter with the style chosen for a certain region of the composition, often symbolically: scrapers, squeegees and oil crayons might be employed to highlight characters, gestures and moods. Her paintings also frequently involve the desecration and display of the body, as in her so-called self-eaters (paintings of people eating their own faces and therein figuring creation through destruction) or *Presentation* (2005), a long, emphatically horizontal painting – based on sources including El Greco's *The Burial of the Count of Orgaz* (1586) – that is centred on a partially dismembered figure lying on a board balanced above a chasm in the ground: impending burial or reaching exhumation.

244 In the Whitney exhibition, one of Schutz's contributions was *Open Casket* (2016), a gruesome, near-sculptural painting of Emmett Till, a black teenager from Chicago, Illinois, who was murdered in Jim Crow-era Mississippi in 1955 when visiting relatives. His mother insisted on an open casket (topped with glass) at his funeral, so that the world could see the brutality with which her son met his death at the hands of white men punishing the fourteen-year-old for an alleged slight on a white woman. The pictures were published in mainstream media and were instrumental in catalyzing the Civil Rights Movement in the United States, a cause for which Emmett Till remains an icon, his sacred coffin newly enshrined in the Smithsonian's National Museum of African American History and Culture on the Mall in Washington, D.C.

 Schutz's painting was initially praised in the press, but shortly thereafter, opposition mounted. Artist and activist Parker Bright saw the image on social media (as so many did before – if ever – seeing it in person) and staged a protest, standing before *Open Casket* while wearing a t-shirt emblazoned with the words 'Black Death Spectacle' across the back. Photos of him and his message before the painting went viral, and he later made a mixed-media-on-paper rendition

245 of the image, titling it *Confronting My Own Possible Death* (2018). In the meantime, Bright had set off a debate regarding cultural appropriation, white privilege and Black suffering, the role of the artist, the culpability of the institution (lying with the curators and the educators, among others) and the stakes of censorship. Writer and artist Hannah Black (b. 1981, Manchester, UK) followed up with an open letter, in which

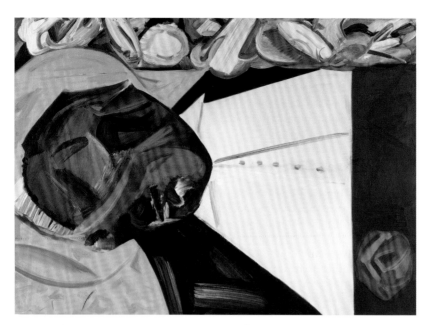

244 TOP Dana Schutz, *Open Casket*, 2016
245 ABOVE Parker Bright, *Confronting My Own Possible Death*, 2018

she not only furthered the call for the exploitative painting's removal, but also advocated for the painting's destruction, for 'treating Black pain as raw material' and effectively centring whiteness.

Schutz defended her painting with the words 'I don't know what it is like to be black in America but I do know what it is like to be a mother. Emmett was Mamie Till's only son.' In this discourse, however, Schutz is paired not with Till's grieving mother – despite her avowal of maternal solidarity – but rather with the white woman who was complicit in his murder. Even so, these calls for censorship were surprising in the United States. There, cries for suppression of art, however incendiary, are still associated with the political Right, in a hangover from the culture wars of the 1980s (p. 10). These were fuelled by civic outcry at Robert Mapplethorpe's (1946–1989) photographs of sex acts between men, which were exhibited in a travelling retrospective in the wake of his untimely death from AIDS-related complications, and the legal battles that these photos instigated. (Politicians challenged Mapplethorpe's work's status as art, denouncing it as pornographic, and the exhibition of the photographs in Cincinnati, Ohio, resulted in an obscenity trial in 1990, marking the first time an American museum was taken to court on criminal charges for the art that it showed.) Yet in the present day, calls for censorship are no longer the sole remit of the Right, with the Left just as likely to highlight the effects of representation, albeit for very different reasons. Arguments for the removal or destruction of *Open Casket* draw further attention to the fact that free speech historically has been sanctioned for only some citizens and not others.

Schutz's painting stayed in place and generated a level of art-world introspection that is truly unprecedented. In direct contrast to debates around Mapplethorpe's photographs, which ultimately, if unwittingly, withdrew the responsibility of art (defenders of his work counter-intuitively argued that they were merely photos), those around *Open Casket* have, conceivably more than any other instance, asserted the significance of representation in the public sphere. The work in question and its surrounding controversy, to say nothing of the structural problems it exposed, evidenced a failure to achieve allyship – and yet it is precisely in this failure that it also unequivocally highlighted the conceivable task of painting in the institutions of art and the broader culture. This points to the medium's continuing consequence: painting is not separate from the ongoing situations from which it emerges and on which it reflects, but wholly implicated within it. Much work remains to be done.

Postscript

This book was finished in 2019 and edited in the months that followed. It was set to go to press when, in early 2020, a novel coronavirus circulated internationally and brought life to a standstill. I am writing this Postscript while sheltering in place in Los Angeles, where local institutions have shuttered. The immediate impact on the art world has been immense. Museums and galleries quickly furloughed and laid off staff; the former are making news in their attempts to stave off financial collapse by entertaining the possibility, previously unthinkable, of deaccessioning parts of their collections. Concluding lines from the introduction of this volume, a missive from another time, resonate anew in their acknowledgment of the accidental temporality of writing. A text about the contemporary does not typically provide narrative closure, but this is something COVID-19 might accomplish. It is early days, however, and as with other moments of rupture that portended transformation and instead returned society to the old order, perhaps conditions will not really change on the other side. Museums may soon reopen and galleries survive, lined with art made while artists were in lockdown, and travel could resume to see them first-hand. For now though, art institutions are imagining audiences and their relevance to them in altered ways. They are sending links to recent programmes and virtual 'viewing rooms' for archived shows, and openings of new exhibitions and art fairs have migrated online. All educational content – lectures, artmaking exercises and public conversations – is delivered remotely, and curators are conducting high-profile studio visits through video conferencing portals. So, as with the introduction, this note intends to foreground the interval between drafting ongoing history and reading it: it is an interval of open contingency, conceptually if not actually punctuated by an ellipsis, rather than a full stop, which awaits the next chapter. April 2020

Glossary

abstract expressionism A movement in American painting of the 1940s and 1950s, centred in New York, works of which display an engagement with the unconscious mind and its automatic registrations: **gestural**, process-based abstraction is employed to communicate intense emotion, expression or experience. Artists associated with the movement are further categorized as action painters (e.g. Jackson Pollock and Willem de Kooning) or colour-field painters (e.g. Mark Rothko and Barnett Newman, as well as a so-called 'second generation' in the later 1950s and 1960s).

afrofuturism An aesthetic movement that uses science fiction and technology to re-imagine histories of and possibilities for people of the African diaspora.

appropriation The self-conscious use or adaptation of images from a pre-existing source as the basis for a new work; through this process of re-framing or transformation, the imagery acquires new meaning.

avant-garde In French, avant-garde means the 'vanguard' or the 'advance guard' (the soldiers who entered battle first). Since the 19th century, the term has been applied to people or artworks that are deemed ahead of their time, or outside the norms of the society from which they arise. A synonym for **modernism** (or name for its ambitions), it often implies a reinvention of the existing aesthetic, social and institutional order, and also radical politics.

bad painting Artwork that, through its content or its style, intentionally or ironically offends the viewer to query the bounds of acceptable taste. The term was coined by critic and curator Marcia Tucker in 1978 (in a show of the same name exhibited at New Museum of Contemporary Art, New York), in this context referring to figurative painting.

Bauhaus This movement began in 1919, when Walter Gropius established a school (called the Bauhaus, founded in the German city of Weimar) that combined crafts and fine arts, which aimed to integrate the arts into everyday life. The Bauhaus regarded painting as equal to and logically interdependent with other media and practices, such as architecture, weaving, wood or glasswork, which were ordinarily associated with the applied or decorative arts, craft or design.

conceptual art As defined by artists in the United States, Europe and Latin America in the 1960s, art that prioritizes the message, or 'concept', over traditional aesthetic, technical and material concerns; the process of making the piece is also prioritized over the finished product.

contemporary A period of art generally agreed to come after modernism and postmodernism; it is not identified by a coherent style but is instead understood relative to shifting historic, social and technological conditions; a pluralism of artistic approaches; and the rise of international exhibition formats, such as the biennial. It is variably defined as beginning as early as the aftermath of World War II or as late as the 1990s, following the fall of the Berlin Wall or developing alongside the proliferation of the Internet.

criticality The quality of being critical of an artistic context or tradition. This can be addressed within a work. Critical cultural practices (art, but also writing, music, drama and dance, among others) work to reveal and change conventions of race, class, gender, sexuality, ability and other aspects of identity and subjectivity.

Cultural Revolution A socio-political movement (1966–76) launched by Chinese leader Mao Zedong, who sought to purge traces of traditional thought or bourgeois values from Chinese society to defend Communism against capitalism. The effort was accompanied by a comprehensive propaganda campaign typified by utopic images of idealized, spirited citizen-workers supporting and fulfilling Mao's vision.

cynical realism Art movement originating in China following the Tiananmen Square protests in 1989. Artists use figuration (in

a parody of **socialist realism**) and irony to critique socio-political issues and events.

death of painting The notion that painting had arrived at a point of exhaustion – a depletion of energy and cultural relevance – or even the moment of its demise. An idea that has been variously articulated since ancient times, it gained traction anew in the 1980s in response to **neo-expressionist** painting, critics of which preferred work in other media, including photographic-based appropriation, film, video and performance.

endgame A term borrowed from chess, referring to the last stages of a game; in art, it is used to describe the theory that, having reached **postmodernism**, art could not be developed further and would instead become a potentially endless re-examination of ideas that had come before.

expressionism A **modernist** movement that expresses an individual's psychological, emotional or spiritual experience (extending the tradition of **romanticism**) through non-naturalistic, sometimes proto-abstract styles. It started in Europe (especially Germany, with the Brücke and Blaue Reiter groups) in the early years of the 20th century, though the term may also apply adjectivally to painting after that moment.

feminism A political orientation and social movement for women's rights that commenced in the 19th century and extends to the present day, advocating for political, economic and social equality, and confronting cultural norms of gender and sex roles.

Fluxus An international movement of interdisciplinary artists from the early 1960s to the late 1970s. Their works and events (including publications, performance, sculpture, music and dance) frequently encouraged the participation of the viewer in their creation and welcomed chance occurrences, or everyday activity, into the space of art.

formalism An interpretive approach to visual art that foregrounds formal qualities such as line, value, colour and texture; these are seen as being of primary importance and autonomously meaningful. It rose in prominence alongside **modernist** painting in the 20th century, expounded first by British painter and critic Roger Fry and writer Clive Bell, and later by the American critic Clement Greenberg.

gestural A quality in mark-making or surface texture exemplified by a palpable sense of the gesture involved in its making; often found in layered, thick or impasto surfaces that maintain individual strokes as part of the composition. It is consistently connected to **expressionism.**

globalization The process of interaction between people, companies, nations and cultures worldwide, resulting in an integrated global economy. In the late 20th century this was typified by free trade, the flow of capital and the expansion of labour markets.

historicism A relativist, as opposed to **universalist**, approach to art history, which considers the significance of historical or geographical circumstance in the development of art.

iconoclasm Formerly applied specifically to the act of destroying religious icons, images or public monuments for doctrinal or political reasons, this concept now extends more broadly to describe behaviour that rejects established values, institutions or beliefs.

identity politics A strand of politics in which people united by any element of identity – be that gender, ethnicity, religion, race, sexual orientation or culture – self-identify as a group and actively promote concerns specific to that group, often in reaction to injustice.

illusionism A term first used for decoration in Baroque buildings (e.g. ceiling paintings that appear to open up to the heavens), it refers to a style of painting that looks like it extends into or blends seamlessly with the real three-dimensional space of the spectator. In the 20th century, many artists worked against illusionism in favour of truth to materials.

institutional critique A branch of conceptual art that began in the late 1960s that takes the scrutiny of institutions, especially those that present art (museums and galleries, biennials and fairs, but also publications and publicity materials) as its primary task and subject matter. Critique is levied at the institution's part in conferring value onto artworks and artists; its involvement in securing funding from compromised sources; and so on.

interiority The condition of having an inner life; used to describe a connection between an artwork's surface and the psyche, character or subjectivity of the artist.

kitsch Originating in the 19th century, the term initially implied poor taste, and was used to refer to creativity that was considered less

refined than art; in the 20th century, it was similarly linked with mass-produced, cheap commodities, and with popular entertainment and sentimentality. In 1939, the critic Clement Greenberg argued that kitsch was the antithesis of avant-garde art, but later generations revalued it in a positive light.

low culture Derogatory in connotation, this term is applied to forms of culture that are popular and have mass appeal. It is a counterpoint to the elitism and supposed refinement of taste associated with its opposite, high culture.

mannerism From the Italian *maniera*, 'manner', or 'style'; the style of European art after the High Renaissance and before the Baroque (roughly between 1510–1600). Such art used the classical vocabulary established by the Italian Renaissance but departed from its previously harmonious ideal by playing with exaggerated scale, bodily proportions and unnatural colours. **Expressionists** in the 20th century have been associated with its strategies of formal experimentation.

medium specificity An aesthetic ideal first proposed in the 18th century by Gotthold Ephraim Lessing, and popularized in the 20th century by Clement Greenberg (see **formalism**), arguing that each medium should concentrate on effects unique to it. This means in painting, flatness and abstraction are seen as more appropriate than illusion, perspectival extension or figuration.

medium Physical material of any kind that is employed for the realization of artistic ideas or expression. Also used to denote types of artmaking: painting, sculpture, collage, etc. 'Mixed media' means that multiple materials were used to create an artwork. Medium also, more narrowly, refers to the liquid in which pigment is suspended to make paint.

minimalism A style of visual art, music and dance that emerged in the 1960s. In visual art, it generally denotes a concentration on fundamental geometric forms such as cubes or grids and a visual simplicity or classicizing tendency. Forms are often presented serially, in an ascetic manner, and/or realized in impersonal or industrial material. It is commonly associated with artists who engage assistance in fabricating their work.

modernism A variety of artistic responses to the emergence of modernity, which developed following the Industrial Revolution in the 19th century (a period marked by transformations in labour, manufacturing and technology, accompanied by demographic shifts to more populous areas). In this period, artists shifted from working on commission (for private patrons, religious organizations or political powers) to making art based on subjective experience. The term is used most frequently to describe an interconnected sequence of experimental **avant-garde** art practices, stretching from the 19th century to **postmodernism.**

monochrome Used to describe painting (or other artwork), the surface of which consists of only one colour. Ordinarily there will be little or no line or other surface incident beyond potential modulation of shade, marks of a brush or texture of the support showing through its applied layers. Often incorrectly thought to mean black and white, monochrome in fact means any single colour.

multiculturalism A theory of culture that values the coexistence of distinct ethnic or cultural traditions, without their individual distinctions being lost within the larger group. It is often used to describe a body of academic theory or cultural criticism that embraces a more diverse, less North American and Eurocentric canon of artists or artworks.

neo-expressionism A style identified by expressive and **gestural** large-scale painting; it first developed in Germany in the late 1970s and was popularized in the early 1980s, when works were characterized by vibrantly coloured, figuration-based reactions against the **formalism** of **minimal** and **conceptual art**. Centred in New York, neo-expressionism was associated with other contemporary international movements including the Italian Transavanguardia and the German Junge Wilde or Neue Wilden.

old masters An umbrella term used to refer to a loose group of esteemed European artists who were active before the 19th century.

outsider art Art produced by artists who have not received training and who work outside the art establishment.

participatory/relational art Art that encourages participation in order to emphasize or query the relationship between an art object and viewing subjects, or that between viewing subjects in social space. Such works or events as these might seek to highlight or exaggerate community or disunity for ethical or political ends.

pastiche In visual art, a work that is eclectic and imitative of the work of other artists, styles

or periods; such quotations may or may not acknowledge their primary context or means of circulation. The term is related to parody, but the implication of pastiche is less mocking.

Pattern and Decoration A movement in the 1970s that opposed the uptight classicism of minimalism, finding force – and feminist agenda – in decoration, with designs sourced from quilts, mosaics and textiles.

persona A role or character suggested by an artist's behaviour or artwork.

photorealism A precise and finely detailed style of painting that emulates the representation of the world as it is captured by a photograph. The style emerged in the late 1960s and early 1970s but continues to the present. Unsurprisingly, such works are often based on a source photograph.

pluralism Culture, and cultural theory and criticism, of the late 1980s and 1990s that embraced the coexistence of more than one school of theoretical orientation or artistic course, including those understood by some as mutually exclusive. Critics pursued conflicting evaluative criteria and artists embraced distinct media in order to honour divergent aesthetic precedents and represent different perspectives.

pop art Short for 'popular art'; a style of art that arose in the mid-1950s in the United States and Britain (though the term also encompasses international manifestations including nouveau réalisme in France, capitalist realism in Germany and anti-art in Japan). Pop art took up everyday subject matter including household and consumer products, and made use of found imagery from advertising, cartoons and comics. Artists created pop works using handmade and mechanical or commercial techniques, such as silk-screening, to challenge traditional methods and the boundaries between media.

postcolonialism Referring to Western colonialism, the cultural condition that arises after a colonial occupation concludes, and the study of the effects of this process on the colonized populations. It indicates a particular strain of critical theory associated with scholars such as Edward Said, Gayatri Spivak and Homi Bhabha.

post-studio The idea, especially popular after 1970, of a new period in which artwork is realized outside of (and/or without recourse to) traditional material- or medium-based

training and studio practice. Idea-driven, the search for the appropriate form to realize a work may involve developing new relations to existing structures of production and display, and might also engage novel technology.

postmodernism The cultural period that followed **modernism**; developed after the 1960s, the term was originally popular as a description of architectural eclecticism, and was later applied to the rejection of modernism, critique of its canons and cultural norms, and a general pluralism (or subjectivism and relativism). Such concerns were staged by art in a variety of media by the 1980s. Postmodernism is further characterized by suspicion of reason and explanatory narratives, and a critique of the role of ideology in forging and maintaining political and economic power.

pseudomorphism In art, a term referring to the presumption that artworks that share physical characteristics are alike. Viewers might consider things that look similar to be connected, in a prioritization of formal likeness over possible differences in positions behind conception or intent.

readymade A term generally associated with and popularized by the found-object sculptures of Marcel Duchamp: any found object, typically manufactured, that is appointed as an artwork by an artist's decision to present it as such, with little or no need for alteration.

realism Sometimes called naturalism, a style of painting associated with the un-idealized figuration of Gustave Courbet (and other artists in mid-19th century France, where the term was coined by the French critic and novelist Champfleury). It is generally concerned with real, ordinary people of the present, as opposed to historic or mythic subject matter. It may also refer to any work since that point that embraces unembellished depiction.

Pictures Generation A generation of 1980s artists engaged in critique of representation, canonical modernism and mainstream cultural values; this was often achieved by re-presenting found imagery, such as from advertising or other mass-media outlets, in various photographic and moving-image formats.

post-structuralism A movement in criticism and theory that contested **structuralism**, the idea that cultural representations hew to a singular coherent logic. Post-structuralism

suggests that this is more an expectation imagined by the historian's desire for narrative or authorial coherence rather than an objective reality verified by the world.

Romanticism An artistic and intellectual movement originating in the late 18th century, concerned with individualism and intended to inspire emotion.

socialist realism A style of idealized figurative art, first declared in Soviet Russia and imposed across the Soviet Union and in China during the revolutionary era. The style was used for propagandistic images.

social realism Realist art that involves social or political commentary.

structuralism A movement in criticism and theory developed in post-World War II France, associated with the linguistics of Ferdinand de Saussure and the anthropology of Claude Lévi-Strauss, and predicated on the idea that there is an underlying structure on which the logic of all aspects of culture is based.

surrealism An international movement across several artistic and intellectual fields in the 20th century, inspired by the writings of Sigmund Freud. It involves an interest in the subject matter and logic of dreams, as well as methods of creating that encourage chance or repress the conscious mind, such as automatic drawing – mark-making without pursuing any conscious intent or form – or creating a drawing in collaboration with other artists without viewing their contributions (a game the surrealists called 'the exquisite corpse').

universalism The concept that some ideas can be applied universally, regardless of context.

Further Reading

(Udine: Adienda Speciale Villa Manin Passariano, 2006).

Brutvan, Cheryl, and Taiye Selasi, *Njideka Akunyili Crosby: I Refuse to be Invisible* (West Palm Beach: Norton Museum of Art, 2016).

Buchloh, Benjamin H. D., 'Allegorical Procedures: Appropriation and Montage in Contemporary Art', *Artforum* 21:1 (September 1982), 43–56.

Bürgi, Bernhard, *Painting On the Move: Kunstmuseum Basel* (Basel: Schwabe, 2002).

Cotter, Holland, 'Obama Portraits Blend Paint and Politics, and Fact and Fiction', *The New York Times* (12 February 2018).

Crimp, Douglas, 'The End of Painting', *October* 16 (Spring 1981), 69–76.

Curiger, Bice, ed., *Birth of the Cool: American Painting from Georgia O'Keeffe to Christopher Wool* (Deichterhallen Hamburg, Ostfildern: Hatje Cantz, 1997).

Darling, Michael, ed., *Painting in Tongues* (Los Angeles: Museum of Contemporary Art, 2006).

de Duve, Thierry, *Clement Greenberg Between the Lines: Including a Debate with Clement Greenberg* (Chicago: University of Chicago Press, 2010).

Deitch, Jeffrey, ed., *The Painting Factory: Abstraction After Warhol* (Los Angeles: Museum of Contemporary Art, 2012).

Droitcour, Brian, 'Siebren Versteeg', *Art in America* (21 April 2017).

D'Souza, Aruna, *Whitewalling: Art, Race & Protest in 3 Acts* (New York: Badlands Unlimited, 2018).

Dumbadze, Alexander, and Suzanne Hudson, eds, *Contemporary Art: 1989 to the Present*, (Chichester, West Sussex: Wiley Blackwell, 2013.)

Eberling, Knut, *Painting Pictures: Painting and Media in the Digital Age* (Wolfsburg, Germany: Kunstmuseum Wolfsburg, 2003).

Eisenman, Nicole, *Dear Nemesis, Nicole Eisenman 1993–2013* (Saint Louis: Contemporary Art Museum, Saint Louis, 2014).

Eklund, Douglas, *The Pictures Generation, 1974–1984* (New York: Metropolitan Museum of Art, New York/New Haven: Yale University Press, 2009).

Elkins, James, *What Painting Is* (New York: Routledge, 1999).

Essl, Karlheinz, *Made in Leipzig: Pictures from a City* (Vienna: Sammlung Essl, 2006).

Evans, David, ed., *Whitechapel Documents of Contemporary Art: Appropriation* (London: Whitechapel, 2009).

Addison, Ruth, and Kate Fowle, eds, *Rashid Johnson* (Moscow: Garage Museum of Contemporary Art, 2016).

Armstrong, Philip, Laura Lisbon and Stephen Melville, eds, *As Painting: Division and Displacement* (Columbus: Wexner Center for the Arts, 2001).

Badura-Triska, Eva, and Susanne Neuburger, eds, *Bad Painting: Good Art* (Museum of Modern Art, Ludwig Collection, Vienna) (Cologne: Dumont, 2008).

Bayrle, Thomas, *Vitamin P: New Perspectives in Painting* (London: Phaidon, 2002).

Beckwith, Naomi, and Valerie Cassel Oliver, *Howardena Pindell: What Remains to Be Seen,* (Chicago: Museum of Contemporary Art Chicago, 2018).

Beers, Kurt, *100 Painters of Tomorrow* (London and New York: Thames & Hudson, 2014).

Bell, Julian, *What is Painting? Representation and Modern Art* (London and New York: Thames & Hudson, 1999).

Benjamin, Andrew, *Contemporary Painting* (New York: St. Martin's Press, 1992).

Binstock, Jonathan P., *Sam Gilliam: A Retrospective* (Berkeley: University of California Press, 2005).

Bois, Yve-Alain, *Painting as Model* (Cambridge, MA: MIT Press, 1990).

——, et al., *Endgame: Reference and Simulation in Recent Painting and Sculpture* (Boston: ICA, 1986).

——, et al., 'The Mourning After', *Artforum* 41:7 (March 2003), 206–11, 267–72.

Bonami, Francesco, *Infinite Painting: Contemporary Painting and Global Realism*

Falconer, Morgan, *Painting Beyond Pollock* (London: Phaidon, 2014).

Fibicher, Bernhard, and Suman Gopinath, eds, *Horn Please: Narratives In Contemporary Indian Art* (Ostfildern: Hatje Cantz, 2007).

Filipovic, Elena, *Lynette Yiadom-Boakye: Under-Song for a Cipher* (New York: New Museum, 2017).

Fogle, Douglas, ed., *Painting At the Edge of the World* (Minneapolis: Walker Art Center, 2001).

Foster, Hal, 'Signs Taken for Wonders', *Art in America* 74:6 (June 1986), 80–91, 139.

Fricek, Anita, 'Contemporary Painting as Institutional Critique', in *Deleuze and Contemporary Art*, eds Stephen Zepke and Simon O'Sullivan (Edinburgh: Edinburgh University Press, 2010).

Gaines, Charles, et al., *Henry Taylor* (New York: Rizzoli, 2018).

Gao, Minglu, *Total Modernity and the Avant-garde in Twentieth-Century Chinese Art* (Cambridge, MA: MIT Press, 2011).

Geers, David, 'Neo-Modern', *October*, 139 (winter 2012), 9–14.

—— 'The Gold Standard', *The Brooklyn Rail* (6 May 2014).

Gingeras, Alison M., ed., *Dear Painter, Paint Me...: Painting the Figure Since Late Picabia* (Paris: Centre Pompidou, 2002).

Godfrey, Tony, *The New Image: Painting in the 1980s* (New York: Abbeville Press, 1986).

—— *Painting Today* (London: Phaidon, 2014).

Gohr, Siegfried, and Jack Cowart, eds, *Expressions: New Art From Germany: Georg Baselitz, Jörg Immendorff, Anselm Kiefer, Markus Lüpertz, A.R. Penck* (Munich: Prestel-Verlag Munich in association with the Saint Louis Art Museum, 1983).

Graw, Isabelle, 'Conceptual Expression: On Conceptual Gestures in Allegedly Expressive Painting, Traces of Expression in Proto-Conceptual Works and the Significance of Artistic Procedures', in *Art After Conceptual Art*, eds Alexander Alberro and Sabeth Buchmann (Cambridge, MA: MIT Press, 2006).

—— 'Social Realism: The Art of Jana Euler', *Artforum* 51:3 (November 2012), 234–40.

—— *The Love of Painting: Genealogy of a Success Medium* (Berlin: Sternberg Press, 2018).

——, Daniel Birnbaum and Nikolaus Hirsch, eds, *Thinking through Painting: Reflexivity and Agency beyond the Canvas* (Berlin: Sternberg Press, 2012).

——, et al., *Painting Beyond Itself: The Medium in the Post-medium Condition* (Berlin: Sternberg Press, 2016).

Green, David, and Peter Seddon, eds, *History Painting Reassessed: The Representation of History in Contemporary Art* (Manchester: Manchester University Press, 2000).

Greenberg, Clement, 'Modernist Painting [1960]', in *Clement Greenberg: The Collected Essays and Criticism* (Chicago: University of Chicago Press, 1993).

Harris, Jonathan, *Critical Perspectives on Contemporary Painting: Hybridity, Hegemony, Historicism* (Liverpool: Tate Liverpool, 2003).

Hicks, Alistair, *The School of London: The Resurgence of Contemporary Painting* (Oxford: Phaidon, 1989).

Hochdörfer, Achim, David Joselit and Manuela Ammer, *Painting 2.0: Expression in the Information Age* (Munich: Prestel, 2016).

Hoptman, Laura, *The Forever Now: Contemporary Painting in an Atemporal World* (New York: MoMA, 2014).

Hudson, Suzanne, *Robert Ryman: Used Paint*, (Cambridge, MA: MIT Press, 2009).

Huhn, Tom, ed., *Between Picture And Viewer: The Image In Contemporary Painting: An Exhibition* (SVA) (New York: Visual Arts Press, 2010.

Jacobson, Karen, *Henry Taylor* (New York: MoMA PS1, 2014).

Joachimides, Christos M. and Norman Rosenthal, eds, *Zeitgeist: International Art Exhibition, Berlin 1982* (New York: Braziller, 1983).

——, ——, and Nicholas Serota, eds, *A New Spirit in Painting* (London: Royal Academy of Arts, 1981).

Joselit, David, *After Art* (New Jersey: Princeton Press, 2012).

—— 'Painting Beside Itself', *October* (Fall 2009), 125–34.

Kantor, Jordan, 'The Tuymans Effect', *Artforum* 43:3 (November 2004), 164–71.

Kee, Joan, *Contemporary Korean Art: Tansaekhwa and the Urgency of Method* (Minneapolis: University of Minnesota Press, 2018).

Köb, Edelbert, ed., *Painting: Process and Expansion: From the 1950s to the Present Day* (Cologne: Walther König, 2010).

Krens, Thomas, *Refigured Painting: The German Image, 1960–88* (New York: Guggenheim and Williams College Museum of Art, 1989).

Krug, Simone, 'Njideka Akunyili Crosby', *Art in America* (17 November 2015).

Lawson, Thomas, 'Last Exit: Painting', *Artforum* 40:2 (May 1981), 40–47.

Levén, Ulrika, and Sven-Olov Wallenstein, *Painting: The Extended Field* (Stockholm: Magasin 3 Stockholm Konsthall, 1996).

Lind, Maria, ed., *Whitechapel Documents of Contemporary Art: Abstraction* (Cambridge, MA: MIT Press, 2013).

Lord, Catherine, ed., *CalArts Skeptical Belief(s)* (Newport Beach, CA: Newport Harbor Art Museum, 1988).

Manchanda, Catharina, ed., *Figuring History: Robert Colescott, Kerry James Marshall, Mickalene Thomas* (Seattle: Seattle Art Museum, 2018).

Marshall, Richard, *New Image Painting* (New York: Whitney Museum of American Art, 1978).

McShine, Kynaston, *International Survey of Recent Painting and Sculpture* (New York: Museum of Modern Art, 1984).

Melandri, Lisa, and Eddie Silva, *Amy Sherald* (Saint Louis: Contemporary Art Museum, Saint Louis, 2019).

Moss, Avigail, and Kerstin Stakemeier, eds, *Painting: The Implicit Horizon* (Maastricht: Jan van Eyck Academie, 2014).

Moszynska, Anna, *Abstract Art* (World of Art) (London and New York: Thames & Hudson, 1990).

Mullins, Charlotte, *Painting People: The State of the Art* [UK]/*Figure Painting Today* [US] (London: Thames & Hudson; New York: DAP, 2006).

Myers, Terry R., ed., *Whitechapel Documents of Contemporary Art: Painting* (London: Whitechapel Gallery, 2011).

Nesbitt, Judith, and Francesco Bonami, *Examining Pictures: Exhibiting Paintings* (London: Whitechapel Art Gallery, 1999).

Nickas, Robert, *Painting Abstraction: New Elements in Abstract Painting* (London: Phaidon, 2009).

Obrist, Hans-Ulrich, *Urgent Painting* (Paris: Musée d'Art Moderne de la Ville de Paris, 2002).

——, Uta Nusser and Kasper König, eds, *Der Zerbrochene Spiegel: Positionen Zur Malerei* [The Broken Mirror: Positions in Painting] (Vienna: Kunsthalle Wien, 1993).

Paulson, Ronald, *Figure and Abstraction in Contemporary Painting* (New Brunswick: Rutgers University Press, 1990).

Petersen, Anne Ring, et al., eds, *Contemporary Painting in Context* (Copenhagen: University of Copenhagen, 2010).

Price, Marshall N., *Nina Chanel Abney: Royal Flush* (Durham, NC: Duke University Press, 2017).

Raiford, Leigh, and Emily Kuhlmann, *Toyin Odutola: Matter of Fact* (Petaluma: Cameron, 2019).

Reyburn, Scott, 'Banksy Painting Self-Destructs After Fetching $1.4 Million at Sotheby's', *The New York Times* (6 October 2018).

Robinson, Walter, 'Flipping and the Rise of Zombie Formalism', *Artspace* (3 April 2014).

Rosenberg, Harold, 'The American Action Painters', in *The Tradition of the New* (New York: Da Capo Press, 1994).

Rugoff, Ralph, *The Painting of Modern Life: 1960s to Now* (London: Hayward Publishing, 2007).

Rutland, Beau, 'Jennifer Packer', *Artforum* 56:9 (May 2018), 216–19.

Salle, David, *How to See: Looking, Talking, and Thinking About Art* (New York: Norton, 2016).

Saltz, Jerry, 'Zombies on the Walls: Why Does So Much New Abstraction Look the Same?', *NY Magazine* (16 June 2014).

Sambrani, Chaitanya, Kajri Jain and Ashish Rajadhyaksh, *Edge of Desire: Recent Art in India* (London: Philip Wilson, 2005).

Scala, Mark W., *Chaos and Awe: Painting for the 21st Century* (Cambridge, MA: MIT Press, 2018).

Schor, Mira, *Wet: On Painting, Feminism, and Art Culture* (Durham, NC: Duke University Press, 2012).

Schwabsky, Barry, *Vitamin P2* (London: Phaidon, 2011).

——*Vitamin P3: New Perspectives in Painting* (London: Phaidon, 2016).

Searle, Adrian, and Linda Schofield, *Unbound: Possibilities in Painting* (Hayward Gallery, London: Southbank Centre, 1994).

Siegel, Katy, and Dawoud Bey, eds, *High Times, Hard Times: New York Painting, 1967–1975* (New York: Independent Curators International, 2006).

Sillman, Amy, with Helen Molesworth, et al., *Amy Sillman: One Lump or Two* (Boston: ICA Boston and Delmonico, 2013).

Smith, Karen, *Nine Lives: The Birth of Avant-Garde Art in New China* (New York: Timezone 8, 2008).

Smith, Roberta, 'Painting: An (Incomplete) Survey of the State of the Art', *The New York Times* (2 August 2018).

Smith, Terry, *What is Contemporary Art?* (Chicago: University of Chicago, 2009).

Stadler, Eva Marie, ed., *Why Painting Now?* (Nuremberg: Moderne Kunst Nürnberg, 2014).

Storr, Robert, 'Thick and Thin; a Roundtable
Discussion' *Artforum* 41:3 (April 2003),
174–79, 238–44.

Sussman, Elisabeth, and Caroline Jones, *Remote
Viewing: Invented Worlds in Recent Painting
and Drawing* (New York: Whitney Museum
of American Art, 2005).

Tannert, Christoph, and Jens Asthoff, eds,
New German Painting: Remix (Munich:
Prestel, 2006).

Tuchman, Maurice, *The Spiritual in Art: Abstract
Painting 1890–1985* (New York: Abbeville
Press, 1986).

Tucker, Marcia, *"Bad" Painting* (New York: New
Museum of Contemporary Art, 1978).

Tuymans, Luc, and Narcisse Tordoir, *Trouble
Spot: Painting* (Antwerp: MUHKA/NICC, 1999).

Valli, Marc, and Margherita Dessanay, *A Brush
with the Real: Figurative Painting Today*
(London: Laurence King Publishing, 2014).

Vogt, Paul, *Contemporary Painting* (New York:
Abrams, 1981).

Wallis, Brian, ed., *Art After Modernism: Rethinking
Representation* (New York: New Museum of
Contemporary Art, 1984).

Wallis, David, *Hybrids: International
Contemporary Painting* (London: Tate
Publishing, 2001).

Wei, Lily, *After the Fall: Aspects of Abstract Painting
since 1970* (Staten Island: Snug Harbor
Cultural Center, 1997).

Weibel, Peter, *Pittura, Immedia: Malerei in den
90er Jahren* (Neue Galerie am Landesmuseum
Joanneum Graz, Klagenfurt: Ritter, 1995).

White, Simone, 'Skin, Or Surface: Njideka
Akunyili Crosby', *Frieze* (9 March 2018).

Wiley, Chris, 'The Toxic Legacy of Zombie
Formalism, Part 1: How an Unhinged
Economy Spawned a New World of "Debt
Aesthetics"' *Artnet News* (26 July 2018).

Woodall, Joanna, *Portraiture: Facing the Subject*
(Manchester: Manchester University
Press, 1997).

Sources of Illustrations

Measurements are given in centimetres (inches)

1 Yue Minjun, *Inside and Outside the Stage*, 2009. Oil on canvas, 267 × 336 (105⅛ × 132⁵⁄₁₆). Courtesy Yue Minjun Studio
2 Patrick Lundberg, *No title*, 2019. Acrylic on fabric, enamel on pin, 113 × 1 (44½ × ½). Photo Samuel Hartnett. Courtesy the artist and Ivan Anthony Gallery, Auckland, New Zealand
3 Raqib Shaw, *Paradise Lost*, 2001–13. Oil, acrylic, glitter, enamel, resin and rhinestones on birch wood, 304.8 × 1828.8 (120 × 720). Photo Kerry Ryan McFate. Courtesy Pace Gallery and White Cube
4 Francis Alÿs, *The Green Line,* Jerusalem, 2004. Video documentation of an action. In collaboration with Julien Devaux. Photo Rachel Leah Jones. Courtesy the artist and David Zwirner. © Francis Alÿs
5 Sheila Hicks, *Escalade Beyond Chromatic Lands*, installation view, Arsenale, 57th Venice Biennale, 2017. Photo Pierluigi Palazzi/Alamy Stock Photo. Hicks © ADAGP, Paris and DACS, London 2020
6 Kristaps Ģelzis, *Artificial Peace*, installation view, Latvian Pavilion, 54th Venice Biennale, 2011. Courtesy the artist
7 Sofie Bird Møller, *Interferenz*, 2011. Acrylic paint on page torn from Playboy magazine, 29 × 21 (10⅞ × 8⅛). Courtesy Martin Asbæk Gallery, Copenhagen
8 Bénédicte Peyrat, *Dog*, 2007. Acrylic on canvas, 230 × 195 (90⁹⁄₁₆ × 76¾). Courtesy the artist and Paolo Curti/Annamaria & Co., Milan
9 Adam de Boer, *Narsisis Mantrijeron no. 1*, 2017. Wax-resist acrylic ink and rabbit skin glue on linen, polychrome carved wood, 183 × 103 × 5 (72⅛ × 40⅝ × 2). Courtesy the artist and Hunter Shaw Fine Art, Los Angeles
10 Jumaldi Alfi, *Een Prachtig Landscape #4 (Postcard from My Past)*, 2005. Acrylic on canvas, 135 × 135 (53¼ × 53¼). Mr Herman Collection, Jakarta. Courtesy Jumaldi Alfi Studio
11 Chatchai Puipia, *Vase with twelve sunflowers 120 years after Van Gogh*, 2009. Pigments, gold leaf, carbon and wax on canvas, 180 × 154.5 (70⅞ × 60¹³⁄₁₆). Courtesy 100 Tonson Gallery, Bangkok
12 Lynette Yiadom-Boakye, *A Whistle in a Wish*, 2018. Oil on canvas, 101 × 70 (29¾ × 27⁹⁄₁₆). Courtesy the artist, Jack Shainman Gallery, New York and Corvi-Mora, London. © Lynette Yiadom-Boakye
13 Michaël Borremans, *Six Crosses*, 2006. Pencil, watercolour and acrylic on paper, 23.4 × 21 (9³⁄₁₆ × 8¼). Courtesy Zeno X Gallery, Antwerp
14 Drea Cofield, *Double Spank*, 2018. Oil on linen, 127 × 152.4 (50 × 60). Courtesy the artist
15 Lucy McKenzie, 'Slender Means', 2010, installation view, Galerie Daniel Buchholz, Cologne. Courtesy Galerie Buchholz, Berlin/Cologne/New York
16 Karen Kilimnik, *Fountain of Youth (Cleanliness is Next to Godliness)*, 2012, installation view, Brant Foundation, Connecticut. Courtesy Brant Foundation and 303 Gallery, New York
17 Florian Meisenberg, *Continental Breakfast, Overmorrow at Noon*, 2011. Oil on canvas, 245 × 215 (96 7/16 × 84⁵⁄₁₆). Photo Jörg Lohse. Courtesy the artist, Kate MacGarry, London and Simone Subal Gallery, New York
18 Analia Saban, *Claim (from Chair)*, 2013. Linen on chair and canvas, 226 × 264 × 173 (89 × 104 × 68). Photo Brian Forrest. Courtesy the artist
19 Ana Teresa Fernández, *Borrando la Frontera (Erasing the Border)*, 2011. Courtesy the artist and Gallery Wendi Norris, San Francisco
20 Konstantin Bessmertny, *E. Meets W. Lost in Translation*, 2011. Oil on canvas, 50 × 50 (19¾ × 19¾). Courtesy the artist
21 Gabriel Orozco, *Stream in the Grid*, 2011. Pigment ink and acrylic on canvas, 86.4 × 76.8 (34 × 30¼). Courtesy the artist and Marian Goodman Gallery, New York
22 Cory Arcangel, *Super Mario Clouds*, 2002. Handmade hacked Super Mario Bros. cartridge, Nintendo NES video game system, artist software, dimensions variable. © Cory Arcangel
23 Vik Muniz, *Wheat Field with Cypresses, after Van Gogh (Pictures of Magazines 2)*, 2011. Digital c-print produced in two editions, each an edition of 6 plus 4 artist's proofs, editions in two different sizes, 180.3 × 227.3 (71 × 89½) and 101.6 × 128.3 (40 × 50½). Courtesy Sikkema Jenkins & Co., New York. © Vik Muniz/VAGA at ARS, NY and DACS, London 2020

24 threeASFOUR featuring Stanley Casselman, runway show during New York Fashion Week, February 2019. Photo Johannes Eisele/AFP/ Getty Images
25 Kelley Walker, *Black Star Press (rotated 90 degrees)*, 2006. Triptych, digital print with silkscreened white, milk and dark chocolate on canvas, three sections, each composed of two panels. Total of six panels, each 213.4 × 132.1 (84 × 52), overall 213.4 × 802.6 (84 × 316). Photo EPW Studio. Courtesy Paula Cooper Gallery, New York. © Kelley Walker
26 Wang Guangyi, *Great Criticism – Cartier*, 2002. Oil on canvas, 300 × 200 (118⅛ × 78¾). Courtesy the artist
27 José Toirac and Meira Marrero, *1869–2006*, 2006. 39 oil paintings on canvas, wooden frames, metal identification labels and nails, dimensions variable. Photo Will Lytch. Courtesy PanAmerican Art Projects, Miami
28 Alexander Vinogradov and Vladimir Dubossarsky, *Our Best World*, installation view, 2003. Courtesy the artists
29 Christian Marclay, *The Clock*, 2010. Single-channel video installation, duration 24 hours. Courtesy White Cube and Paula Cooper Gallery, New York. © Christian Marclay
30 Sam McKinniss, *American Idol (Lana)*, 2018. Oil and acrylic on canvas, 248.9 × 182.9 (96 × 72). Photo Charles Benton. Courtesy the artist and JTT, New York
31 Tomoo Gokita, *Mother and Child*, 2013. Acrylic gouache, charcoal and gesso on linen, 229 × 183 (90 × 72). © Tomoo Gokita
32 Makiko Kudo, *Missing*, 2010. Oil on canvas, 227.3 × 363.8 (89½ × 143¼). Photo Robert Wedemeyer. Courtesy Tomio Koyama Gallery, Tokyo
33 Jesse Mockrin, *Syrinx*, 2018. Oil on linen, 172.7 × 238.8 (68 × 94). Photo Marten Elder. Courtesy the artist and Night Gallery, Los Angeles
34 Tammy Nguyen, *Đức Mẹ Chuối (*Holy Mother of Bananas), 2018. Mixed media on panel, 152.4 × 101.6 (60 × 40). Courtesy the artist
35 William Daniels, *The Shipwreck*, 2005. Oil on board, 30 × 40 (11¾ × 15¾). Courtesy Vilma Gold, London
36 Caragh Thuring, *4*, 2009. Oil, gesso and acrylic on linen, 145 × 192 (57⅛ × 75⅝). Courtesy Thomas Dane Gallery, London. © Caragh Thuring. All Rights Reserved, DACS/Artimage 2020
37 Wilhelm Sasnal, *Untitled (Choke)*, 2017. Oil on canvas, 160 × 200 (63 × 78). Courtesy Anton Kern Gallery, New York and Sadie Coles HQ, London. © Wilhelm Sasnal

38 Yevgeniy Fiks, *Songs of Russia no. 10*, 2005-7. Oil on canvas, 91.4 × 121.9 (36 × 48). Courtesy the artist and Galerie Sator, Paris
39 Julie Mehretu, *Mogamma (A Painting in Four Parts)*, 2012. Ink and acrylic on canvas, each 457.2 × 365.8 (180 × 144). Installation, Documenta 13, Kassel, Germany. Photo Anders Sune Berg. Courtesy the artist, Marian Goodman Gallery and White Cube
40 Maryam Najd, *Self-Portrait VIII*, 2006-7. Oil on canvas, 80 × 60 (31½ × 23⅝). Courtesy Maryam Najd
41 Ruth Root, *Untitled*, 2017. Fabric, Plexiglass, enamel paint and spray paint, 251.5 × 133.4 (99 × 52½). Courtesy the artist and Andrew Kreps Gallery, New York
42 Mamma Andersson, *Memory Banks*, 2018, installation view, Contemporary Arts Center, Cincinnati, OH. Photo Tony Walsh. Andersson © DACS 2020
43 Andrew Grassie, *Installation: Martin Creed, Rennie Collection, Vancouver*, 2012. Tempera on paper on board, 15 × 26.4 (6 × 10½). Courtesy Maureen Paley, London. © Andrew Grassie
44 Matts Leiderstam, *Grand Tour*, (1997–2007), installation view, Grazer Kunstverein, Graz, 2010. Photo Johanna Glösl. Courtesy the artist and Andréhn-Schiptjenko, Stockholm
45 Uwe Henneken, *Vanguard #66*, 2006. Oil on canvas, 45 × 66 (17¾ × 26). Courtesy Galerie Gisela Capitain, Cologne
46 Dirk Bell, *Zitat*, 2007. Mixed media on canvas, diptych, each panel 60.9 × 80 (24 × 31½). Courtesy Sadie Coles HQ, London. © Dirk Bell
47 Pavel Büchler, *Modern Paintings No. A45 (cartoon figures in a barn, "Sumie 98," Manchester, August 2007)*, 1997–2007. Reclaimed paint on canvas, 114.5 × 113.5 (45¹⁄₁₆ × 44¹¹⁄₁₆). Courtesy the artist and Max Wigram Gallery, London
48 Lucas Ajemian, *Laundered Painting (26x26) I*, 2014. Painting on dropcloth, 66 × 66 (26 × 26). Photo Bill Orcutt. Courtesy the artist
49 Radu Comsa, 'Being Radu Comsa', 2010, installation view, Sabot Gallery, The Paintbrush Factory, Cluj. Courtesy the artist and Sabot Gallery, Cluj-Napoca, Romania
50 Alex Da Corte, 'Fun Sponge', 2013, installation view, ICA at MECA, Portland, Maine. Courtesy the artist
51 Urs Fischer, 'Who's Afraid of Jasper Johns?', installation view, Tony Shafrazi Gallery, New York, 2008. Wallpaper: Urs Fischer, *Abstract Slavery*, 2008. Works featured on wallpaper, from left to right: Gilbert & George, *MENTAL NO. 4*, 1976; Cindy Sherman, *Untitled #175*, 1987. Photo

Stefan Altenburger. Courtesy the artists and Tony Shafrazi Gallery, New York. © The artists
52 Peter Halley, *New York, New York*, 2018, installation view, Lever House Art Collection, New York. © Peter Halley Studio
53 Sherrie Levine, *Gray and Blue Monochromes After Stieglitz: 1–36* (detail), 2010. Flashe on mahogany, each 71.1 × 53.3 (28 × 21). Installation view, 'Sherrie Levine', Paula Cooper Gallery, 534 W 21st Street, New York, November 6–December 15, 2010. Photo EPW Studio. Courtesy the artist, Paula Cooper Gallery, New York and David Zwirner. © Sherrie Levine
54 Blake Rayne, *Untitled Painting No. 3*, 2008. Acrylic, gesso, linen and lacquer on wood, 232.4 × 167 (91½ × 63¾). Photo John Berens. Courtesy Miguel Abreu Gallery, New York
55 Wade Guyton, *Untitled*, 2010. Epson UltraChrome inkjet on linen, 213.4 × 175.3 (84 × 69). Photo Ron Amstutz. Courtesy the artist and Petzel, New York
56 R. H. Quaytman, *+ ×, Chapter 34*, installation view, October 12, 2018–April 23, 2019, Solomon R. Guggenheim Museum, New York. Photo David Heald. Solomon R. Guggenheim Museum, New York and Miguel Abreu Gallery, New York
57 Rob Pruitt, 'Pattern and Degradation', installation view, 2010. Courtesy the artist and Gavin Brown's enterprise, New York/Rome
58 Jeff Koons, *Gazing Ball (Rubens Tiger Hunt)*, 2015. Oil on canvas, glass and aluminium, 163.8 × 211.1 × 37.5 (64½ × 83⅛ × 14¾). © Jeff Koons
59 Chloé Wise, *Lactose Tolerance*, 2017. Oil on canvas, 210 × 300 (82⅝ × 118⅛). Photo Rebecca Fanuele. Courtesy the artist and Almine Rech
60 Banksy, *Love Is In The Bin*, 2018. Spray paint and acrylic on canvas, mounted on board, in artist's frame, 101 × 78 × 18 (39¾ × 30¾ × 7). Courtesy Pest Control Office
61 Yoshitomo Nara, *Miss Spring*, 2012. Acrylic on canvas, 227 × 182 (89⅜ × 71⅝). Photo Keizo Kioku. Courtesy the artist. © Yoshitomo Nara
62 Wangechi Mutu, *Forbidden Fruit Picker*, 2015. Collage painting, 100.3 × 148.9 (39½ × 58⅝). Courtesy Gladstone Gallery, New York/Brussels, Susanne Vielmetter Los Angeles Projects and Victoria Miro, London/Venice. © Wangechi Mutu
63 Nedko Solakov, *The Yellow Blob Story* (from *The Absent-Minded Man* project), 1997–present, installation view, 'Emotions' solo exhibition, Kunstmuseum Bonn, 2008. Yellow paint, handwritten text on wall, dimensions variable. Collections of MUMOK Museum Moderner Kunst Stiftung Ludwig Wien, Vienna; MARTa Herford; Private Collection, Italy; Van Abbemuseum,

Eindhoven; Collection Deutsche Telekom, Bonn. Photo Nedko Solakov. Courtesy the artist
64 Peter Saul, *Quack-Quack Trump*, 2017. Acrylic and oil on canvas, 198 × 305 (78 × 120). Private Collection. © Peter Saul/ARS, New York and DACS, London 2020
65 Toyin Ojih Odutola, *Wall of Ambassadors*, 2017. Charcoal, pastel and pencil on paper, 101.6 × 76.2 (40 × 30) (paper), 116.2 × 90.2 × 3.8 (45¾ × 35½ × 1½) (framed). Courtesy the artist and Jack Shainman Gallery, New York. © Toyin Ojih Odutola
66 Francesco Clemente, *Self-Portrait with and without the Mask*, 2005. Oil on linen, 116.8 × 234.3 (46 × 92¼). Courtesy Francesco Clemente
67 Albert Oehlen, *FM 38*, 2011. Oil and paper on canvas, 220 × 190 (86⅝ × 74¹³⁄₁₆). Courtesy Gagosian. © Albert Oehlen. All Rights Reserved, DACS 2020
68 Charline von Heyl, *Corrido*, 2018. Oil, acrylic and charcoal on linen, 274.3 × 228.6 (108 × 90). Courtesy the artist and Petzel, New York. © Charline von Heyl
69 Günther Förg, *Untitled*, 2008. Acrylic on canvas, 260.5 × 280 (102¹⁵⁄₁₆ × 110¼). © Estate Günther Förg, Suisse/DACS 2020
70 Cosima von Bonin, 'The Juxtaposition of Nothings', installation view, Petzel, New York, 2011. Courtesy the artist and Petzel, New York
71 Michael Krebber, *Das politische Bild (1968/2010)*, installation view, Galerie Buchholz, Berlin, 2010. Oil on canvas mounted on cotton, 98.3 × 126 (38¾ × 49⅝). Courtesy Galerie Buchholz, Berlin/Cologne
72 John M. Armleder, *John M. Armleder*, installation view, Almine Rech Paris, June 06–July 28, 2018. Photo Rebecca Fanuele. Courtesy the artist and Almine Rech
73 Anselm Reyle, *Little Yorkshire*, 2011. Mixed media on canvas, steel frame and effect lacquer, 69 × 89 × 4 (27³⁄₁₆ × 35¹⁄₁₆ × 1⁹⁄₁₆). Photo Matthias Kolb. © 2011 Anselm Reyle
74 André Butzer, *Blauer Schlumpf* (Blue Smurf), 2009. Oil on canvas, 180.3 × 240 (71 × 94½). Courtesy the artist and Metro Pictures, New York
75 Jim Shaw, *Oist Children Portrait (Girl & Dog)*, 2011. Oil on canvas, 119.4 × 185.4 (47 × 73). Courtesy the artist and Metro Pictures, New York
76 Mike Kelley, *Horizontal Tracking Shot of a Cross Section of Trauma Rooms*, 2009. Acrylic on wood panels, steel, video monitors, Roku media players, SD video cards, wiring and video mounts, 243.8 × 487.7 × 61.1 (96 × 192 × 24¹⁄₁₆), video high-definition NTSC, 8:51 minutes. Photo Fredrik Nilsen Studio. © Mike Kelley Foundation for the

Arts. All Rights Reserved/VAGA at ARS, NY and DACS, London 2020
77 Carroll Dunham, *(Hers) Night and Day #1*, 2009. Acrylic on canvas, 129.5 × 167.6 (51 × 66); framed 136.5 × 174.6 (53¾ × 68¾). Courtesy Gladstone Gallery, New York and Brussels. © Carroll Dunham
78 Tala Madani, *Projections*, 2015. Oil on linen, 203.2 × 249.6 (80 × 98¼). Photo Josh White. Courtesy the artist and Pilar Corrias, London
79 Lenka Clayton and Jon Rubin, *Fruit and Other Things*, 2018. Commissioned by Carnegie Museum of Art for the exhibition 'Carnegie International, 57th Edition', 2018. Photo Bryan Conley. Courtesy the artists
80 Odili Donald Odita, *Equalizer*, installation view, Studio Museum in Harlem, New York, November 14, 2007–March 9, 2008. Courtesy the artist and Jack Shainman Gallery, New York. © Odili Donald Odita
81 Imran Qureshi, *They Shimmer Still*, 2012, installation view, 18th Biennale of Sydney. Courtesy the artist and Corvi-Mora, London
82 Shahzia Sikander, *Disruption as Rapture*, 2016. HD video animation with 7.1 surround sound; music by Du Yun featuring Ali Sethi; animation by Patrick O'Rourke; commissioned by the Philadelphia Museum of Art. Duration 10 minutes 7 seconds, edition of 3 with 2 artist's proofs. Courtesy the artist and Sean Kelly, New York. © Shahzia Sikander
83 Bharti Kher, *Blind matter, dark night*, 2017. Bindis on painted board, 249.5 × 188.3 × 8.9 (98¼ × 74⅛ × 3½). Photo Jeetin Sharma. Courtesy the artist and Hauser & Wirth. © Bharti Kher
84 Meena Hasan, *Wedding Marigold 2*, 2018. Oil and acrylic on panel, 35.6 × 27.9 (14 × 11). Courtesy the artist
85 Benjamín Domínguez, *El Sueño II*, 2013. Oil on linen, 99.1 × 109.2 (39 × 43). Courtesy Ruiz-Healy Art, San Antonio, TX
86 Mohammad Ehsai, *Loving Whisper, 1973–2008*, 2008. Oil on canvas, 300 × 184.5 (118⅛ × 72⅝). Private Collection/Christie's Images/The Bridgeman Art Library. Courtesy the artist and Mah Art Gallery, Tehran
87 Tsherin Sherpa, *Peace Out*, 2013. Gold leaf, acrylic, and ink on paper, 56 × 56 (22 × 22). Private Collection. Courtesy the artist and Rossi & Rossi Ltd., London
88 Dedron, *Down below the Snow Mountain*, 2009. Mineral pigments on Tibetan paper, 54 × 38 (21 × 15). Courtesy the artist and Rossi & Rossi Ltd., London

89 Lisa Yuskavage, *PieFace*, 2008. Oil on linen, 121.9 × 102.2 (48 × 40¼). Courtesy the artist and David Zwirner. © Lisa Yuskavage
90 John Currin, *Hot Pants*, 2010. Oil on canvas, 198.1 × 152.4 (78 × 60). Photo Robert McKeever. Courtesy Gagosian Gallery. © John Currin
91 Will Cotton, *Cotton Candy Cloud*, 2004. Oil on linen, 190.5 × 254 (75 × 100). Courtesy Mary Boone Gallery, New York. © Will Cotton
92 Merlin James, *Two Poplar Trees*, 2009–11. Acrylic on canvas, 57.5 × 90.5 (22⅝ × 35⅝). Courtesy of Sikkema Jenkins & Co., New York. © Merlin James
93 Bjarne Melgaard, 'IDEAL POLE. Repetition Compulsion by Bjarne Melgaard', installation view, Ramiken Crucible, New York, 2012. Photo Jason Mandella. Courtesy the artist and Gavin Brown's enterprise, New York/Rome
94 Olivier Mosset, *Untitled*, 2010, installation view, Leo Koenig Gallery, New York, 2011. Polyurethane on canvas, forty parts, each 121.9 × 121.9 (48 × 48). Photo Thomas Mueller. Courtesy Koenig & Clinton, New York
95 I Nyoman Masriadi, *Masriadi Presents – Attack From Website*, 2009. Acrylic on canvas, 200 × 300 (78¾ × 118¼). Courtesy the artist and Paul Kasmin Gallery, New York
96 Damien Hirst, *Winner/Loser*, 2018. Glass, painted steel, silicone, monofilament, bull sharks and formaldehyde solution, 196.5 × 249.6 × 123.2 (77⅜ × 98⅜ × 48⅝). Photo courtesy Clint Jenkins. © Damien Hirst and Science Ltd. All Rights Reserved, DACS/Artimage 2020
97 Damien Hirst, *Oleandrin*, 2010. Household gloss on canvas, 37 × 33 (14⅝ × 13). © Damien Hirst and Science Ltd. All Rights Reserved, DACS/Artimage 2020
98 Emily Kame Kngwarreye, *Ntange Dreaming*, 1989. Synthetic polymer paint on canvas, 135 × 122 (53¼ × 48⅛). National Gallery of Australia, Canberra. Purchased 1989/Bridgeman Images. © Emily Kame Kngwarreye/Copyright Agency. Licensed by DACS 2020
99 Bernard Frize, *Ledz*, 2018. Acrylic and resin on canvas, 281 × 523 (110⅝ × 205⅞). Courtesy the artist and Perrotin. © ADAGP, Paris and DACS, London 2020
100 Takashi Murakami, *727-727*, 2006. Acrylic on canvas, mounted on board, three panels: overall dimensions 300 × 450 × 7 (118⅛ × 177³⁄₁₆ × 2¾). Courtesy Perrotin. © 2006 Takashi Murakami/Kaikai Kiki Co., Ltd. All Rights Reserved
101 Aya Takano, *All Was Light*, 2012. Oil on canvas, 194 × 130 (76⅜ × 51). Courtesy Perrotin.

102 Louis Vuitton and Richard Prince, runway show 'Nurses', during Paris Fashion Week, October 2007. Photo Lorenzo Santin/WireImage/Getty Images
103 Kehinde Wiley, *Barack Obama*, 2018. Oil on canvas, 213.4 × 147.3 (84 × 58). Courtesy the National Portrait Gallery, Smithsonian Institution. The National Portrait Gallery is grateful to the following lead donors for their support of the Obama Portraits: Kate Capshaw and Steven Spielberg; Judith Kern and Kent Whealy; Tommie L. Pegues and Donald A. Capoccia. © 2020 Kehinde Wiley
104 Subodh Gupta, *Saat Samunder Paar VII*, 2003. Oil on canvas, 167.4 × 228.6 (65⅞ × 90). Courtesy the artist and Hauser & Wirth
105 Liu Ding, *Samples from the Transition – Products, Part 2*, 2005-6. Traditional living-room furniture and forty paintings in gilded frames, each 69 × 99.5 (27³⁄₁₆ × 39³⁄₁₆). Courtesy the artist and Galerie Urs Meile, Beijing-Lucerne
106 Christian Jankowski, *China Painters (Still Life)*, 2008. Oil on canvas, 224.4 × 315 (88⅜ × 124). Courtesy Lisson Gallery, London
107 Ragnar Kjartansson, *The End – Venice*, 2009. Six-month performance during the 53rd Venice Biennale. Commissioned by the Center for Icelandic Art, Reykjavik. Photo Rafael Pinho. Courtesy the artist, Luhring Augustine, New York and i8 Gallery, Reykjavik
108 Josh Smith, 'Emo Jungle', installation view, David Zwirner, New York, 2019. Courtesy the artist and David Zwirner. © Josh Smith
109 Eliza Douglas, *Josh Smith*, 2019. Oil on canvas, 175 × 175 (69 × 69). Courtesy Overduin & Co., Los Angeles
110 Parker Ito, *A Lil' Taste of Cheeto in the Night*, 2015, installation view, Château Shatto. Photo Elon Schoenholz. Courtesy the artist and Château Shatto, Los Angeles
111 Josef Strau, *What Should One Do*, 2011. Floor lamp and painting with metal chains and rings, canvas, 76.2 × 101.6 (30 × 40), lamp height 152.4 (60). Photo Martha Fleming-Ives. Courtesy the artist and Greene Naftali, New York
112 Aaron Young, *Greeting Card (Armory, quadriptych)*, performance at the Park Avenue Armory, New York, 2007, dimensions variable. Courtesy the artist and Bortolami Gallery, New York
113 Seth Price, *Untitled*, 2008-9, from the *Vintage Bomber* series. Autobody enamel on vacuum-formed high-impact polystyrene, 243.8 × 121.9 (96 × 48). Courtesy Seth Price
114 Michel Majerus, *if we are dead, so it is*, 2000. Acrylic paint, digital print and lacquer on multiplex and wood, 310 × 992 × 4732 (122⅛ × 390⁹⁄₁₆ × 1863). Photo David Franck, Stuttgart. Courtesy neugerriemschneider, Berlin and Matthew Marks Gallery, New York. © Michel Majerus Estate 2000
115 Tom Moody, *sketch_i7a*, 2012. Digital painting, dimensions variable. Courtesy the artist
116 Corinne Wasmuht, *Brueckenstr.*, 2008. Oil on wood, 227 × 519 (89⅜ × 204⅜). Courtesy the artist and Petzel, New York
117 Harm van den Dorpel, *On Usability*, 2011. Mixed media, 24.1 × 18.6 × 2 (9½ × 7⁵⁄₁₆ × 1³⁄₁₆). Courtesy the artist
118 David Hockney, *No. 522*, 2009. iPhone drawing, dimensions variable. © David Hockney
119 Joshua Nathanson, *David Gets a Cupcake*, 2015. Acrylic and oil stick on canvas, 205.7 × 154.9 × 3.8 (81 × 61 × 1½). Courtesy the artist
120 Michael Williams, *Truth About Painting 2*, 2017. Inkjet on canvas, 309.2 × 215.9 × 2.5 (121¾ × 85 × 1). Courtesy the artist and Gladstone Gallery, New York and Brussels. © Michael Williams
121 Simon Ingram, *Radio Painting Station: Looking for the Waterhole*, 2017-18. Aluminium, steel, cable, electronics, software, computer, brush, tape, oil paint on linen, dimensions variable. Installation, 'Open Codes – Living in Digital Worlds', ZKM, Center for Art and Media Karlsruhe, 2017-18. Photo Jonas Zillius. ZKM, Center for Art and Media, Karlsruhe. © Simon Ingram
122 Siebren Versteeg, *A Rose*, 2017. Algorithmically generated image printed on canvas, flash drive, 274.3 × 162.2 (108 × 65). Courtesy bitforms gallery, New York
123 Obvious, *Portrait of Edmond de Belamy*, 2018. GAN algorithms, inkjet print on Japanese canvas, 70 × 70 (27½ × 27½). Obvious – @obvious_art
124 Manuel Solano, *Fairuza I*, 2014 from the series *Blind Transgender with AIDS*. Acrylic on paper, 86.5 × 56.5 (34⅛ × 22¼). Photo PJ Rountree. Collection of the artist
125 Pamela Rosenkranz, 'The Most Important Body of Water is Yours', installation view, Karma International, Zürich, 2010. Photo Gunnar Meier. Courtesy the artist and Karma International, Zürich and Los Angeles
126 Amoako Boafo, *Reflection 1*, 2018. Oil on paper, 130 × 110 (51¼ × 43⅜). Photo Robert Wedemeyer. Courtesy the artist and Roberts Projects, Los Angeles

127 Neo Rauch, *Die Lage*, 2006. Oil on canvas, 300 × 420 (118⅛ × 165⅜). Private Collection, USA. Photo Uwe Walter, Berlin. Courtesy Galerie EIGEN+ART Leipzig/Berlin, David Zwirner, New York/London. © Neo Rauch courtesy Galerie EIGEN+ART Leipzig/Berlin/DACS, 2015

128 Christoph Ruckhäberle, *Nacht 32*, 2004. Oil on canvas, 190 × 280 (74¹³⁄₁₆ × 110¼). Courtesy ZieherSmith Gallery, New York

129 Zhang Xiaogang, *Lovers*, 2007, from the series *Bloodline*. Oil on canvas, 200 × 260 (78¾ × 102⅜). Courtesy the artist and Pace Gallery, Beijing

130 Yue Minjun, *Inside and Outside the Stage*, 2009. Oil on canvas, 267 × 336 (105⅛ × 132⁵⁄₁₆). Courtesy Yue Minjun Studio

131 Liu Xiaodong, *Time*, 2014. Oil on canvas, 20 canvases each 60 × 60 (23¾ × 23¾), overall 240 × 300 (94½ × 118⅛). Courtesy Lisson Gallery, London. © Liu Xiaodong Studio

132 Chéri Samba, *Problème d'eau*, 2004. Acrylic on canvas, 135 × 200 × 4 (53¼ × 78¾ × 1⅝). Courtesy CAAC – Pigozzi Collection. © Chéri Samba

133 Swarna Chitrakar, *HIV*, 2004–5. Patua painting on paper, made of six panels, overall 284 × 56 (111⅞ × 22⅛). Photo DGPC/ADF. Museu Nacional de Etnologia/National Museum of Ethnology, Lisbon

134 Pablo Baen Santos, *Baboons in Session*, 2008. Oil on canvas, 182.9 × 213.4 (72 × 84). Collection of Patrick Reyno. Courtesy the artist

135 Carla Busuttil, *No Country for Poor People*, 2013. Oil on canvas, 100 × 80 (39⅜ × 31½). Courtesy the artist and Goodman Gallery

136 Vasan Sitthiket, *Bomb for Liberty*, 2017. Acrylic on canvas, 61 × 40.6 (24 × 16). Courtesy the artist and Ethan Cohen Gallery

137 Teresa Margolles, *Flag I*, 2009. Fabric, blood, earth and other substances, 298 × 188 (117⅜ × 74⅛). Photo Tate. Courtesy Teresa Margolles

138 Kara Walker, 'After the Deluge', installation view, The Metropolitan Museum of Art, The Lila Acheson Wallace Wing, The Gioconda and Joseph King Gallery, March 21–August 6, 2006. The Metropolitan Museum of Art/Art Resource/Scala, Florence. Courtesy Sikkema Jenkins & Co., New York. © Kara Walker

139 Ronald Ophuis, *The Death of Edin, Srebrenica July 1995*, 2007. Oil on linen, 345 × 480 (135¹³⁄₁₆ × 189). Courtesy Aeroplastics Bruxelles, Upstream Gallery Amsterdam, Galerie Ceysson & Bénétière Paris, Luxembourg, New York, Saint-Étienne

140 Pablo Alonso, *You've Never Had it So Good 1*, 2003. Acrylic and marker on unprimed cotton canvas, 280 × 400 (110¼ × 157½). Private Collection, Beijing. Courtesy Pablo Alonso

141 Miguel Aguirre, *Ana Martín Fernández*, 2008, from the series *In Memoriam*. Oil on paper, 50 × 35 (19¹¹⁄₁₆ × 13¾). Courtesy the artist

142 Luc Tuymans, *Turtle*, 2007, installation view, Palazzo Grassi, Venice, 2019. Oil on canvas, 368 × 509 (145 × 200½). Courtesy the artist and David Zwirner. © Luc Tuymans

143 Luc Tuymans, *Schwarzheide*, installation view, Palazzo Grassi, Venice, 2019. Marble mosaic realised by Fantini Mosaici, Milan. Courtesy the artist and David Zwirner. © Luc Tuymans

144 Bracha L. Ettinger, *Eurydice n. 53 – Pieta*, 2012–16. Oil on canvas, 50 × 41 (19¾ × 16¼). Courtesy the artist

145 Serban Savu, *Blue Shadow*, 2010. Oil on canvas, 137 × 106.5 (54 × 42). Courtesy the artist and David Nolan Gallery, New York. © Serban Savu

146 Alexander Tinei, *Uncle J*, 2006. Oil on canvas, 100 × 80 (39⅜ × 31½). Courtesy the artist and Deák Erika Gallery, Budapest

147 Njideka Akunyili Crosby, *Ike Ya*, 2016. Acrylic, transfers, colour pencil and charcoal on paper 213.4 × 233.7 (84 × 92). Courtesy the artist, Victoria Miro and David Zwirner. © Njideka Akunyili Crosby

148 Ghada Amer, *The Woman Who Failed To Be Shehrazade*, 2008. Acrylic, embroidery and gel medium on canvas, 157.5 × 172.7 (62 × 68). Courtesy the artist and Marianne Boesky Gallery, New York and Aspen. © Ghada Amer

149 Weaam Ahmed El-Masry, *The Embrace*, 2011. Pen and glass colours on hard paper, 100 × 70 (39⅜ × 27⅝). Collection of Ms. Stefania Phacos Nazzal. Courtesy the artist

150 Anna Bjerger, *Toxic/Rock*, 2018. Oil on aluminium, 105 × 130 (41⅜ × 51¼). Courtesy Galleri Magnus Karlsson, Stockholm

151 Chantal Joffe, *Blonde in a Black Sweater*, 2015. Oil on board, 61 × 45.8 (24⅛ × 18⅛). Courtesy the artist and Victoria Miro, London/Venice. © Chantal Joffe

152 Richard Phillips, *Frieze*, 2009. Oil on canvas, 213.4 × 284.5 (84 × 112). Courtesy Gagosian. © Richard Phillips

153 Kathe Burkhart, *Fuck Off*, 2015, from the *Liz Taylor Series (Raintree County)*, 2015. Acrylic and mixed media on canvas, 228.6 × 152.4 (90 × 60). Courtesy the artist

154 Jenny Saville, *Fate I*, 2018. Oil on canvas, 260 × 240 (102⅜ × 94½). Photo Mike Bruce.

Courtesy Gagosian. © Jenny Saville. All Rights Reserved, DACS 2020
155 Cecily Brown, *Paradise to Go 1*, 2015. Oil on linen, 246.4 × 226.1 (97 × 89). Courtesy Gagosian. © Cecily Brown
156 Mickalene Thomas, *Origin of the Universe 1*, 2012. Rhinestones, acrylic and oil on wood panel, 121.9 × 152.4 (48 × 60). © ARS, NY and DACS, London 2020
157 Ellen Altfest, *The Penis*, 2006. Oil on canvas, 27.8 × 30.4 (11 × 12). Photo Cary Whittier. Courtesy White Cube. © Ellen Altfest
158 Ivy Haldeman, *Full Figure, Open Book*, 2018. Acrylic on canvas, 152.4 × 213.4 (60 × 84). Collection of Ari Mir. Courtesy the artist and Downs & Ross, New York
159 Ulrike Müller, 'Container', exhibition view at Kunstverein für die Rheinlande und Westfalen, Düsseldorf, 2018–19. Photo Katja Illner. Courtesy Callicoon Fine Arts, New York
160 Mark Beard, *[Bruce Sargeant (1898–1938)], Seven Gymnasts on the Ropes*, n.d. Oil on canvas, 213.4 × 182.9 (84 × 72). Courtesy ClampArt, New York
161 Nicole Eisenman, *Sloppy Bar Room Kiss*, 2011. Oil on canvas, 99.1 × 121.9 (39 × 48). Photo Robert Wedemeyer. Courtesy Susanne Vielmetter Los Angeles Projects
162 Christina Quarles, *Moon (Lez Go Out N' Feel Tha Nite)*, 2017. Acrylic on canvas, 127 × 101.6 (50 × 40). Courtesy the artist, Pilar Corrias, London, and Regen Projects, Los Angeles
163 Louis Fratino, *Andrea in Gambara*, 2018. Oil on canvas, 27.9 × 35.6 (11 × 14). Courtesy Sikkema Jenkins & Co., New York. © Louis Fratino
164 Jonathan Lyndon Chase, *dimonds all over my body*, 2018. Acrylic, rhinestones, glitter, pastel and marker on canvas, 152.4 × 101.6 (60 × 40). Courtesy the artist, and Kohn Gallery, Los Angeles
165 Didier William, *M vle santi w andelan m*, 2018. Wood carving, collage, ink and acrylic on panel, 152.4 × 121.9 (60 × 48). Photo Jason Mandella. Courtesy James Fuentes LLC
166 Carsten Höller, *Revolving Hotel Room*, installation view, 'theanyspacewhatever', October 24, 2008–January 7, 2009, Solomon R. Guggenheim Museum, New York. Photo David Heald. Solomon R. Guggenheim Foundation, New York. © DACS 2020
167 Richard Aldrich, 'Once I Was...', installation view, Bortolami Gallery, New York, 2011. Courtesy the artist and Bortolami Gallery, New York
168 Robert Ryman, *No Title Required 3*, 2010, installation view, Pace Gallery, New York. Enamel and acrylic on birch plywood (panels 1–4 and 6–9) and enamel and acrylic on board panel (panels 5 and 10), overall installation dimensions 213.4 × 1331 (84 × 524). © Robert Ryman/DACS, London 2020
169 Pieter Vermeersch, *Untitled*, 2009. Acrylic paint on wall, each 500 × 3100 (196⅞ × 1220½). Exhibition view of 'Beyond These Walls', South London Gallery, London, 2009. Photo Pieter Huybrechts. Courtesy Carl Freedman Gallery, London
170 Clément Rodzielski, *Untitled*, 2008, installation view. Five notebook sheets, each 41 × 30 (16⅛ × 11¹³⁄₁₆); three wooden boards, 136 × 136 (53⁹⁄₁₆ × 53⁹⁄₁₆), 203 × 136 (79¹⁵⁄₁₆ × 53⁹⁄₁₆), and 207 × 136 (81½ × 53⁹⁄₁₆), dimensions of installation variable. Photo Remy Lidcreau. Courtesy the artist, Galerie Chantal Crousel, Paris and Campoli Presti, London
171 Angela de la Cruz, *Deflated XVII (Yellow)*, 2010. Oil on canvas, 153 × 180 (60¼ × 70⅞). Courtesy Lisson Gallery, London. © Angela de la Cruz
172 Dan Rees, *Payne's Grey and Vermillion*, 2010. Acrylic on canvas and wall, 142.2 × 101.6 (56 × 40). Courtesy the artist and Tanya Leighton, Berlin
173 David Ostrowski, *F (Between Two Ferns)*, 2014. Acrylic and lacquer on canvas, wood, 241 × 191 (95 × 75¼). Photo Matthias Kolb. Courtesy Peres Projects, Berlin
174 Jennifer Bartlett, *Recitative*, 2009–10. Enamel over silkscreen grid on baked enamel, steel plates, 340.4 × 4823.5 (134⅛ × 1899⅛), 372 plates: 159 at 30.5 × 30.5 (12 × 12), 117 at 45.7 × 45.7 (18 × 18), 96 at 61 × 61 (24 × 24). Photo courtesy Pace Gallery. Courtesy the artist and Marianne Boesky Gallery, New York
175 Laura Owens, 'Ten Paintings', installation view, CCA Wattis Institute, San Francisco, 28 April – 23 July 2016. Photo Johnna Arnold. Courtesy CCA Wattis Institute, San Francisco. and Sadie Coles HQ, London. © Laura Owens
176 Yunhee Min, *Hammer Project*, installation view, 2019. Photo Jeff McLane. Courtesy the artist and Miles McEnery Gallery, New York
177 Katharina Grosse, *One Floor Up More Highly*, 2010, installation view, Massachusetts Museum of Contemporary Art. Acrylic on wall, floor, clothing, Styrofoam and glass fibre reinforced plastic, 780 × 1680 × 8260 (307 × 661½ × 3252). Photo Art Evans. © Katharina Grosse and VG Bild-Kunst Bonn, 2015
178 Alex Hubbard, 'El Cafecito', installation view, House of Gaga, Mexico City, 2016. Photo Omar

Olguín. Courtesy the artist and Gaga, Mexico City and Los Angeles

179 Mika Tajima, *The Extras*, installation view, X Initiative, New York, 2009. Photo Tom Powell. Courtesy Mika Tajima

180 Sigrid Sandström, *Projection I*, 2018. Acrylic on polyester canvas, light projection, 193 × 152 (76 × 59⅞). Courtesy the artist

181 Jacqueline Humphries, installation view, Carnegie Museum of Art, Pittsburgh, Pennsylvania, 2015. Courtesy the artist and Greene Naftali, New York

182 Mary Weatherford, *from the Mountain to the Sea*, 2014. Flashe and neon on linen, 297.2 × 594.4 (117 × 234). Photo Fredrik Nilsen Studio. Courtesy the artist

183 Julia Dault, *Sure You Can*, 2011. Oil on vinyl, dimensions variable. Courtesy the artist, Bob van Orsouw, Zürich, and Marianne Boesky Gallery, New York

184 Jutta Koether, *Lux Interior*, performance documentation at Reena Spaulings Fine Art, New York, 2009. Photo John Kelsey. Courtesy the artist and Reena Spaulings Fine Art, New York

185 Emily Sundblad, '¡Qué Bárbaro!', installation view, Algus Greenspon Gallery, New York, 2011. Courtesy the artist and Algus Greenspon, New York

186 Ei Arakawa, *I am an Employee of UNITED, Vol. 2*, performance at Overduin and Kite, Los Angeles, 2012. Courtesy Overduin & Co., Los Angeles

187 Nikolas Gambaroff, 'Tools for Living', installation view, Overduin and Kite, Los Angeles, 2012. Courtesy Overduin & Co., Los Angeles

188 Math Bass, 'Off the Clock', 2015, installation view, MoMA PS1, New York. Courtesy the artist, MoMA PS1, and Tanya Leighton, Berlin

189 Vanessa Maltese, *Duped by the grapes*, 2018. Oil on panel, powder-coated steel and wooden magnets, 132.1 × 104.1 (52 × 41). Courtesy Vanessa Maltese and COOPER COLE, Toronto

190 Michael Lin, 'Locomotion', 2016, installation view, Museum of Contemporary Art and Design (MCAD) Manila. Photo At Maculangan, Pioneer Studio, Manila. Courtesy the artist

191 Mary Heilmann, 'To Be Someone', installation view, Orange County Museum of Art, Newport Beach, California, 2007. Courtesy the artist, 303 Gallery, New York, and Hauser & Wirth

192 Sarah Crowner, 'The Wave', installation view, Nicelle Beauchene Gallery, New York, 2014. Courtesy the artist, Casey Kaplan, New York and Nicelle Beauchene Gallery, New York

193 Marc Camille Chaimowicz, 'Your Place or Mine…', installation view, The Jewish Museum, New York, 2018. Photo Jason Mandella. Courtesy the artist and Andrew Kreps Gallery, New York

194 Elise Adibi, *Persian Rose Monochrome*, with plants, from *Respiration Paintings*, installation view, The Frick Pittsburgh Greenhouse, 2017. Rabbit skin glue, graphite, oil paint, rose, bergamot, sweet orange and lemon essential plant oils on canvas, 76.2 × 76.2 (30 × 30). Courtesy the artist

195 Firelei Báez, *19.604692°N 72.218596°W*, 2019. Concrete panels, paint, wood, 365.8 × 213.4 × 299.7 (144 × 84 × 118). A High Line Commission. On view April 2019–March 2020. Photo Timothy Schenck. Courtesy James Cohan, New York

196 Paul Branca, *Couch Crash*, 2010. Oil on multiple canvases, dimensions variable. Courtesy Scaramouche, New York and Golden Parachutes, Berlin

197 Oda Projesi, *Picnic*, Galata, Istanbul, 2004. Community project. Courtesy Oda Projesi archive

198 Theaster Gates, *Land Ownership on Conspiracy Blue*, 2016. Acrylic on board, 183.2 × 124.5 × 5.7 (72⅛ × 49 × 2¼). Photo Nathan Keay. Courtesy White Cube. © Theaster Gates

199 Maurizio Cattelan, 'All', installation view, Solomon R. Guggenheim Museum, New York, 2011. Courtesy the artist, Marian Goodman Gallery, New York, Galerie Emmanuel Perrotin, Paris/Hong Kong and Galleria Massimo De Carlo, Milan/London

200 Heimo Zobernig, 'Ohne Titel (In Red)', installation view, Kunsthalle Zürich at Museum Bärengasse, 2011. Stefan Altenburger Photography, Zürich. © DACS 2015

201 Stephen Prina, *Exquisite Corpse: The Complete Paintings of Manet, 135 of 556: L'Execution de Maximilien de Mexique III (The Execution of Maximilian of Mexico III), 1867*, installation view, Kunsthalle Mannheim, 1990. Courtesy Maureen Paley, London. © Stephen Prina

202 Scott Lyall, *Nanofoil (SLStudio.clone_1/13/3)*, 2018 (detail). UV-engraved photonic structures in aluminium foil, polymer coating, casein-painted frame, 9.2 × 6.8 (3⅝ × 2¹¹/₁₆), framed: 33 × 30.5 (13 × 12). Photo Stephen Faught. Courtesy the artist and Miguel Abreu Gallery, New York

203 Merlin Carpenter, 'TATE CAFÉ', 2012, installation view, Reena Spaulings Fine Art, New York. Dimensions variable. © Merlin Carpenter

204 Nick Mauss, *Concern, Crush, Desire*, installation view, Whitney Biennial, New York,

2012. Courtesy Nick Mauss and 303 Gallery, New York
205 Nasrin Tabatabai and Babak Afrassiabi, 'Two Archives', installation view with paintings from the series *Depot of the Tehran Museum of Contemporary Art*, Tensta Konsthall, Stockholm, 2013. Photo Emily Fahlén. Courtesy the artists
206 ABOVE Michelle Hartney, *Separate the Art From the Artist?*, 2018. Guerrilla performance at the Metropolitan Museum of Art, New York. Photo Michelle Hartney
206 BELOW Michelle Hartney, *Separate the Art From the Artist?*, 2018. Guerrilla performance at the Metropolitan Museum of Art, New York. Photo Nate Brav-McCabe
207 Kara Walker, *Dredging the Quagmire (Bottomless Pit)*, 2017. Oil stick and Sumi ink on paper collaged on linen, triptych, overall 228.6 × 548.6 (90 × 216). Courtesy Sikkema Jenkins & Co., New York. © Kara Walker
208 Cheyney Thomson, *Chromachrome (S6/SPR) (Tondo)*, 2009. Oil on canvas, 76.2 × 61 (30 × 24). Courtesy Campoli Presti, London/Paris
209 Anna Betbeze, *Gutter*, 2016. Wool, acid dyes and ash from burning, 188 × 106.7 (74 × 42). Courtesy the artist
210 Sergej Jensen, *Golden Shower Chanel Strip*, 2019. Fabric, UV-Print and acrylic on sewn linen, 188 × 160 (74 × 63). Photo Eduardo Ortega. Courtesy Fortes D'Aloia & Gabriel, São Paulo/Rio de Janeiro; Galerie Buchholz, Cologne/Berlin/New York; and White Cube
211 Dianna Molzan, *Untitled*, 2019. Oil on canvas with poplar, 68.6 × 45.7 × 3.8 (27 × 18 × 1.5). Photo Brica Wilcox. Courtesy the artist and Kristina Kite Gallery, Los Angeles
212 Lesley Vance, *Untitled*, 2017. Oil on linen, 78.7 × 61 × 1.9 (31 × 24 × ¾). Photo Fredrik Nilsen Studio. Courtesy David Kordansky Gallery, Los Angeles
213 Josephine Halvorson, *Sign Holders*, 2010. Oil on linen, 101.6 × 76.2 (40 × 30). Courtesy Sikkema Jenkins & Co., New York. © Josephine Halvorson
214 Nathlie Provosty, *Visions*, 2017. Oil on linen, 254 × 222.3 (100 × 87½). Courtesy the artist and Nathalie Karg Gallery, New York
215 John Nixon, *Black Monochrom (Ruler)*, 2019. Enamel, plaster and wood on canvas, 45 × 35 (17¾ × 13⅞). Photo Conradin Frei. Courtesy Mark Müller Gallery, Zürich
216 Ian Davenport, *Puddle Painting: Dark Grey (after Uccello)*, 2010. Acrylic on aluminium mounted on aluminium frame,

148 × 128 (58¼ × 50⅜). © Ian Davenport. All Rights Reserved, DACS 2020
217 Stephen Prina, *PUSH COMES TO LOVE, Untitled, 1999–2013*, 2013. The contents of a can of enamel spray paint applied to Wade Guyton's *Untitled*, 2013, Epson UltraChrome inkjet on linen, dimensions variable. Courtesy the artists and Petzel, New York
218 Ida Ekblad, 'ILLUMInations', installation view, 54th Venice Biennale, 2011. Photo Luca Campigotto. Courtesy the artist; Herald St, London; Karma International, Zürich/Los Angeles; Galerie Max Hetzler, Berlin/Paris/London
219 Matt Connors, *Table II (16 Cups)*, 2010. Oil and acrylic on canvas 91.4 × 66 (36 × 26). Courtesy CANADA, New York; Herald St, London; The Modern Institute, Glasgow and Xavier Hufkens, Brussels
220 Fergus Feehily, *Grey Foxed*, 2009. Oil and acrylic on card, board and wood, screws, 25 × 20 × 1.2 (9⅞ × 7⅞ × ½). Photo Michaela Konz. Courtesy the artist, Misako & Rosen, Tokyo and Galerie Christian Lethert, Cologne
221 Robert Janitz, 'Uptown Canvas', installation view, Anton Kern Gallery, New York, 2018. Courtesy the artist and Anton Kern Gallery, New York. © Robert Janitz
222 Markus Amm, *Untitled*, 2017. Oil on gesso board, 35 × 30 (13¾ × 11⅞). Photo Annik Wetter. Courtesy David Kordansky Gallery, Los Angeles
223 Ruth Laskey, *Twill Series (Robin's Egg Blue/Yucca/Light Green)*, 2007. Hand-dyed and handwoven linen, 50.2 × 46.4 (19¾ × 18¼). Courtesy the artist and Ratio 3, San Francisco
224 Tauba Auerbach, *Untitled (Fold)*, 2012. Acrylic on canvas on wooden stretcher, 182.9 × 137.2 (72 × 54). Marciano Art Collection. Courtesy Paula Cooper Gallery, New York. © Tauba Auerbach
225 Paul Sietsema, *Swipe painting (Chase)*, 2016. Enamel on linen, 111 × 107 (43⅞ × 42⅛). Courtesy Matthew Marks Gallery. © Paul Sietsema
226 Tomma Abts, *Weie*, 2017. Acrylic and oil on canvas, 48 × 38 (19 × 15). Courtesy Galerie Buchholz, Berlin/Cologne/New York
227 Lucien Smith, *Southampton Suite #3*, 2013. Acrylic on unprimed canvas, 274.3 × 213.4 (108 × 84). Courtesy the artist
228 Jacob Kassay, 'EXPO 1: New York', installation view, MoMA PS1, 2013. Photo John Berens. Courtesy 303 Gallery, New York
229 Gary Hume, *Water*, 2018. Gloss paint on paper, 120 × 361 × 0.3 (47¼ × 142⅛ ×⅛), framed 121.5 × 363 × 4.5 (47⅞ × 143 × 1¾). Courtesy

the artist, Sprüth Magers and Matthew Marks Gallery. © Gary Hume. All Rights Reserved, DACS 2020

230 Tomashi Jackson, *Avocado Seed Soup (Davis, et. al. v County School Board of Prince Edward County) (Brown, et. al. v Board of Education of Topeka) (Sweatt v Painter)*, 2016. Mixed media on gauze, canvas, rawhide and wood, 281.9 × 426.7 × 83.2 (111 × 168 × 32¾). Courtesy the artist and Tilton Gallery, New York

231 Juan Uslé, *In Kayak (Silente)*, 2012. Vinyl, acrylic, dry pigment and dispersion on canvas, 46 × 31 (18⅛ × 12³⁄₁₆). Courtesy the artist and Frith Street Gallery, London

232 Peter Dreher, *Tag um Tag guter Tag Nr. 2685 (Night)* (Day by Day, Good Day), 2013. Oil on linen, 25.1 × 20 (9⅞ × 7⅞). Courtesy the artist and Koenig & Clinton, New York. © 2015 Peter Dreher/ Artists Rights Society (ARS), New York

233 On Kawara, *19 SEPT. 2013*, 2013, from *Today* series, 1966–2013. Acrylic on canvas, 20.3 × 25.4 (8 × 10). Courtesy One Million Years Foundation and David Zwirner. © One Million Years Foundation

234 Vija Celmins, *Night Sky #24*, 2016. Oil on canvas, 86 × 81 (33¾ × 32). Courtesy Matthew Marks Gallery. © Vija Celmins

235 Dashiell Manley, *The Financial Times, front page, Jun 15 2019. jun152019*, 2019. Watercolour pencil, acrylic and enamel on canvas, 182.9 × 152.4 (72 × 60). Photo Jeff Mclane. Courtesy the artist, Marianne Boesky Gallery, New York and Aspen and Jessica Silverman Gallery, San Francisco. © Dashiell Manley

236 Adam Pendleton, 'Personne et les autres', installation view, Belgian Pavilion, 56th Venice Biennale, 2015. Courtesy the artist. © Adam Pendleton

237 Mark Bradford, *Pickett's Charge*, installation view, Hirshhorn Museum and Sculpture Garden, Washington, D.C., 2017. Mixed media on canvas, 353.1 × 1523.9 (139 × 600). Photo Cathy Carver. Courtesy the artist and Hauser & Wirth. © Mark Bradford

238 Aliza Nisenbaum, *Wise Elders Portraiture Class at Centro Tyrone Guzman, 'En Familia hay Fuerza', Mural on the History of Immigrant Farm Labor to the United States*, 2017. Oil on linen, 190.5 × 241.3 (75 × 95). Courtesy the artist and Minneapolis Institute of Art, Minneapolis; Anton Kern Gallery, New York. © Aliza Nisenbaum

239 Jordan Casteel, *Three Lions*, 2015. Oil on canvas, 137.2 × 182.9 (54 × 72). Courtesy the artist and Casey Kaplan, New York. © Jordan Casteel

240 Kerry James Marshall, *Untitled (Studio)*, 2014. Acrylic on PVC panel, 211.9 × 301.8 (83½ × 118⅞). Courtesy the artist and David Zwirner, London. © Kerry James Marshall

241 Tschabalala Self, *Bodega Run Diptych*, 2017. Acrylic, watercolour, flashe, gouache, coloured pencil, pencil, hand-coloured photocopy and hand-coloured canvas on canvas, each panel 243.8 × 213.4 (96 × 84). Photo Damian Griffiths. Courtesy the artist and Pilar Corrias, London

242 Janiva Ellis, *Open Pour Reality*, 2017. Oil on canvas, 90.2 × 90.2 × 3.8 (35½ × 35½ × 1½). Photo Jörg Lohse. Courtesy the artist and 47 Canal, New York

243 Henry Taylor, *Split*, 2013. Acrylic and charcoal on canvas, two parts, each 182.9 × 152.4 × 6.4 (72 × 60 × 2½), overall 182.9 × 308.6 × 6.4 (72 × 121½ × 2½). Courtesy the artist and Blum & Poe, Los Angeles/New York/Tokyo. © Henry Taylor

244 Dana Schutz, *Open Casket*, 2016. Oil on canvas, 97.8 × 135.3 (38½ × 53¼). Courtesy the artist and Petzel, New York. © Dana Schutz

245 Parker Bright, *Confronting My Own Possible Death*, 2018. Oil pastel on paper, 48.3 × 61 (19 × 24). Courtesy the artist

Index

'The single most influential series of art books ever published' *Apollo*

'Outstanding ... exceptionally authoritative and well-illustrated' *Sunday Times*

Comprehensive in coverage and accessible to all, the World of Art series explores both the newest and the perennial in all the arts, covering themes, artists and movements that straddle the centuries and the gamut of visual culture around the globe.

You may also like:

Art Since 1989
Kelly Grovier

Movements in Art Since 1945
Edward Lucie-Smith

Graffiti and Street Art
Anna Waclawek

The Photograph as Contemporary Art
Charlotte Cotton

World of Art